PAUL STARR
ON BEAUTY

CONVERSATIONS WITH THIRTY CELEBRATED WOMEN

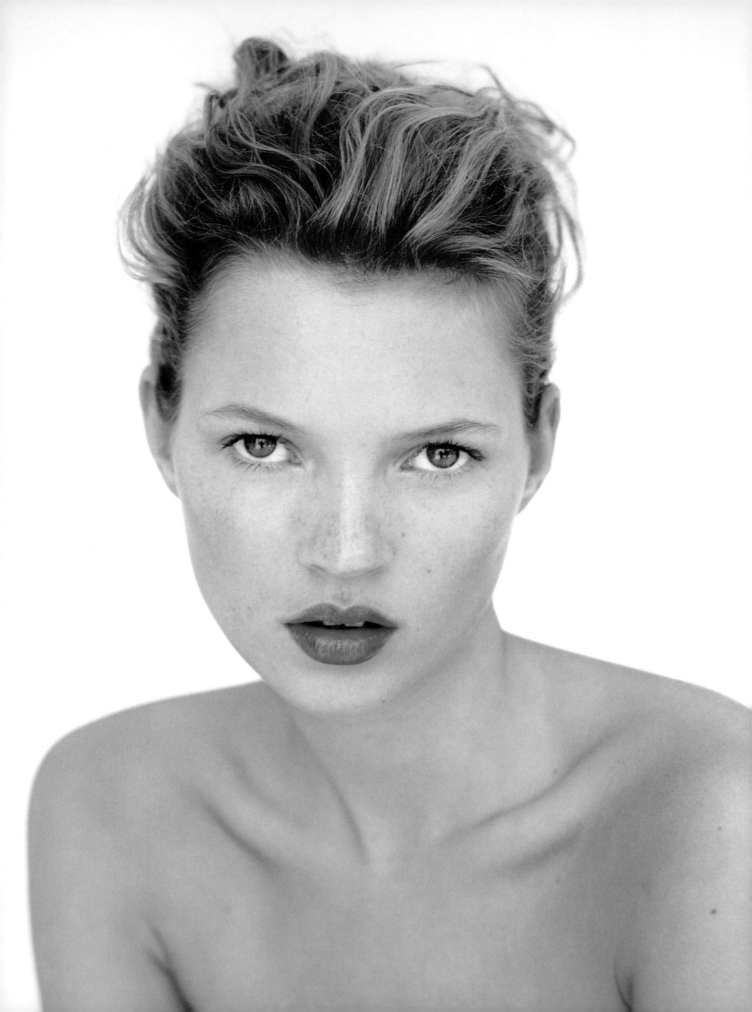

Paul Starr
On Beauty

CONVERSATIONS WITH THIRTY CELEBRATED WOMEN

Foreword by Linda Wells

Introduction by Gavin Lambert

Interviews and makeup by Paul Starr

MELCHER
MEDIA

in collaboration with ESTĒE LAUDER

Opposite: Kate Moss, photograph by Andrew Macpherson

Published by

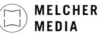 **MELCHER
MEDIA**

124 West 13th Street New York, NY 10011

www.melcher.com

Publisher: Charles Melcher Editor in Chief: Duncan Bock

Editor: Lia Ronnen Editorial Assistant: Lauren Nathan

Publishing Manager: Bonnie Eldon Production Director: Andrea Hirsh

Text editor: Larry Schubert Photo researcher: Sue Hostetler

Make-up text editor: Abbie Kozolchyk Copy editor: Elizabeth B. Johnson

Illustrations by Cindy Luu

Design by Sam Shahid & Company

09 08 07 06 05 10 9 8 7 6 5 4 3 2 1

Printed in China

ISBN-13: 978-1-59591-007-3

ISBN-10: 1-59591-007-7

Library of Congress Control Number: 2005012026

To all the women who have educated and inspired me

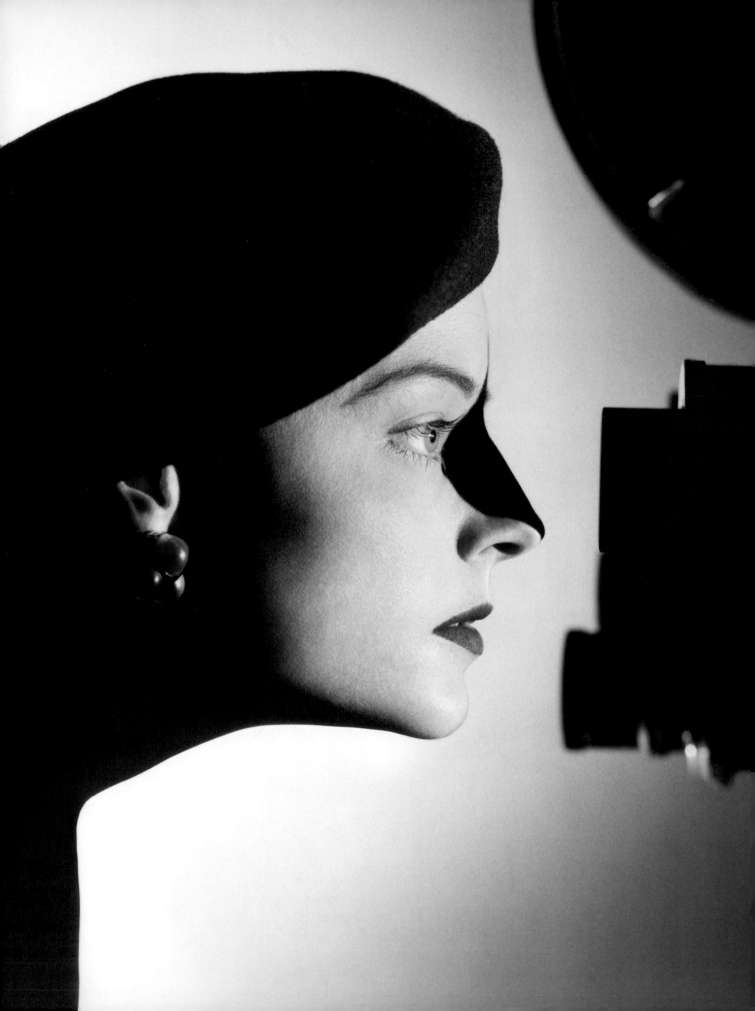

Contents

Opposite: Jodie Foster, photograph by Matthew Rolston

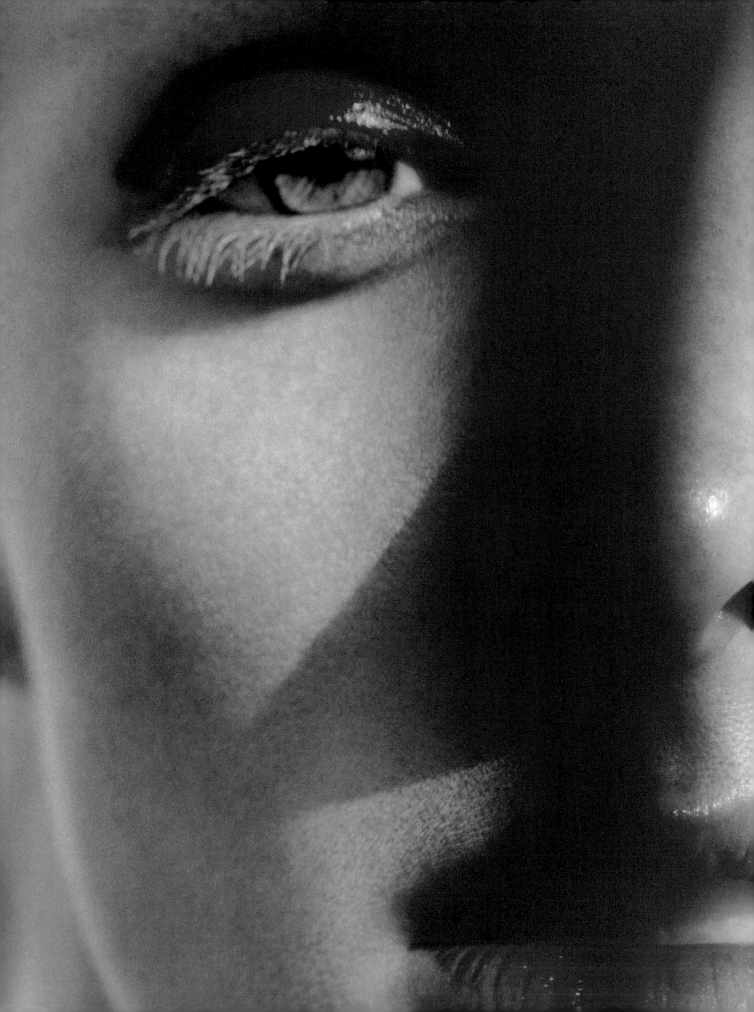

FOREWORD

Most women—whether lovely or homely—believe that beauty stems from confidence. Glowing skin, bright eyes, a wide smile (any smile) are all expressions of a healthy self-regard. Besides, confident women take care of themselves; they believe, as the saying goes, that they're worth it. This is an indisputable fact.

And yet, confidence is fragile—more fragile, certainly, than symmetrical features and an exquisite pair of cheekbones. It has to be nurtured and bolstered on a daily basis, starting each morning in front of the bathroom mirror. There, a woman confronts her face and sets out to enhance what she likes and correct what she doesn't with concealer, blush, lip gloss, and mascara. In making a woman look better, these simple products give her self-assurance. That may explain why some women cling to a particular shade of lipstick or blush as if it were a good luck charm, a talisman with special powers.

If cosmetics are ego boosters, then a highly skilled makeup artist is the ignition. He can render blemishes invisible without pasting them with spackle. He can turn flimsy eyelashes into something Bambi would envy. Lips become plush and pouty with his touch. And if he's really good, the makeup artist leaves no obvious evidence of his work.

It sounds so easy. It isn't.

Many years ago, *Allure* arranged to photograph Sophia Loren, a woman for whom the overused and much-abused term "icon" truly fits. A real icon doesn't surrender her face to just anyone, which is why we enlisted Paul Starr for the job. But Loren showed up at the photo studio in full makeup, dashing Starr's hopes of working with a legend. When the photographer explained Starr's talents to Loren, she asked him to bring her two bottles of Evian, and then pulled out a sponge from her bag and proceeded to wipe her face clean. She turned to Starr and said, "I'm yours."

I got a taste of what Sophia Loren experienced when Starr did my makeup before a party in Los Angeles. He set up his tools on my hotel room's terrace and sat me in a chair under the dappled light. My husband, who tends to get twitchy around beauty procedures, eyed Starr's armamentarium with suspicion. He likes me best when I look natural, bless him. Starr dipped and blended and patted his fingers gently over my skin, making the whole process seem like a soothing massage. And when he was finished, my husband surveyed the results and smiled. I didn't so much as glance in a mirror the rest of the evening. And when I rolled in at midnight, my makeup looked as fresh as it had on that hotel terrace.

The finest makeup artist understands that his work is an act of supreme trust; he holds a woman's face in his hands and decides how she's going to look. On that photo shoot with Paul Starr, Sophia Loren explained why she tends to steer clear of makeup artists: "They're in heaven," she said, "but they do too much. I want to be as simple as I can."

Paul Starr has the ability, as Sophia Loren and I can both attest, to make a woman look entirely flawless and yet completely recognizable. The point, as Loren said that day, is "You have to feel good in your skin." More than makeup, Paul Starr applies confidence.

—Linda Wells, 2005

The face is a makeup artist's primary canvas, and the makeup he applies to it may be either enhancement or art. In the right hands it can be realist, impressionist, or even surreal. In these photographs of a model by Race Willard on the previous and opposite pages, color, mood, and atmosphere predominate.

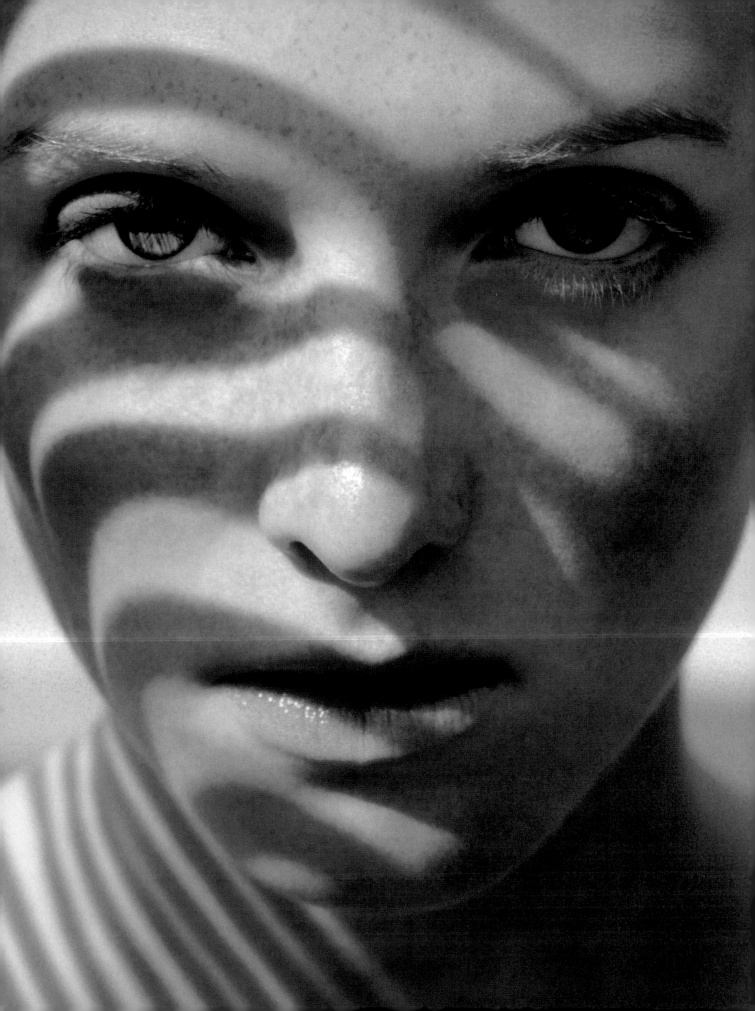

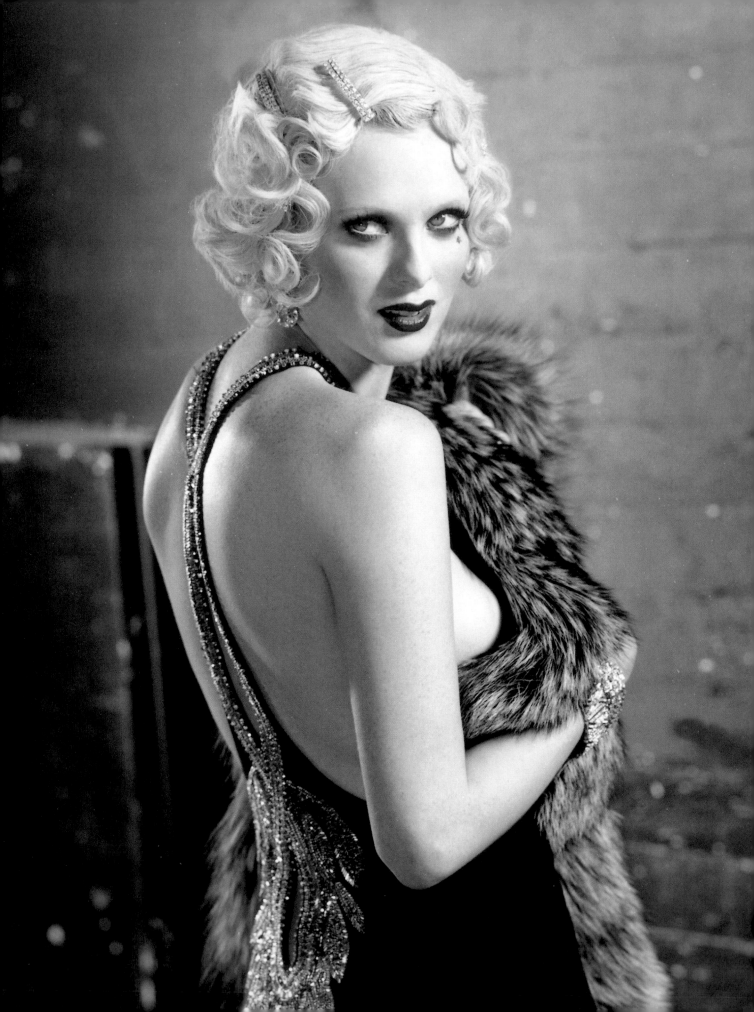

INTRODUCTION

For thousands of years, beauty was in the eye of the beholder, but after the invention of photography, it was also in the eye of the camera. And by the late 1920s, when the movies reached a high point of visual sophistication, beauty was also in the eye of the makeup artist, whose skill is impressively displayed in this book.

Cosmetics, as Gore Vidal revealed in *Creation,* a novel that evokes the ancient world in richly abundant detail, existed as long ago as the fifth century B.C. Persians, female and male, used various types and colors of eyeliner and hair dyes: women favored white enamel in order to disguise facial imperfections; men opted for matching tints of hair and beards. By now, of course, cosmetic resources have developed as unimagineably as the M-16 rifle from the medieval musket, and the makeup artist works from a palette as diverse as a painter's.

But not even the makeup artist can always persuade the human and the camera eye to agree. Some faces (Tallulah Bankhead's) were simply not photogenic, and others (Irene Dunne's) less beguiling off-camera. But where the most farseeing eyes agree is that when there's nobody home, there's just another pretty face. The greatest beauties have personal character as well as gorgeous, alluring features, and the more intriguing the character, the greater the impact of beauty. This applies to natural beauties—Vivien Leigh, Gene Tierney, Mary Astor, Catherine Deneuve, Bianca Jagger, Princess Stephanie of Monaco—as well as those who achieve beauty.

Among the achievers: Compare a photograph of Garbo arriving in New York in 1925 with a still from *Queen Christina.* Eight years later, MGM's makeup artists, hairdressers, and dieticians have completed their work and revealed what was always there. Or compare a photo of Margarita Cansino with Rita Hayworth, the star of *Gilda.* Electrolysis has heightened her forehead by eliminating a widow's peak,

her hair is auburn instead of jet black, and a less intrusive frame allows makeup to highlight a face with a bone structure as classic as Garbo's. Or again, compare the 1991 Nicole Kidman of *Billy Bathgate* with the astonishing beauty of *Moulin Rouge.* Ten years later, a lavishly freckled, almost girl-next-door face has become a pure, luminous, whiter shade of pale, the line from forehead to tip of nose positively Grecian.

Sometimes, then, the arrival and not the journey matters. And sometimes the journey doesn't quite reach its destination. The arresting dramatic allure of Maria Callas, and of Joan Crawford in a more obvious way, created beauty at first sight, an illusion that faded on closer inspection. But true beauty, natural or achieved, depends on a makeup artist who knows what to leave alone, what to disguise, and what to heighten. For no kind of beauty is perfect, as Cecil Beaton wrote, and in Audrey Hepburn's case, a "generously proportioned nose" saved her from "mere prettiness," while unique eye makeup transformed her into the real thing. And fine bone structure is a more lasting preservative than Botox. "No Spring, No Summer Beauty hath such grace/As I have seen in one Autumnal face," John Donne wrote, and two faces come immediately to mind: Garbo at fifty, photographed by Beaton, Vanessa Redgrave at sixty, in the movie *Mrs. Dalloway.*

The preferred makeup artist of more than a few models as well as actresses, Paul Starr works at a time when more has become monotonously less, with hordes of starlets and fashion models going so far over the top (or being pushed there) that it's not hard to mistake them for drag queens or parodies of *Extreme Makeover.* No risk of that here. His approach is imaginatively discreet, never turns a face into a mask or a human being into an android, and one part of the fascination of his book lies in the way it invites you to search any face for any sign of exactly what his art has made more or less visible. The other part is how clearly it reveals that, like all visual artists, he sees more than meets the eye. But that, of course, is also the secret of true beauty, whose face invites you to read into it anything you care to imagine.

—Gavin Lambert, 2005

Previous page: This photograph by Herb Ritts recreates the Depression-era beauty and artifice of old Hollywood screen icons. Opposite: Shot on the beach at Malibu, this image of Reese Witherspoon, also by Herb Ritts, embodies the fresh-faced look of contemporary young Hollywood.

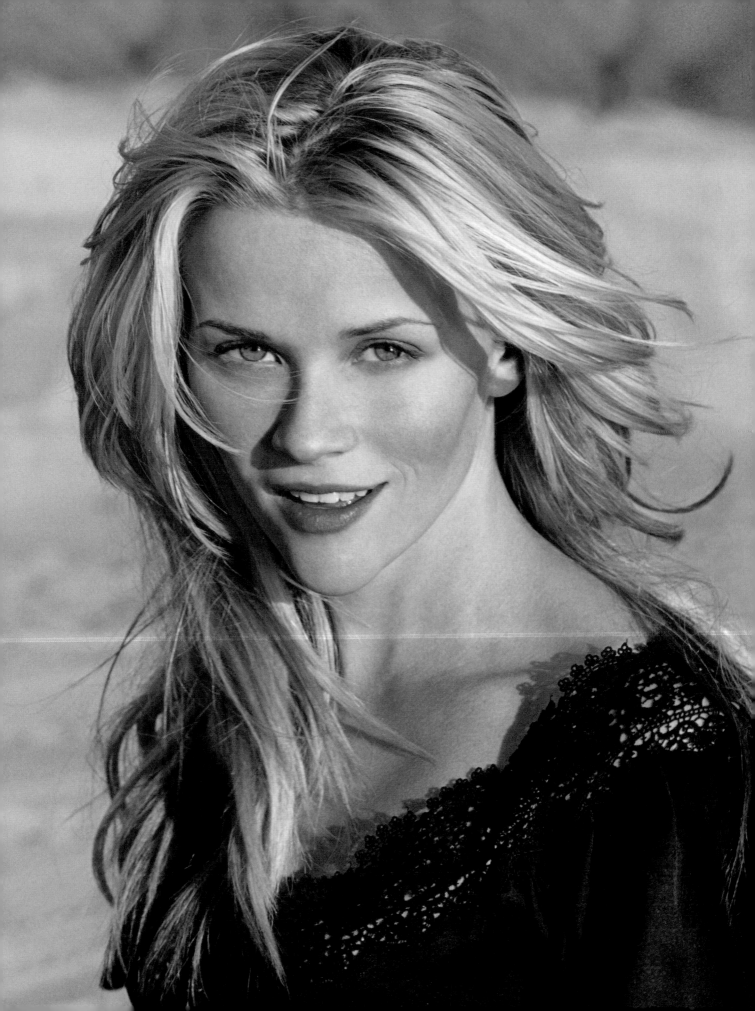

"Without emotion, there is no beauty." —Diana Vreeland

ON BEAUTY

To a makeup artist, every face is an empty canvas. That, however, is where the metaphor ends.

I happened onto my career in makeup almost by accident. I studied art in college, planning to pursue a career in painting or sculpture; but lacking the money to support myself, I began to consider how I could turn my artistic instincts to a more sustainable enterprise in the meantime. I'd always had an interest in makeup—from my childhood love of old movies to my teenage fascination with glam rock and its icons—so I decided to enroll in a makeup academy. Upon arriving, I soon discovered that school tuition was just as out of reach for me as a studio on the Left Bank. However, on the way out, a posted notice advertising "Makeup Lessons at Home" caught my eye.

Lessons were by the hour and though not cheap were reasonable enough for me to afford a few sessions. The teacher was an experienced working movie makeup artist whose home was filled with pictures of him either on film sets or posing with popular stars of the day. I'd never thought of makeup as a profession, but surveying his well-appointed abode, I saw that it could be a very rewarding one, financially and artistically. By my final lesson, I knew that my art education had not been wasted. For me, makeup was a combination of watercolor and sculpture; the only difference was the medium. My canvas would be the human face, not a stretched piece of cloth or a lump of marble. My art education merged with my makeup lessons, and I suddenly realized, "I can do this." So I did.

At the outset of my career, I decided to follow the road less traveled and live in Los Angeles. It was not my birthplace, but it was my home, and I resisted the conventional wisdom that anyone hoping to succeed in the world of fashion and celebrity makeup must be based in Manhattan. Los Angeles in the early 1980s was almost a ghost town—a very thriving ghost town, but the days of Max Factor and the House of Westmore were clearly a thing of the past. Hollywood seemed faded, like an old print of a movie that's been shown too many times.

There were, however, a few creative oases in this artistic wasteland—photographers such as Herb Ritts, who was defining "California style," and Matthew Rolston, a scholar of classic Hollywood portraiture who was shooting covers for *Interview* and *Harper's Bazaar*. Matthew was one of the first photographers to give me the opportunity to grow as an artist, and celebrities became my muses. Those were heady days: Hollywood was transitioning from the studio era to the corporate era, and there was almost a spirit of anything goes. Actors were less constrained, and publicists hadn't yet closed ranks on "pretty and natural" as the universal standard for their clients. Relatively unfettered, we managed to create adventurous editorial looks on actresses, such as doing Annette Bening as a 1920s siren with greasy, black eyelids and lips. It was the kind of makeup you might have seen on a silent film actress, but not the kind you're likely to see today.

At the same time, I made frequent trips to London, where I fine-tuned my skills. England in the '80s, though in the thick of the Thatcher years, still fervently embraced individuality, and I felt right at home. I had the experience of working with music icons such as Annie Lennox, David Bowie, and Boy George, and through them, with cutting-edge photographers like Nick Knight and Jean-Baptiste Mondino. And in Los Angeles, a new generation of music video directors was finding its voice: Americans like David Fincher and Europeans like Mondino, who split their time between continents. This cultural cross-pollination offered the best of both worlds, giving the video form an artistic integrity that laid the foundation for the mega-industry it is today. In those days, everything was collaboration, and nothing mattered except the image, and I've tried to adhere to that standard in all the work I've done since.

Ava Gardner once said, "Deep down, I'm pretty superficial," but with that kind of beauty, superficiality can be pretty deep. I've always been drawn to strong-minded, unique women, and I have encountered many in my career, one that affords me entrée to the inner sanctum of show business, fashion, and that amorphous realm known as "Celebrity." Like any artist, the makeup artist chooses his canvas and his own unique mode of expression. Even for the best, their creations are designed to last but a day, but their essence is preserved for posterity in photographs and films. Today my work takes me around the world, but the course of my career might have been entirely different if I'd established myself in New York City. My muses would have been fashion models instead of musicians and movie stars, and my inspiration very different. But in the two decades that I have practiced

Previous page: In the future, beauty will have no ethnicity, no age, and no limitations. As in this portrait, "Futuristic Beauty" by Stephane Sednaoui, every woman will be her own creation, limited only by her imagination. Opposite: Sophia Loren may be legend, but she is no myth. This photograph, by Michel Comte, originally shot for Allure, was signed to me from "The mother of all mothers, Sophia."

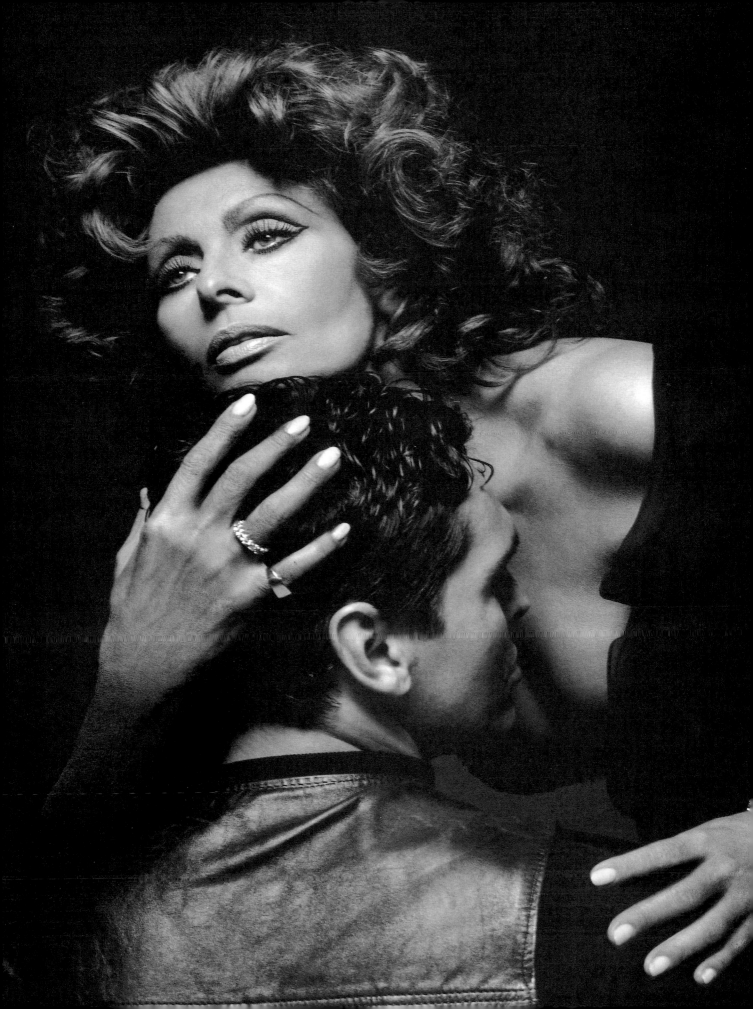

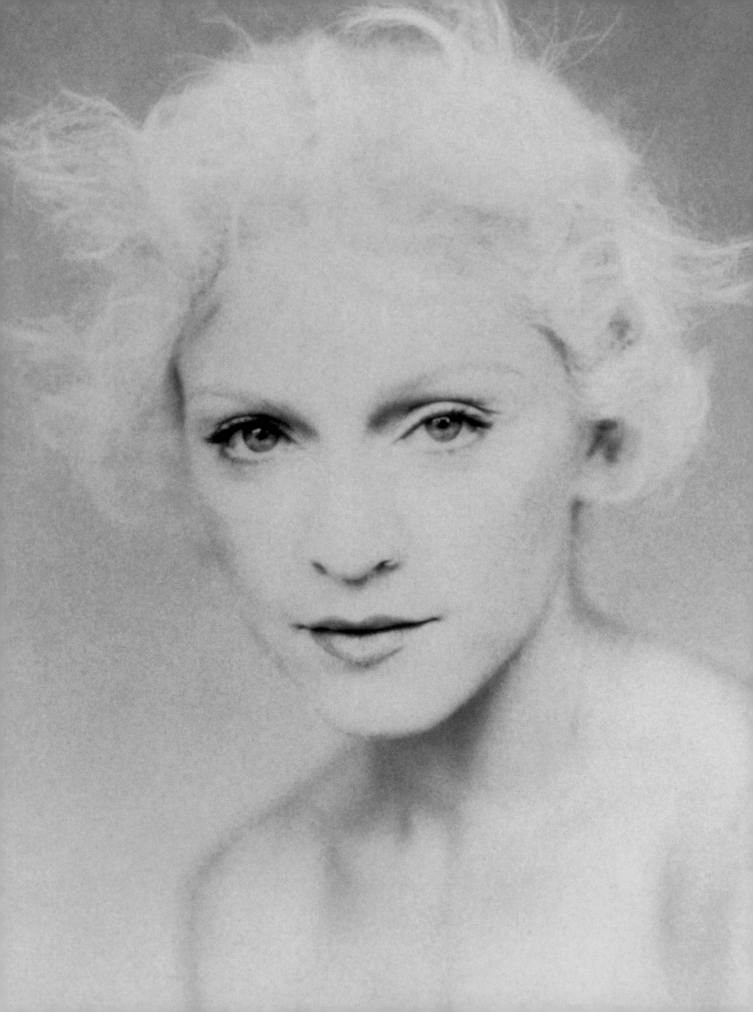

my profession, I've watched the cultural center shift from New York City to Hollywood. Celebrities now model fashion on the red carpet, do advertisements, and endorse products. Celebrity itself is the new cultural muse: Everyone wants to be one, and everyone wants to know one. I feel fortunate to have come up in a time when the standards were a bit more discriminating, and there was still enough of old Hollywood around to remind us of what a star should be.

Makeup is transitory, a fleeting illusion. But there is a beauty to transitory things, and a value as well. Makeup is like the frame around a picture. The frame does not make the art better, but it does make it look better. Similarly, makeup does not make a better person, but if properly applied, it makes a person look better and, by extension, feel better as well. It is less addicting than Prozac, far more pleasant than plastic surgery, and, these days, almost cruelty-free.

In the Hollywood History Museum resides an ingenious piece of machinery known as the Beauty Calibrator. Designed by Max Factor, "Makeup Artist to the Stars" and the inventor of pancake makeup, the Beauty Calibrator resembles a medieval torture device but was, in fact, designed to encompass a woman's head and measure the symmetry of her features. This Pygmalion-like conceit could only have been devised by a man and seems designed exclusively to prove how far short mere mortals, and specifically women, fall from the ideal of perfect beauty. But paradoxically, the Beauty Calibrator may have proved just the opposite: Based on photographic evidence, no one other than a nameless starlet seems to have been able to satisfy its requirements. Jean Harlow, Ava Gardner, Marilyn Monroe, Sophia Loren, Elizabeth Taylor, or any of a thousand women who have left an indelible mark on culture and inspired countless flights of fantasy in both sexes, fell short by its measure. Perhaps physical perfection is overrated: Its source intangible and uncharted, natural beauty seems almost to defy measurement.

My goal in the pages that follow is to present a gallery of women who have enriched my personal and professional lives. All are authentic beauties, but theirs is a beauty born of character, integrity, intellect, and achievement, not only a fortunate happenstance of genetics.

These are some of the women who have helped to define beauty for me.

—Paul Starr, 2005

Opposite: Madonna is the preeminent icon of our age: woman as myth. Portrait by Paolo Roversi. Next page: Elizabeth Taylor photographed by Bruce Weber. Asked to define a woman's beauty, Elizabeth said, "I love the beauty of all women who have had to fight to live and are too busy giving to others to worry about their looks."

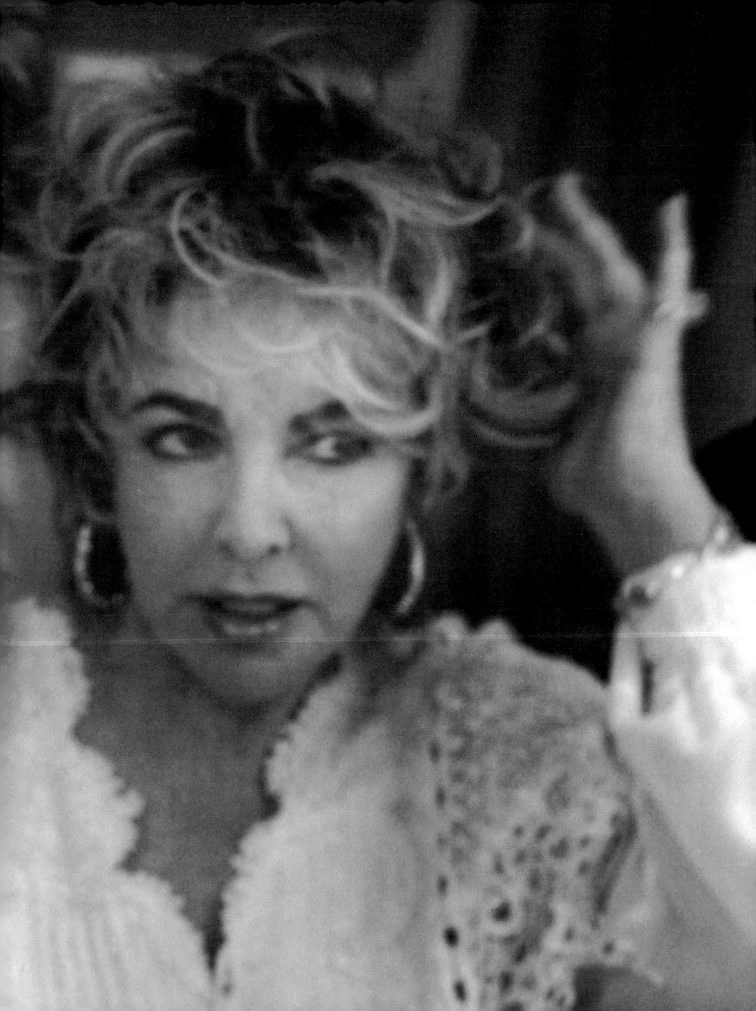

Jennifer Garner

Whether doing Jennifer's makeup for magazine promotions of her hit TV series *Alias,* or for her appearance as a presenter at the Academy Awards, I've learned that Jen is as she seems: the girl-next-door, who happens to be drop-dead gorgeous. Her diligent self-maintenance is why she is the picture of health and vibrancy; her physique is as impressive as her facial features. She is one of the few women I know whose beauty is as astonishing as it is approachable.

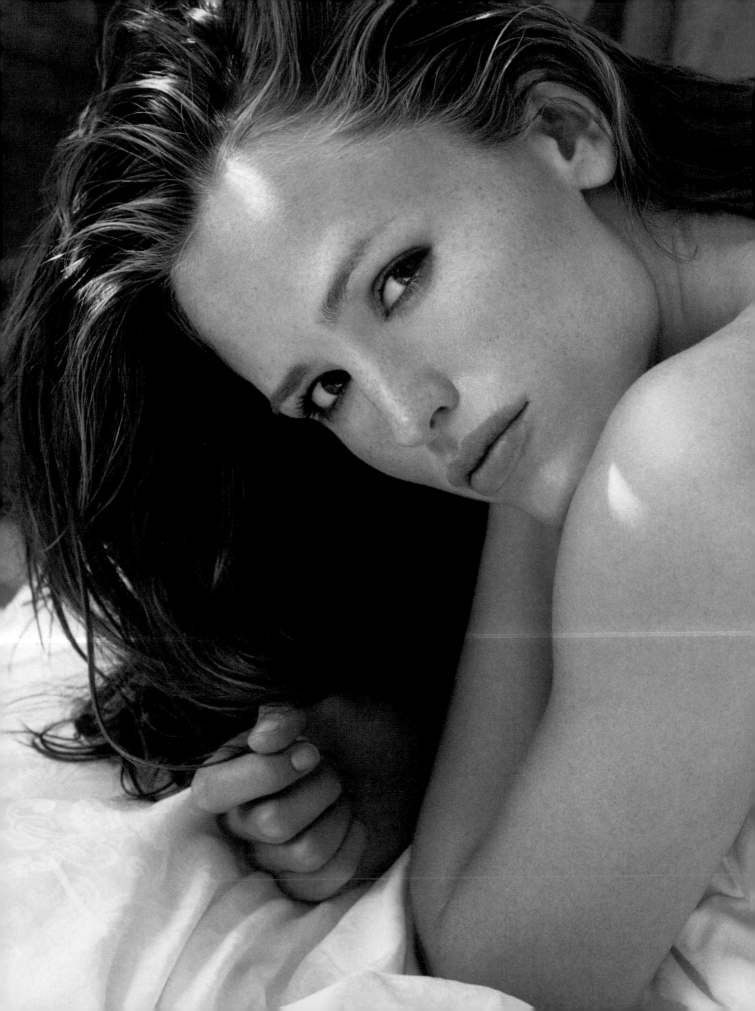

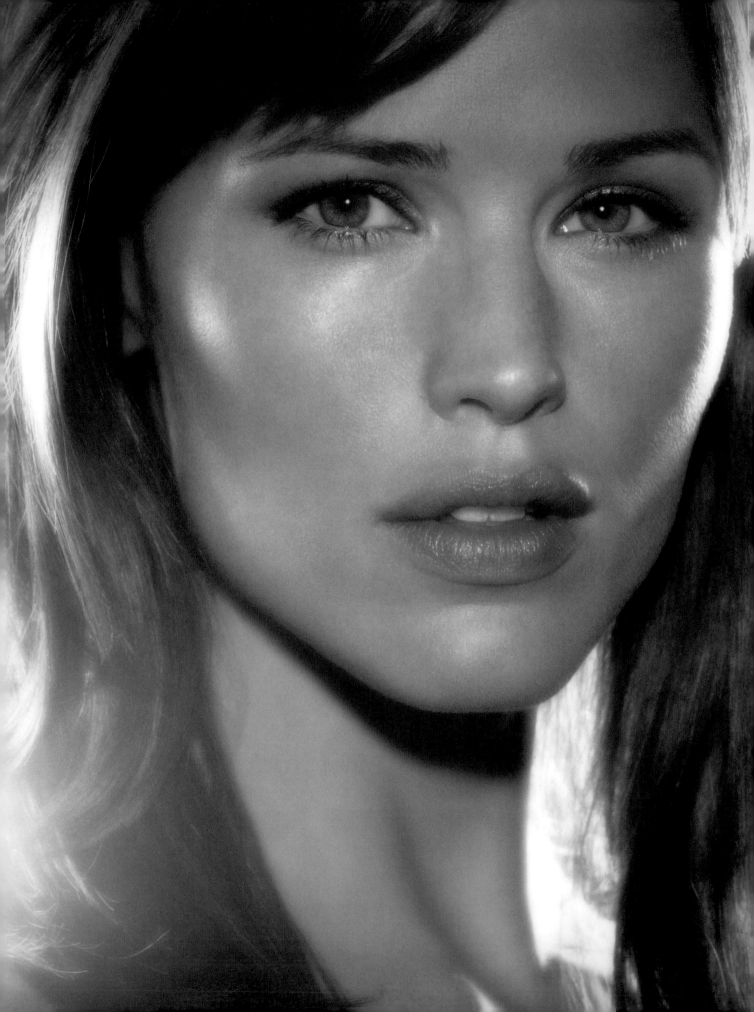

The New York Times **described you as "a style icon." How do you feel about that?** Isn't that the funniest thing you've ever heard in your whole life? It's great and flattering, but anybody who's known me for more than five minutes would think it's the funniest thing they've ever heard.

Well, I can see what they see. You also see what they don't see, and that's what's so funny. It's flattering, but I'm not going to start making choices to try to fulfill a very flattering description. I can't go out feeling like I'm in costume.

When you first look in the mirror every morning, what do you think? This is one of those weeks where I've only slept four hours a night, so I think I'll keep that to myself.

And what do you think about makeup? I think makeup is best left to people who are good with it, which I am not

with temptation? I try not to be a freak about it, but I am careful. Sometimes, in trying to prove to myself that I'm not being a little too crazy, I'll sabotage myself. I try so hard to maintain a sense of balance about this whole food thing. I'm disciplined most of the time, but then, I eat chocolate pretty much every day too. I drink wine almost as often. Chocolate, cheese, wine . . . I really can't resist any of them, so I try to give in only in small doses. I exercise almost every day—cardio, weights, and stretching. 'Cause let's face it, there really is no such thing as a free lunch.

Well, what vices do you allow yourself? I think practically everything is allowable in moderation. I don't smoke and have no desire to, but that's very hard to do in moderation anyway, isn't it? I eat in moderation, I drink in extreme moderation, and I skip workouts every now and then. I allow myself certain luxuries because my whole life I never had

"I always clean my face with something good because I wear so much makeup when I'm working."

particularly. I don't think I look any better with it on, unless it's you putting it on me. When I do my own makeup, I keep it simple because otherwise I'm really bad at it. I usually use a concealer under my eyes if I have circles, and around the base of my nose, and some mascara. Only once, in the middle of dinner, have I ever given myself a little touch-up. If I'm attending an event, I usually carry that beautiful little bejeweled Estée Lauder powder compact you gave me forever ago because it's small and it fits in my purse.

You have such perfect skin, Jen. What do you do to keep it that way? I always clean my face with something good because I wear so much makeup when I'm working. If I have a toner around that I like the smell of I'll spray that on my face. If not, I skip that part, but I always moisturize, and I always use an eye cream. That's something that I got serious about in the last couple of years. And I always moisturize my neck. I'm terrified of not taking good care of my neck.

Are you careful with your diet? And, if so, how do you deal

many, so if I see something I like, I'll probably put down the old credit card. There's one shop I go to where they're very clever. They'll call and say, "Some new T-shirts came in that you'll like." They draw me in with T-shirts and then once I get there they smack me with the leather skirt. [Laughs.]

List ten things you love in life. Wine; my dog, named Martha Stewart; the sky on a blue California day; the mountains in West Virginia; and hearing my friends laugh. I love my work nine days out of ten, but that tenth day is a real bitch. I love Hawaii. I love different places for what they bring out in you, and I love the uniqueness of other people's personalities because each one stimulates a different part of your own character.

Who are the women you most admire, and why? My mother and my sisters. They're all very unique and interesting; my best friends as well as my closest relations. When I was growing up I never looked outside my family circle for role models—I wanted to be like my big sister.

Do you consider yourself beautiful? At weird moments I do. On the set, while watching play-back, I'll see myself walking from behind, or notice a little twitch that reminds me of my little sister. Or I'll see an expression on my face that I stole from someone. That's a weird thing, but as an actor you are forced to look at yourself from all different angles and see parts of yourself you don't usually notice.

And how would you describe ultimate beauty? Beauty that comes from a life well lived.

Did you ever have an ugly duckling phase? Let's put it this way, I wasn't your typical West Virginia blonde, with curls and blue eyes, but I wasn't tortured for being ugly, either. I was right in the middle. I was just another girl in high school. I wasn't on the Homecoming Court, but I wasn't beaten up in the bathrooms, either.

> "I wasn't your typical West Virginia blonde, with curls and blue eyes, but I wasn't tortured for being ugly, either."

If you have a daughter, will you let her wear makeup? And what advice will you give her? I would definitely let her play with it. I'd try to keep it simple, but at home she could play how-ever she wanted to. It's a harmless way to express yourself and to make mistakes and figure out your own sense of beauty and identity. What advice would I give her? Simplify, simplify.

And what are your views on cosmetic surgery? I used to say, Never. People should age grace-fully and naturally, and be true to who they are. After having been in Hollywood a few years, my opinion has shifted slightly. I still don't see it in my future, but that being said, I now say, Never say never.

What would you consider the ultimate compliment? Or, what compliment would you be happiest to receive? If, when I'm seventy-five, someone says, "That is a handsome woman," that would make me happy. When a woman is mature, if she's lived well and her bones are strong and her mind is alert, people look at her and think, Wow. If your frown lines aren't too bad and your smile is in the right place, what more do you need?

Lastly, what is your personal fountain of youth? I always look a bit younger, and feel a bit better, on those days when you walk through the door.

Like her character on Alias, Jen is fearless. She loves to take risks, and always trusts me to make her look her best—the highest form of flattery for any makeup artist. I love each of these photographs, and for the one on the previous page, a promo shot for the new season of Alias, I smudged some brown pencil on her eyes to accentuate their almond shape and used a little blush to highlight her cheekbones and a berry stain for color on those gorgeous lips.

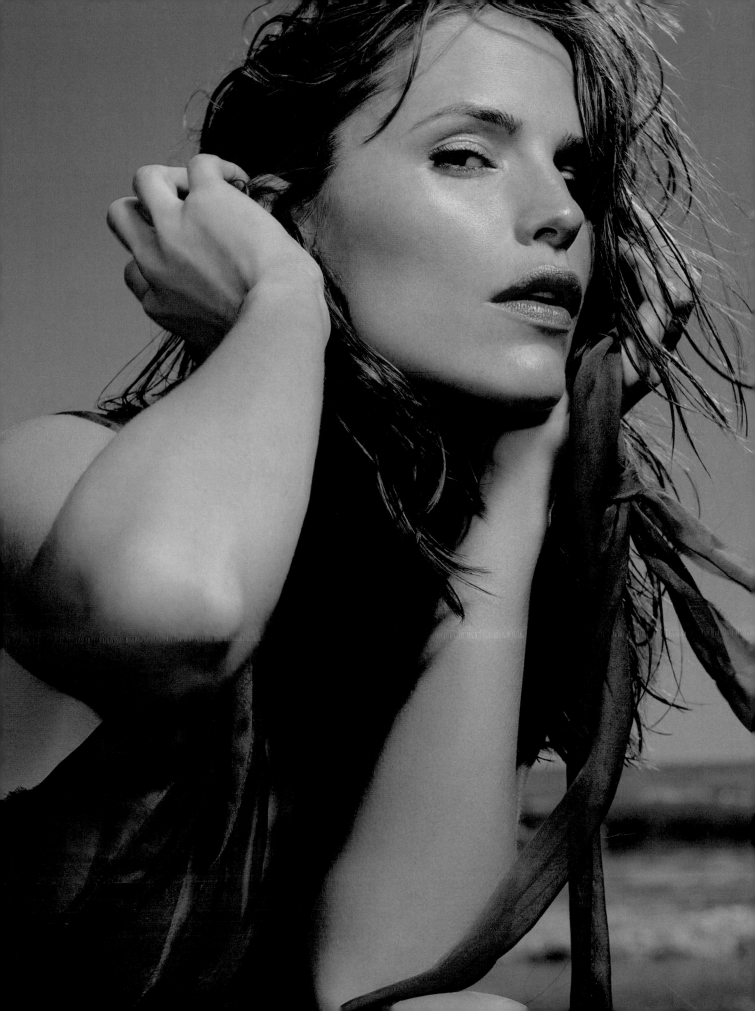

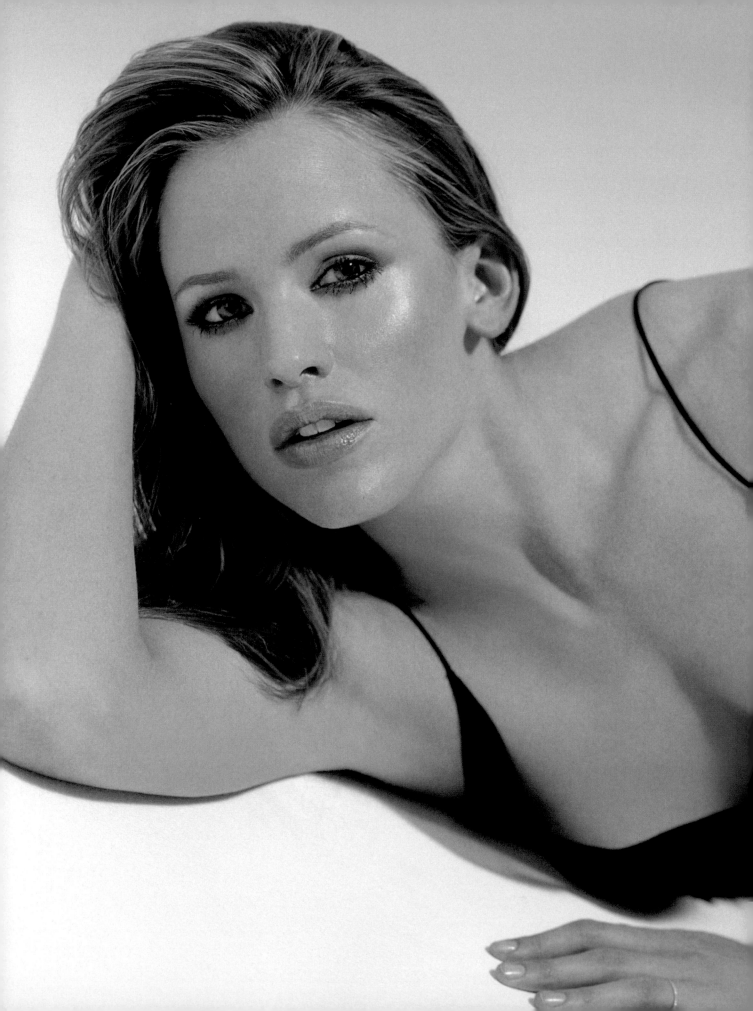

Jada Pinkett Smith

Jada studied dance and choreography before turning her attention to acting, one of the reasons she moves with such grace and agility. A unique combination of delicate beauty and strength, Jada is a dynamo, alternating—effortlessly, it seems—between her roles as mother, wife of Will Smith, actress in films such as *Ali, The Matrix Reloaded,* and *Collateral,* children's book author, and singer in her band, Wicked Wisdom. Jada is, in a word, unstoppable.

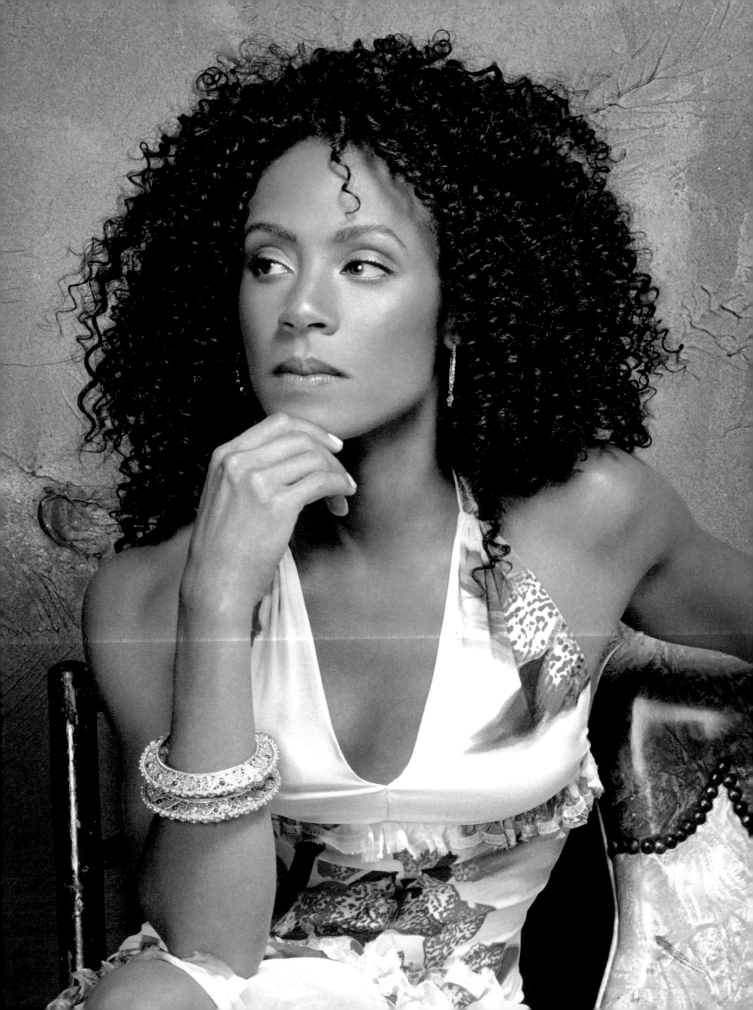

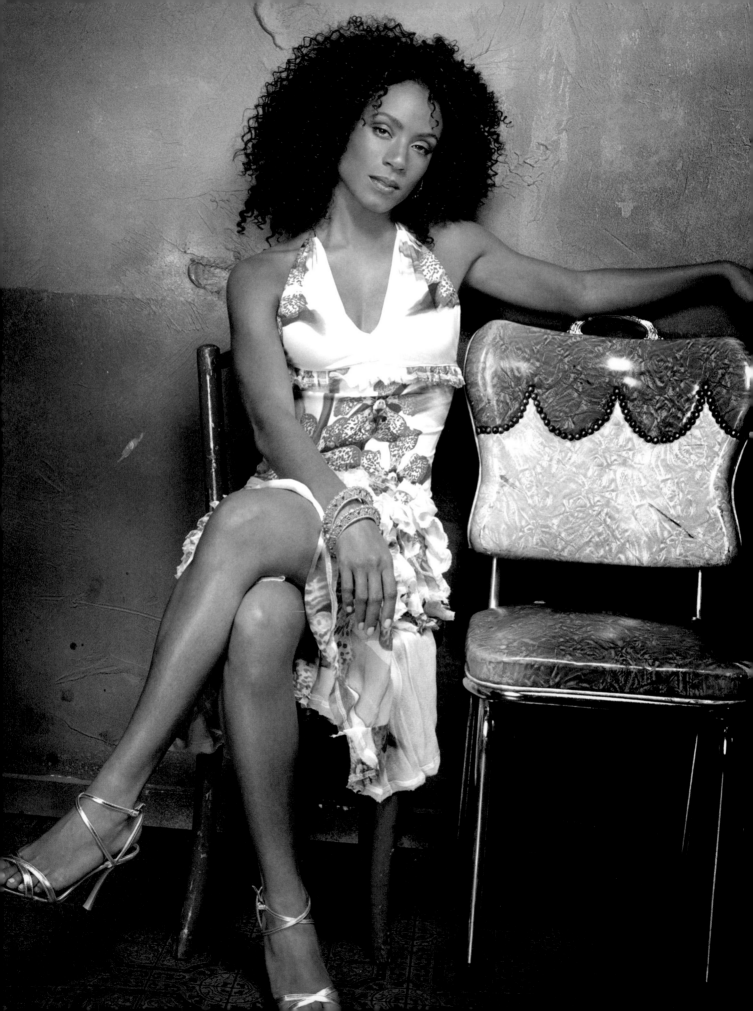

What is your definition of beauty? Beauty is a woman who is confident and sensual, when it is most natural. I love makeup when it accentuates a woman's natural attributes, whether it is her confidence, her sensuality, or her vulnerability. Makeup should emphasize those aspects of her natural beauty and character.

What impression did makeup have on you growing up, before you were old enough to wear it yourself? I used to love sitting in the bathroom and watching my mother apply makeup before she went out dancing. This was in the late '70s, early '80s. I don't know why I was in such awe. I loved watching her get ready, going through the steps. You know? She'd put on her mascara, then her lipstick, it was a gradual

How did they inspire you, your mother and grandmother? I watched my mother kind of overcome certain obstacles, which gave me the confidence that I could do the same, and my grandmother just has a no-bullshit, go-get-'em personality. She never took no for an answer. She is an immigrant from the West Indies, and she made a name for herself in Baltimore as a political activist and a community leader, and I admired her for her courage and conviction. My grandmother is probably the most inspirational person in my life.

Can you list ten things that you love in life? I love my husband, my children, my whole family. I love the moon. I love freedom. I love art, and I love to read. I love to love and to be loved. I love connecting with new people, or meeting some-

"I love makeup when it accentuates

a woman's natural attributes."

transformation. That was my first makeup experience, watching my mom. She was getting ready to go out dancing, and believe me, she was not playing.

Who are some of the women you admire or have been inspired by? Debbie Allen is one of the women who inspired me, probably more than anyone else. When I was in high school I remember seeing *Fame,* and wanting to go to Baltimore School for the Arts, which was like the school in the movie. Debbie Allen did it all—she was a dancer, a singer, an actor, and a choreographer—and she made me believe that I could do it all, too. I always wanted to be just like her in that way. There are so many other women whom I have admired. Of the actresses of this generation, I think Glenn Close has inspired me the most. Sister Souljah is someone who has been inspirational, both for what she represents, and the sacrifices she makes, basically living her life to better her community. And, of course, my mother and my grandmother have both inspired me very much.

one who I never thought I could be friends with and building a wonderful friendship with that person.

Is there one thing that you would like to pass down to your children? The only thing I'd like to pass on to my children is to be happy, to live for themselves, and to live life fully and joyfully. If I can teach them that, then I don't need to worry about what they'll decide to do in their lives, or who they'll marry, or anything else. As long as they're happy, I will be content. Their happiness is the most important thing to me.

What do you consider your most unique quality and what do you think is your fatal flaw? My fatal flaw is that I'm impatient with people sometimes. I can be judgmental. And what I like most about myself is how big my heart is. I don't hold back with the people I love. I give them everything: my loyalty, my guts, my heart and soul. I don't see it as being unique, but my husband brings it up all the time. That's just me.

Jada's unique beauty is a reflection of her personality: feminine, focused, and empowered. Jada is like a lioness wearing a kitten's skin. For these photos, I gave her a bronzed shimmer and a pale lip, for a look best described as "Sheba, Baby, 2005."

Anjelica Huston

Smart, sophisticated, and fiercely independent, Anjelica Huston is third-generation Hollywood royalty—daughter of John, granddaughter of Walter—but that has never stood in the way of her lifelong quest to define herself through her own singular achievements. Oscar-winning actress, director, and producer, she has carved out her own niche in a town that doesn't make anything easy for women except plastic surgery and retirement.

You were a *Vogue* model at the age of fourteen; you're an actress, director, and the scion of a Hollywood dynasty. I think it's safe to say that you've done it all. Do you think standards of beauty have changed from when you were a model to what they are today? I don't know that beauty changes. Beauty is intangible, both reality and illusion, a luxurious vision that moves us, inspires us, and gives us a fresh perspective on things. Aesthetically, we've been attracted by certain elements throughout the ages. Is it evenness of features? Presentation? Style? It certainly incorporates all of these aspects, but I think in terms of the changing face of beauty, whether we're talking about Rubens's women, who are large and fleshy and pink, or about Twiggy or Kate Moss, the through-line is that something, or some combination of things, pleases the eye. Beauty loosens the reins of our judgment and makes us stand back in awe.

What do you think about makeup? Do you wear it? Makeup is great. I've loved it since I was a little girl. One of my first memories is sitting on the edge of my mother's bathtub in London, watching her put on makeup. Even before that I remember being completely entranced by the

"I remember being completely entranced by the

transformation my mother underwent

in order to go out in the evening."

transformation my mother underwent in order to go out in the evening. Or, for that matter, any of the beautiful women who came to stay in my father's house. I would attach myself to them and study—in microscopic detail—their stockings, perfumes, and the way they put on eye makeup, lipstick, fingernails. Those things fascinated me as a child.

How does makeup change the way you feel about yourself? To me it's almost a process of transforming into another person. There's the face you wake up with in the morning, then there's the face that you present to the outside world. Makeup is a magician. It can make you look healthy when you're not particularly healthy. It can emphasize certain features in a way that draws attention to them and away from others. It can embellish or complement your features, or be outrageous and fantastical. The palette of makeup is a wonderful one, because you can make yourself feel better in a matter of minutes. And there are very few things that actually do that, particularly for women. Shopping and makeup, they raise the endorphins.

Are you careful with your diet? And how do you deal with temptation? Generally not at all. I grew up in the country in Ireland, and the objective was to eat as much as you could at every meal because you were starving all the time. When you grow up riding horses and running through the fields you never have a lack of appetite. Meals meant raiding the garden and eating fresh food, and that's given me a very good, basic platform of health. On the other hand, I smoke, which is a disaster. You have to find your own balance. Denying yourself everything that is bad for you is not necessarily any healthier than total indulgence. I can put on weight in a matter of days, and my looks absolutely change depending on what I've eaten the day before. Discovering the Atkins diet was sort of inspiring, because it's a way of eating in which

you're not in total deprivation. When I was modeling, I used to bring a six-pack of Coca-Cola to the photographer's studio, drink a few swigs, and leave the cans littered behind me. I just drank Coke all day and didn't eat—you could get away with things like that then. I try to maintain a healthy diet. I visit the scales and eat accordingly.

What is your skin-care regimen? I put on creams and go in the steam and scrub. I wash my hair a lot, I exercise, and I dance. I brush my teeth and go to bed at the proper hour. I don't stay up late like I used to. I like a lot of sleep.

La Scala in Milan for the opening of an opera he had directed, and Ava had come with us. I remember this extraordinarily beautiful, dark-haired, flashing-eyed woman in turquoise, diamonds, and a big, white fur stole. I was literally enraptured by this vision. There are certain women who, from my earliest memories, have made an impression on me, such as Katharine Hepburn, Catherine Deneuve, and Jacqueline Kennedy. There's a beautiful woman, Mirella Pettini, whom I met years ago at the Taormina Film Festival, who's still completely ravishing. Who else? Joan Crawford, but I only developed a taste for her later on. You have different ideals

"Women have to learn to live with their faces,

and with who they are, and try to be the best

that they can be at whatever age they are."

What cosmetic products do you carry with you as your basic necessities? I'm prone to changeovers in products. I get sort of sick of looking at the bottles for too long, so I'm always happy to try out new stuff. Right now I'm somewhat obsessed with these cosmetics made by Italian monks that I found in Rome. They are sort of the monks' answer to Santa Maria Novella [famous soaps and cosmetics originally made by Dominican monks in Florence from herbs they cultivated in their garden], and they're all natural, wonderful products, like face creams based on bee pollen and rose water. I prefer products that are natural and don't have a lot of perfume. Chamomile is great to calm your face down. Another thing I found in Rome is fermented papaya powder. You stick it under your tongue and it works from the inside.

Who are the women that you most admire, and why? From a very early age, I was entranced by certain icons. Not the ones on the pages of magazines, because I didn't grow up with magazines, but the women who surrounded my father: his actresses, wives, and girlfriends. One of the first staggering visions I had—apart from my mother, who was an amazingly beautiful woman—was Ava Gardner. When I was seven or eight years old, I accompanied my father to

according to your age. Strange as it may sound, I kind of wanted to be Sandra Dee, but I admired the spiky women, the ones who had bite.

I think of you as a muse for so many different people. Do you feel a pressure to live up to your work and lineage? Well, you know, there are a few ways of looking at it. For me it's not a pressure, but more like a challenge to be able to transform oneself into somebody's idea. Working with directors is so enjoyable because there is this sense of serving the people that observe you, providing the best you can for the onlooker. When one is in the public arena, I think it is part of one's duty. I think it's our duty to appear as attractive as possible to each other. Of course, one fails probably fifty percent of the time, but the important part is making the effort.

Every swan was once an ugly duckling. When did your transformation occur? When I was about thirteen years old, I remember accidentally overhearing a conversation between my parents as to the idea that I might not become a pretty girl. I had a particularly uncomfortable adolescent transition period in which my nose was growing very fast and my chin rather more slowly. At a certain point, I think

you make a sort of decision as to how you'll handle this situation. You can see it very clearly in people, even strangers, when you walk along the street. Some people have just surrendered to the idea that they will always be ugly ducklings, while others have decided, you know, that's just not gonna happen. Something as simple as a lift of the shoulders creates a line of confidence down the spine, and a transformation takes place. I think a lot of it has to do with the confidence that, if you apply your imagination to your appearance, you may not become Nicole Kidman, but you will certainly improve the general impression.

What else do you love? Can you list ten things? Love, the sea, animals, my husband, friends, being naked on a balmy day in Hawaii, hot springs, massage, horse-riding, freedom.

What do you consider your most unique quality, and your fatal flaw? My most unique quality . . . that's a very hard question to answer. Really, I don't have a clue. My reactions to things can be rather defensive, but I'd like to think that I have a certain level of compassion. My worst flaw? [Long exhale.] I'm judgmental. I'm judgmental and I'm obstinate. And I can be devious.

What is your view on cosmetic surgery? It hurts, obviously. [Laughs.] And I'm kind of against things that do.

Can cosmetic concerns be taken to extremes? Do you know cases of beauty addiction? Definitely. Women can get really caught up in almost skinning their faces down to mere pinpoints, pulling it back into a knot behind their heads. There's that poor woman who decided she wanted to look like a cat, and succeeded brilliantly. I think in many cases it works nicely if it's done by an extremely fine surgeon, and the Brazilians and the French have it pretty much down. I'm averse to women who sacrifice their character to look younger, or those face-lifts that neutralize all expression. I don't think it's good for actresses, because one wants to convey emotion rather than the absence of it. It's a slippery slope.

How do you feel about aging, and how does it affect you personally? I feel okay about it. I don't see that there's really an alternative. Sometimes you look in the mirror and think, There are wrinkles where there used to not be wrinkles. If you're around dewy-faced twenty-year-olds all day, you might think, Why me?, but there's not much you can do about it. I am much easier in my skin now than I was. It's kind of a nice thing to occupy your age frame with who you are. I much prefer to be a good-looking woman in her fifties than a woman in her fifties who's trying for something much younger, because that's where I think things get off balance. You don't want to see a fifty-year-old woman with a face of a twenty-five-year-old. You don't know where to put it in the context of what you know or what you recognize. Women have to learn to live with their faces, and with who they are, and try to be the best that they can be at whatever age they are. I was at a lunch the other day, a rich lady's luncheon in Beverly Hills, and, looking around, the women who had settled into their faces looked the most beautiful to me.

If you had a daughter, at what age would you allow her to wear makeup, and what advice would you give her? Well, I was reared rather strictly; I wasn't allowed to wear makeup until I was at least fourteen or fifteen. I wish that I'd been allowed to play around with it a bit more. It was a huge yen of mine to look grown-up, like those beautiful women, so that by the time I got my hands on makeup in the 1960s, I laid it on with a trowel. On the other hand, I look at those old pictures and, actually, I had a pretty deft hand. I've always loved putting on makeup, and I've been accused in my time of wearing too much of it. And, you know, so be it.

What do you think when you look in the mirror in the morning? Often, I don't even really look in the mirror. I kind of go through the motions, but I prefer to concentrate on things after I shower and eat breakfast.

What would you consider the ultimate compliment? Or, what compliment would you be happiest to receive? "You look beautiful tonight." There's no nicer compliment.

Would you rather be considered "pretty" or "interesting"? Pretty interesting.

What is your personal fountain of youth? My constant interest in what is going on around me.

Anjelica has one of the most original and memorable faces in Hollywood. When working with her I like to highlight the strong facial features that have come to define her—her stunning wide-set eyes and her high cheekbones.

Angelina Jolie

Angelina is the perfect example of a self-defined woman. Her incredible beauty is the first thing you notice about Angie, but one quickly discovers she is a woman of both substance and depth. Beginning as a bad girl of sorts, she gave indelible performances in *Gia* and *Girl, Interrupted*. As Goodwill Ambassador for the United Nations refugee agency, she roams the globe promoting foreign aid. And to her son, she is, plainly and simply, mom.

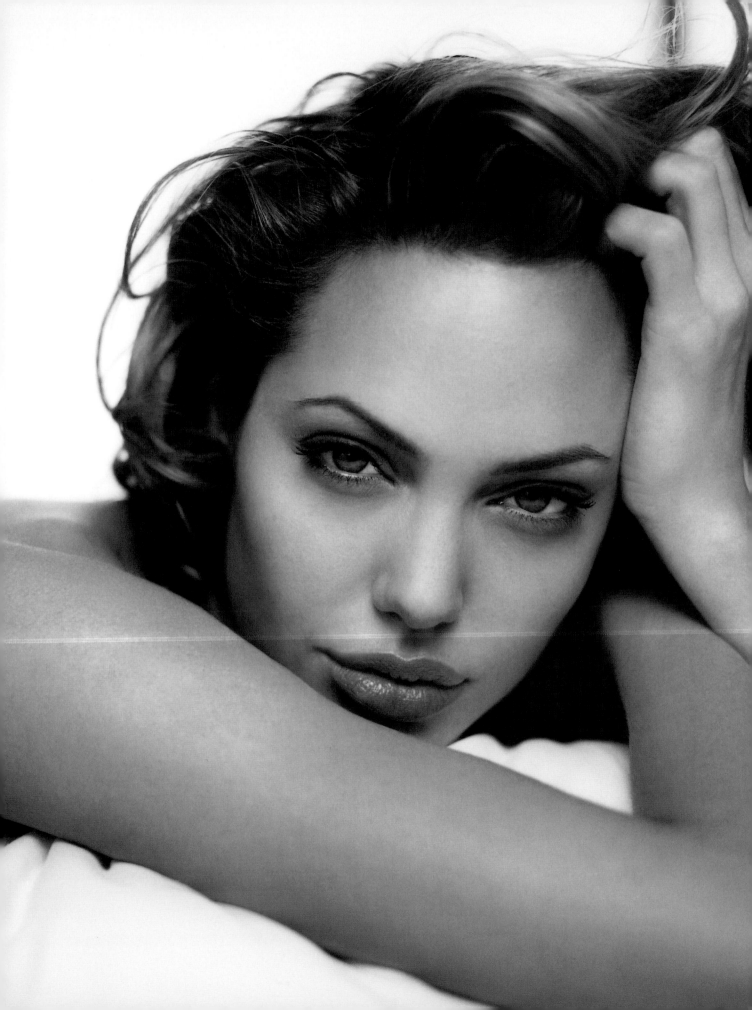

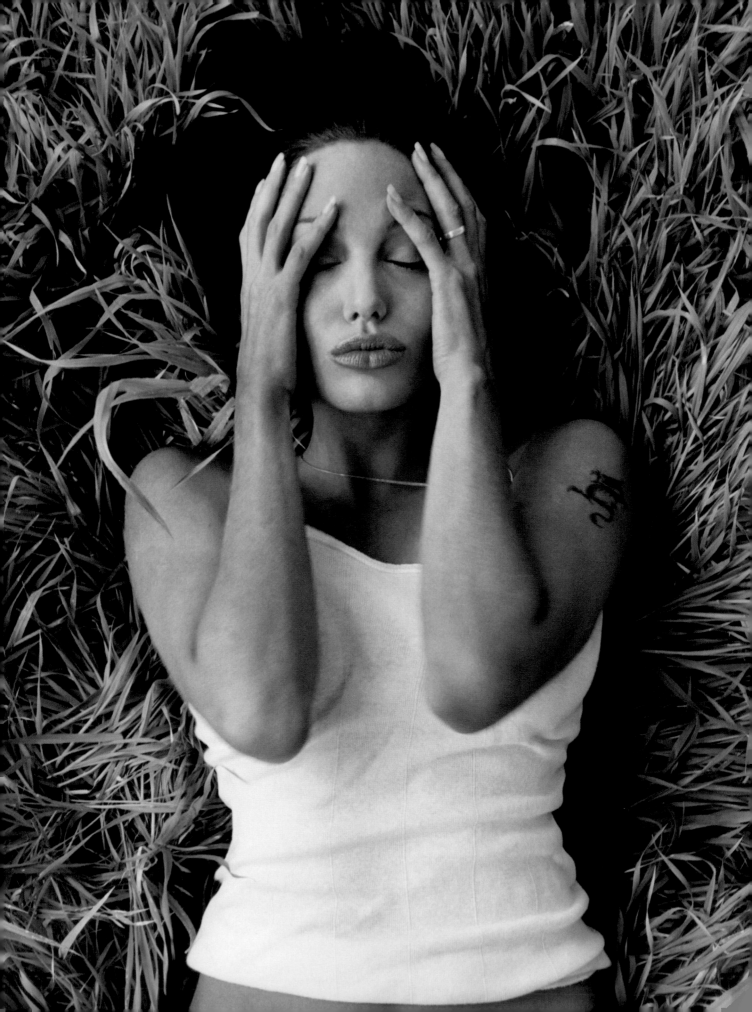

Complete the phrase, "Beauty is . . ." To see a person's soul, their lives in their faces.

What do you think about makeup? As an actor, I love the way it can help transform.

Are you pretty careful with your diet? I'm not too careful with my diet—I believe you must follow what you crave. Your body will tell you what it needs.

And what about exercise? I have an active child, and keeping up with him keeps me fit.

What are your feelings on cosmetic surgery? To each his own, I say, but I also think we should encourage and celebrate our unique differences, not change them.

"[My son] has taught me what it is to be a woman. He has taught me love."

You are a beautiful woman, but also a strong and occasionally tough woman in your screen roles. You were quoted as saying, "I feel both masculine and feminine. I understand that side of men that encompasses the lone person. I have the restless spirit of a man." Do you feel that still applies for you today? Well, I am older now than when I said that, and I realize now that I have a restless spirit, but that's all part of being a woman. At the same time, I have found a renewed sense of purpose in my travels with the U.N. and, most of all, in becoming a mother. So I am less restless and more exhausted now, but happier for it.

What is your most unique quality, and your fatal flaw? The answer to both questions is my need to be in constant motion. I accomplish a lot, but with little peace.

You are the parent of an adopted son, Maddox, who was born in Cambodia. What has parenting taught you? He has taught me what it is to be a woman. He has taught me love. That another culture is exciting, not challenging, and if approached that way, it is easy.

Who are the women you most admire, and why? Aung Sang Suu Kyi [Burma's democracy leader, who is under house arrest], for her unbreakable spirit and dedication to the people of her country.

Finally, can you tell me ten things you love in life? Justice, Maddox, honesty, adventure, discovery, deep discussions, laughter, survival, flight, freedom.

Words show their limits when speaking about Angelina. She is simply the most beautiful creature I have ever seen, with both masculine and feminine qualities, characteristics that are rare and powerful. When doing her makeup, I have learned to leave well-enough alone. The look in these photographs is chic, refined, and sophisticated, and what radiates is Angie's strength and confidence.

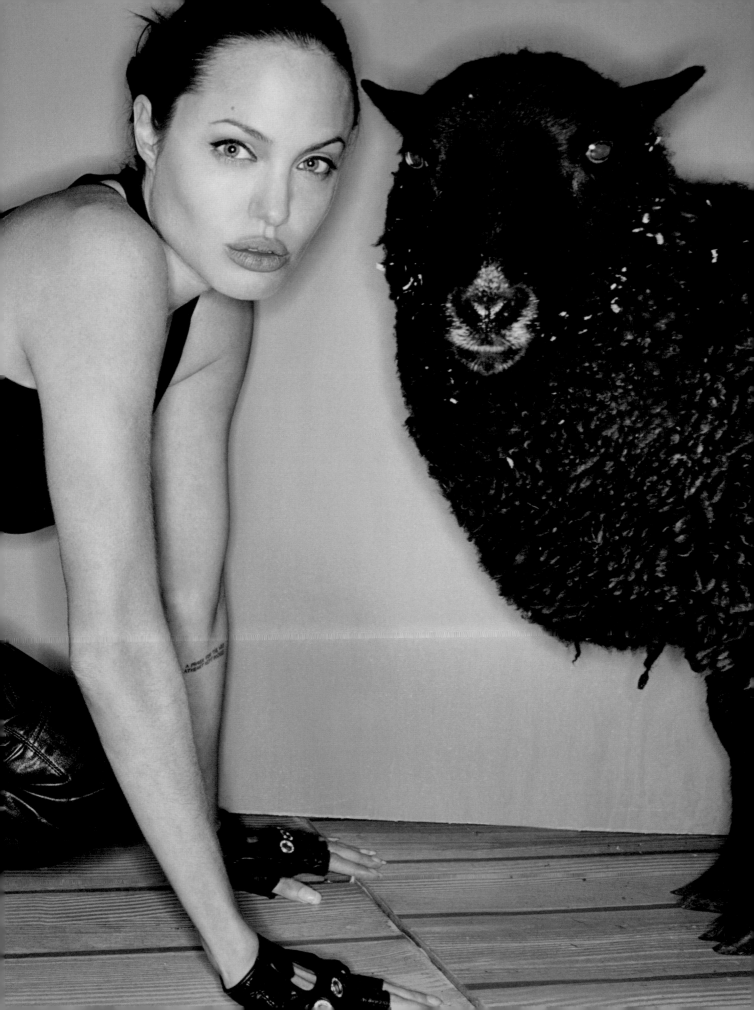

Ellen DeGeneres

Ellen has an androgynous quality about her that I have always found seductive. Sharp, funny, and possessing an unflinching cheerfulness and positivity, Ellen seduced her detractors to become an icon and beacon to millions of men and women. She conquered the night with the pioneering sitcom *Ellen,* and owns the daytime with her wildly successful *The Ellen DeGeneres Show.* I love making Ellen up in unexpected ways, but the no-fuss look she has cultivated for herself is the perfect reflection of her lighthearted approach to life.

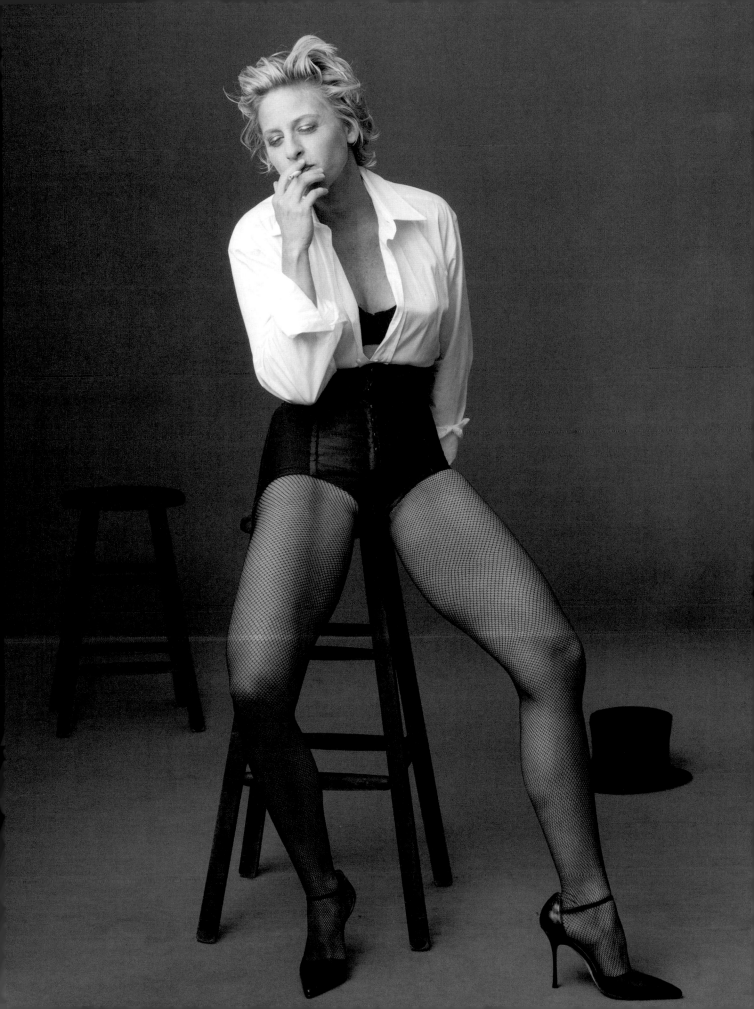

Ellen, how would you define beauty? It's self-confidence.

Who are the women you most admire, and why? I just saw her in a film recently and she was just on the show, so I'm going to say Annette Bening. I think she is just stunning—just beautiful and natural. I feel the same way about Isabella Rossellini and Candice Bergen. I know these women are older, but for me it's about how you carry yourself as you age. I admire them for being stylish, classy, and confident. It really is all about self-confidence.

What about yourself? What do you consider your most unique quality? Most unique quality? I have no idea. I like that I make people happy.

And your fatal flaw? I have so many flaws, God, where do I start? I'd say I'm way too sensitive.

"I think in the last few years I've transformed a lot simply because I'm in a really happy place."

Describe yourself as if you were a disinterested observer. I don't know what other people think about me. There's no way for me to separate me from myself. And I think that's good. I don't really want to know.

Can you tell me ten of the favorite things you love? Nature—specifically trees, animals, and the ocean. My girlfriend. My family. My job. I don't know that I love them all the same. How many is that? I mean, how many more things are there to love, anyway? I can say I love cheese pizza, but I don't know if I really love it. I enjoy it. I could say I love my car, but I usually reserve that word for things I can't do without, because there are a lot of other things I love. I love good movies. I love music. And there is one more thing I love: laughter. Those are the things that I can't do without.

What about foods you love? How do you deal with temptation? I pretty much go my own way. I don't really eat sugar, but every once in a while, if I do crave it, I'll have a dessert. I'm certainly not as careful as certain people who have amazing bodies. Unless it's genetic, you can't have a body like that unless you are really strict. So, I don't eat junk. I eat protein, also pasta and pizza, but I work out—at least five times a week, sometimes more—and I drink tons of water. I'd work out every day if I could, but my big thing is to drink a lot of water.

Do you allow yourself any vices—maybe in moderation? I understand that some people just don't have that control, but personally I believe in moderation. I'll take a drink and, though I'm a bit ashamed to admit it because I quit for a long time, I do smoke occasionally. I think everything in moderation is good, except for drugs. I don't do drugs.

How do you take care of your skin? I use products from a dermatologist. I used to get facials

all the time, but I found that the more facials I had, the more my skin broke out. My skin is sensitive and reacted against them. So now I just use a really mild cleanser and moisturizer. Pretty basic.

What about makeup? Do you wear it? I hate it. It's one of the things that I hate most about this job. Even when I was doing my sitcom, I'd wear makeup maybe once a week and it was enough. Now I have to wear it every day. The first thing I do when we finish taping the show is go to my dressing room and scrub my face. I hate makeup! I know a lot of people love it, but it feels like drag for me. It's not who I am. It feels like I'm covering something up.

Do you carry any cosmetics with you? I don't even own any. As a person who does makeup for a living, you must hate hearing that.

No, I think you look really sexy without makeup. Honestly, more people tell me that I'm prettier in person. I don't know what that says, but it's not about whether or not I look better. I just feel better without that mask. I probably wouldn't do a photo session without makeup, because I'm conditioned to think that I need it. But, boy, do I hate it.

How do you feel about aging? I'm thrilled about it. To me, age is just a number. It's what you do with the time that you have that matters. But admittedly, at a certain age, all of a sudden you appreciate what it means to be twenty years old and have a body that is naturally young.

But is youth wasted on the young? Well, I'm not envious of youth. I like the maturity, knowledge, and wisdom that I've gained from my age and my years. Still, I'd love to have the youthful skin that I once had.

Wouldn't we all. So, what do you think about cosmetic surgery? I used to think if this is how you're born, this is the way you're supposed to look. It's ridiculous that society places all this pressure on women to look younger. But as I've grown older, I've stopped judging things. Now I think that whatever makes you feel better about yourself is a positive thing. I'm ashamed of myself for judging it; I don't really like to be judgmental.

Do you think there is a double standard in the way we judge the beauty of a mature woman versus that of a mature man? Do I think there's a difference? Oh, my God, yes! I mean, it's been said so many times, but a man can have a potbelly, bad hair or no hair, for that matter, but if there's money involved, he is the sexiest person in the world, because he's got a powerful position or drives a nice car. If a woman tried that, no matter how powerful she was, she wouldn't be looked upon as a sex symbol. More likely, she'd be seen as a predator. So, yes, there's a double standard. A king-sized one.

Every swan was an ugly duckling. When did your transformation occur? Mine is still ongoing. When I made the decision to come out, I experienced a lightness and a freedom that felt like the beginnings of some kind of transformation. At least, that's when I first became aware of something changing, but obviously something had to be happening already for that moment to arise. I hadn't known I carried anything heavy or shameful in me, because it was something I was so used to living with. I think in the last few years I've transformed a lot simply because I'm in a really happy place. I feel confident now and I never felt that before. Beauty is many things—it's a huge industry for one—but it's not just perfect abs or lustrous hair. Beauty arises from how you feel about yourself. It's a feeling and an energy that people can sense when they're near you. All that other stuff is just accessories.

What is your personal fountain of youth? I'm very childlike. I'd never call myself a woman or a lady. I feel like a girl. I know some people are offended by "girl," and think you should be a woman or a lady, but I would be insulted if somebody called me a lady, because I'm no lady. I never worry about what I'm supposed to say or act like at this age.

What would you consider the ultimate compliment? That people get something positive from what I do, because that feeling then gets transferred along from one person to another. I like that being positive is contagious.

As her personal preference, Ellen can take or leave makeup, but she is certainly not afraid of it and seemed to enjoy the role-playing aspect of morphing from Vegas showgirl to comic mime to boy-next-door with the aid of just a little foundation, lipstick, and blush.

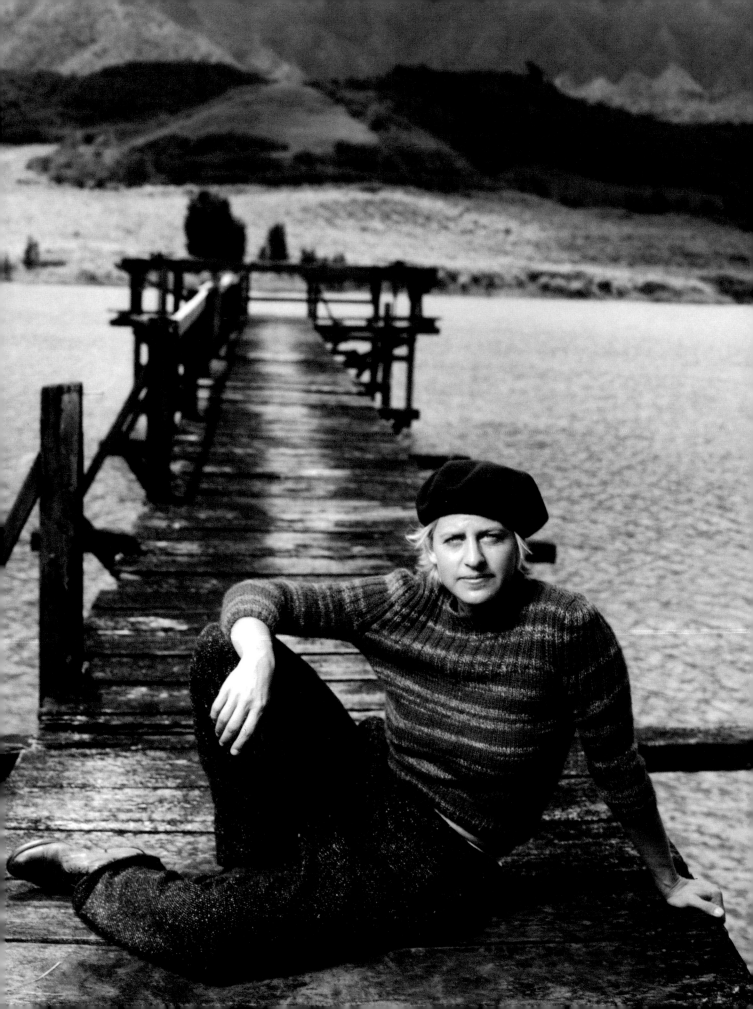

Diane Lane

Diane is the woman other women want to be: cool, elegant, and collected, with a smoldering surface quality that bespeaks fires deep within. Continually evolving, from her teenage debut alongside Sir Laurence Olivier in 1979's *A Little Romance,* to her cult-icon status in films such as *Streets of Fire* and *Rumble Fish,* to her current status as critically acclaimed actress in films such as *Unfaithful, A Walk on the Moon,* and *Under the Tuscan Sun,* Diane Lane is a woman with a past—and several, at that—and a future whose only limit is her own imagination.

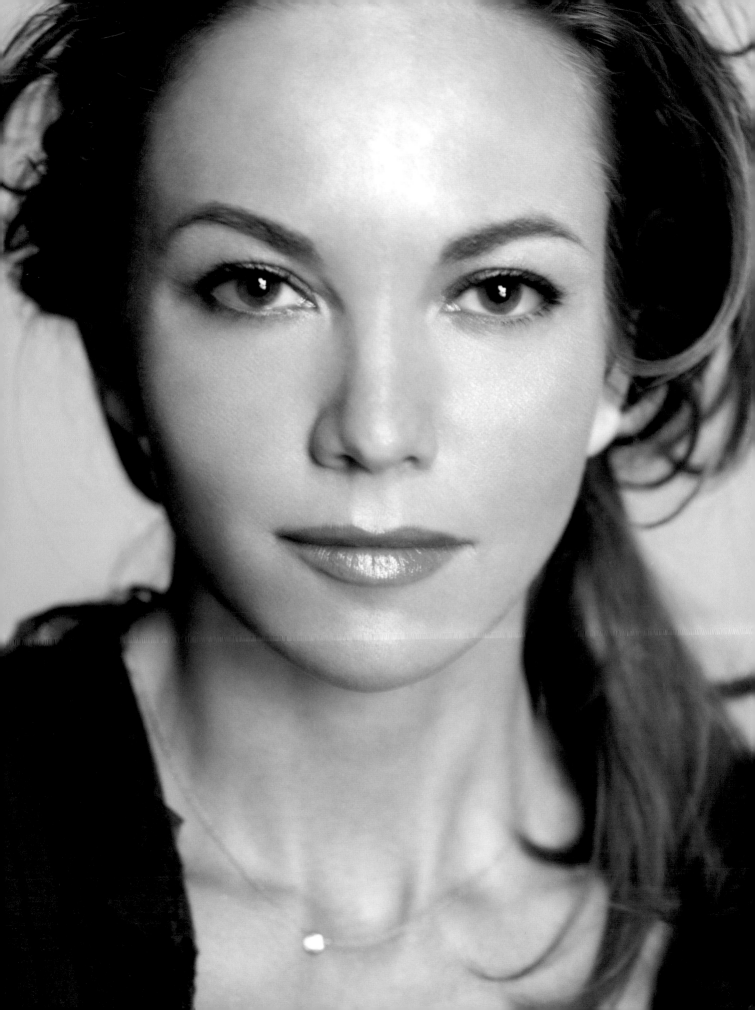

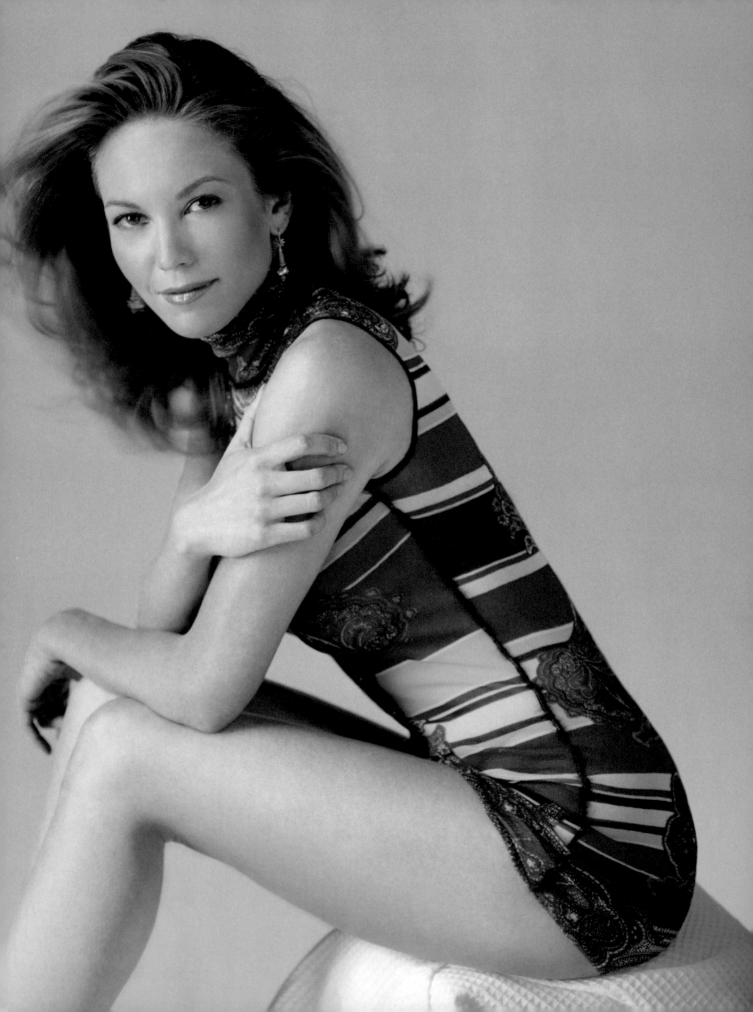

What do you think about makeup, and how much do you wear in your day-to-day life? When I was younger I wore more of it than I do now. It was the fun of experimenting then. Now, using makeup is a strategy against having to wonder, "Do I look tired?" Or, "I could use some sun." I feel that as time goes on, the "me" that I am with makeup on is equal to the "me" stripped clean of makeup. Which is to say, they complement each other. I am either made up to look glamorous for some work-related affair or I am flaunting my naked face to the world and daring them to not love me for who I truly am.

in and of itself. I find obsessing about one's appearance to be sad. I think the answer is this: Don't promise what you don't want to deliver. The truth is, as with many "beautiful" people, I wouldn't be in magazines if not for airbrushing, but then again if I were still young and flawless—by the editors' standards, mind you—then I wouldn't have any copy to go along with the photo. . . . And, personally, I'd rather be quotable than photographable any day of the week!

Are you careful with your diet? How do you deal with temptation? I avoid hydrogenated oils, white flour, and sugar. I

"I'm drawn to the kind of beauty that doesn't mind itself, almost cheats itself out of being discovered."

How does makeup change the way you feel about yourself? Makeup is a crutch, a soft padding, a correction, an embellishment, an apology, a true friend. But I feel one must have the courage to literally "face" the day at least a few days a week, just to stay honest and not abuse the friend.

Okay, and how would you define beauty? When talking about one's own beauty, I would put it this way: Like a good hostess, you have to enjoy your own damn party or who else will? I think taking beauty too seriously can ruin it. There's an element of the captured, of the "not on purpose" to real beauty. I'm drawn to the kind of beauty that doesn't mind itself, almost cheats itself out of being discovered. The louder, the less intimate, the less affecting. But that's just my take on it.

Can cosmetic concerns be taken to extremes? Do you know of any cases of "beauty addiction"? I think beauty addiction happens when a line is crossed from creating personal style to sacrificing a part of one's identity in the pursuit of beauty. The things that make youth so appealing are being open to spontaneity, vitality, and a desire to play. However, wisdom that comes with experience carries with it a potent beauty

believe in keeping fruits away from protein. And I love olive oil and honey. I avoid chemical-laden, prepackaged food. However, if I sin against these principles then I make it count and get what I really like—not just mindless acceptance of food that's convenient. I deal with temptation by reminding myself of the queasy feelings that come from eating something regrettable. Also, for lack of a better way to explain it, sugar makes me feel out of touch with myself. I feel moods that are not my own after consuming more than a teaspoon of it. It's not worth the yucky feeling, unless I'm besieged by a craving for the odd candy bar. If that's the case, then I get one I know I enjoy and have a guilt-free indulgence.

Every swan was once an ugly duckling. When was your transformation? I am transforming every time I wake up and take a reality check; not only on what I see in the mirror, but what is truly important, outside the mirror. There is a funny saying—"The eyes go in the nick of time." But what do we do? We get glasses. Relying on looks doesn't work at any age. Look at our old pictures—we may be young in them, but we are very dated-looking as well. Personally, I think my swan years are still ahead of me, but I made quite a pretty duckling.

Diane Lane has the perfect face for a beauty shot. In these photographs I played up her eyes with individual lashes and some gold shimmer to make them sparkle, and gave her a sculpted eyebrow.

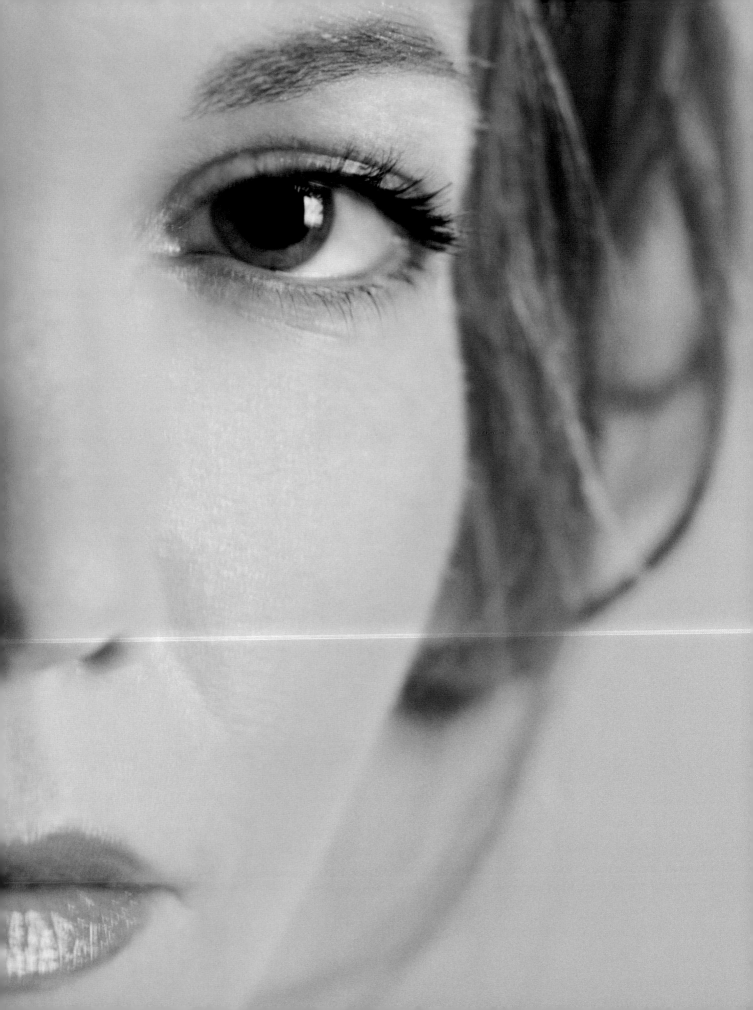

Meg Ryan

Her blonde hair, blue eyes, effervescent personality, and unforgettable smile made Meg one of America's favorite actresses. She practically defined the contemporary romantic comedy heroine, and has proven equally adept in the grittier roles she's taken on in the last few years. From *When Harry Met Sally…* and *Sleepless in Seattle* to *You've Got Mail* and *In the Cut,* Meg has proved her staying power and is as fresh, sexy, and smart today as when she first began.

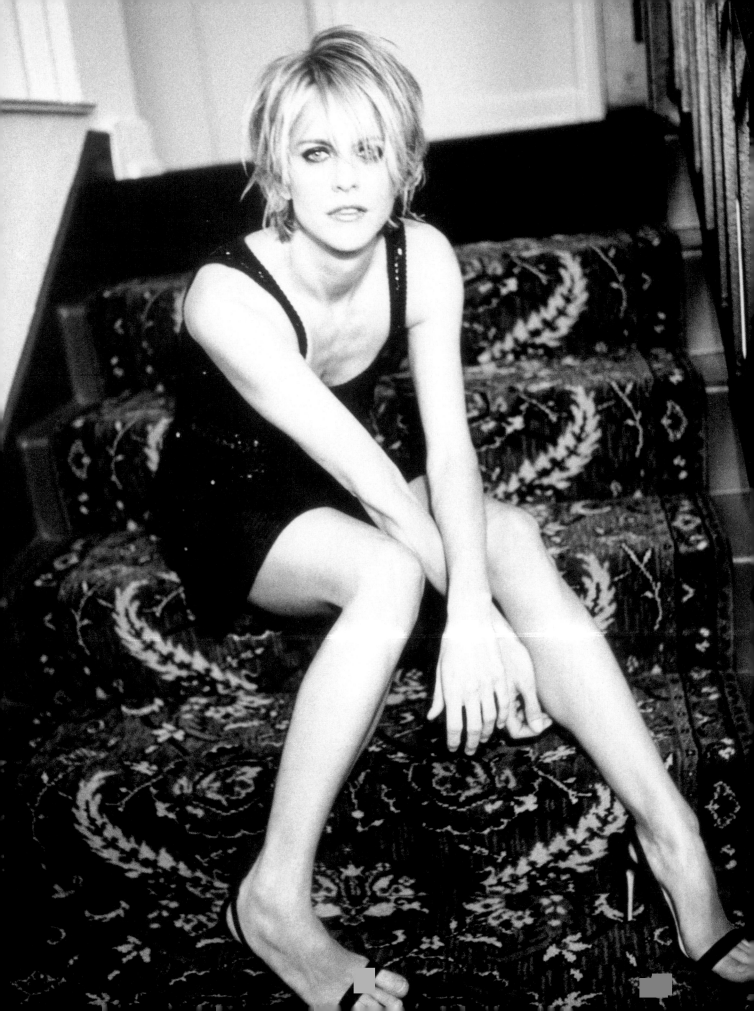

Can you describe yourself as though you were a disinterested observer for me? Oh boy. I don't often consider myself in the third person. It's sort of a defense mechanism I've developed from being in the public eye. I try not to pay too much attention to how others perceive me because every now and then when I do, it's either painful or weirdly elating, and ultimately very disorienting. I don't want to live in reaction mode. I don't want that experience in this life.

In your own words, tell me what is your definition of beauty? I know it's a cliché, but I believe that beauty is truth and truth is beauty, and I see examples of it all the time. When people are authentic, they are the most beautiful. That's why children are so beautiful, every one of them, because they don't pretend to be anything but who they are. They're not reactive; they are full-blown, proactive versions of themselves until adults start telling them, "Don't do this, don't do that, tone that down a little bit." It's beautiful and real. Real elation. That's beauty to me.

You've started taking photographs. Do you want to talk a little about that? I do one thing, really. I shoot with very high-speed black-and-white film. Basically, it's because I don't want to ever have a set-up shot. I bring my camera with me everywhere and photograph as many things as possible. If you're a writer, you're always engaged in the process of observing, and it enlivens your day. I feel like when I'm on it with my eye, it's the same kind of thing. So I like having my camera around. Some pictures are great, and other ones are just. . . . [Laughs.] You know. Well, I have no technical expertise, but I do have a good eye, and I know when to press the shutter. That's really all it's about.

Do you follow a special diet? I don't follow any regimen in particular. I just know what makes me feel good: vegetables, a little bit of protein, and a lot of water.

And what about exercise? I do yoga probably three times a week. It's the easiest thing. And, if I can, I run or ride a bike. I like to keep my body active.

What do you think about makeup? Unless my eyes deceive me, you're not wearing a stitch today. I never wear it when I'm on my own, because I have spent too much time around experts like you who really know how to put it on. No, I don't wear it, and I think that works for me. I actually enjoy photo shoots, because the way they'll do my hair and makeup is not anything I could ever do for myself. [Laughs.] It's really kind of fun—like playing dress-up as a little girl. But if I went through my day-to-day routine with makeup on, I'd feel like a bit of a phony.

How does wearing it change the way you feel? I'm very sensitive to it, actually, because I'm an actor. I did a film [Jane Campion's *In the Cut* of 2003] where I had brown hair and brown eyes, and I had so much fun making it. My character looked nothing like me. There were no big huge prosthetic changes or anything like that—I just had my hair dyed and wore contacts—but it got me right into the character. She had dark eyes because she looked at the world darkly, and with her hair color, she was the kind of person nobody would notice when she entered a room. One day in Manhattan I walked all the way down from 76th Street and Madison to Mercer and Prince, and not one person stopped me. I can't remember the last time that happened. It felt so liberating and so different, you know? It can be a really powerful thing, how you present yourself.

What's your skin like and how do you take care of it? It's really dry, my skin. I need a good strong moisturizer, and to drink a lot of water. I go to this place called the Skin Gym. It's just the most basic facial possible, but I love it.

Do you allow yourself any vices? I don't really drink and I don't really smoke, but I do like chocolate. Sometimes I'm around people who deny themselves any guilty pleasures, and I can't believe that they can go through life like that.

Every swan was once an ugly duckling. When do you think your transformation occurred? You mean, when is it going to happen? [Laughs.] I don't think I'm a great beauty or anything. I think I'm okay. I do the best with what I have. There's no symmetry to my face, it moves around all weirdly, and that's fine by me. It's an awkward mishmash of stuff that all comes together every now and then. It works out, though.

Can you tell me ten of your favorite things in life? Jack, my twelve-year-old. I love his voice. I don't know if that counts

Meg has the curiosity of a child and the unflinching gaze of a photographer, and I love playing up her expressive eyes. The look we did here is one of my favorites on her, a smoky eye combined with a pale lip.

as one or two, but my son has the most spectacular voice. It's a scratchy little voice, but with a tinkle in it. There is a timbre and deepness to it, but it also has its high notes. It's the greatest voice in the whole world. What else do I love? I love when mountains are backlit, and they look purple. It just stops me cold. And I love the way the sun sits on the water and it sparkles. I love my friends. I adore my friends. How many is that? I love so many things that I just don't know where to start, or stop. I love New York. I love the Atlantic Ocean, like up around Maine. It just feels fierce, gutsy, and honest, and I really like it there. I love a good

all that new responsibility and blooming in the most spectacular way. Another thing about her that I found fascinating was that she was navigating a very male-dominated world with a lot of people who thought of her as somebody who didn't need to be paid attention to, but she didn't seem to feel a lot of malice or bitterness about that. She dealt with it and broke down all these boundaries and barriers without anger. I couldn't put her book down. Nora Ephron is someone I admire who I've been fortunate to work with a number of times. She's a fantastic communicator, and I love that about her. Women who use their voices in an authentic

"I know it's a cliché, but I believe that

beauty is truth and truth is beauty,

and I see examples of it all the time."

laugh. I love good conversation—fun, smart, philosophical conversation—where anyone's free to be right or wrong. It's become a lost art.

Do you think youth is wasted on the young? I don't miss being young. It's also such a relative term. I don't miss being twenty at all. I hated being twenty, as a matter of fact. I like being at home in myself. It's a hard road getting there. It's probably easier for some people, but I always take the hard way. But it's finally happened: I finally feel like, Here I am, take it or leave it. It has to do with really realizing that ego has no place in anything. There's so much freedom in that belief.

Who are the women you most admire and why? Good question. I just finished reading *Personal History,* the autobiography of Katharine Graham, the late publisher of *The Washington Post.* It's sort of the ultimate wife-to-woman story. She had a difficult but invigorating marriage: her husband was the owner and editor-in-chief of *The Washington Post.* When he died, she took his place, reinvigorated the paper, and was its owner and editor during the whole era of the Pentagon Papers and Watergate. She is so honest about her experiences as she evolves from this put-upon woman who had shrunk to fit her environment to taking on

way—Jane Fonda, Christiane Amanpour, or Susan Sarandon. These are the women I most admire.

What do you consider your most unique quality, and what do you consider your fatal flaw? I'm really, really impatient. That's my fatal flaw: impatience. Once I get an idea in my head, I want to act on it immediately. I have another fatal flaw: I'm enraged all the time. I'm such a punk. That's what the Bush administration is doing to my body, this administration is about keeping the lid on artists' voices all the time, and it's not a very safe environment to speak out in. I find that enraging and I'm so excited when people do speak their minds. It brings out the punk in me. This is so off-the-point, but I do understand why politicians fear artists. It is because artists have no mandate except to tell the truth. They don't even need to be understood. Their interest lies in expression, not communication. They are two different things. Artists are interested in expressing what they believe to be true to the world. Nothing false comes out of my mouth just because some institution wants it to come out a certain way. That's probably a fatal flaw, but I also like that about myself.

What is your personal fountain of youth? [Laughs.] You know, just keeping an eye on the absurd.

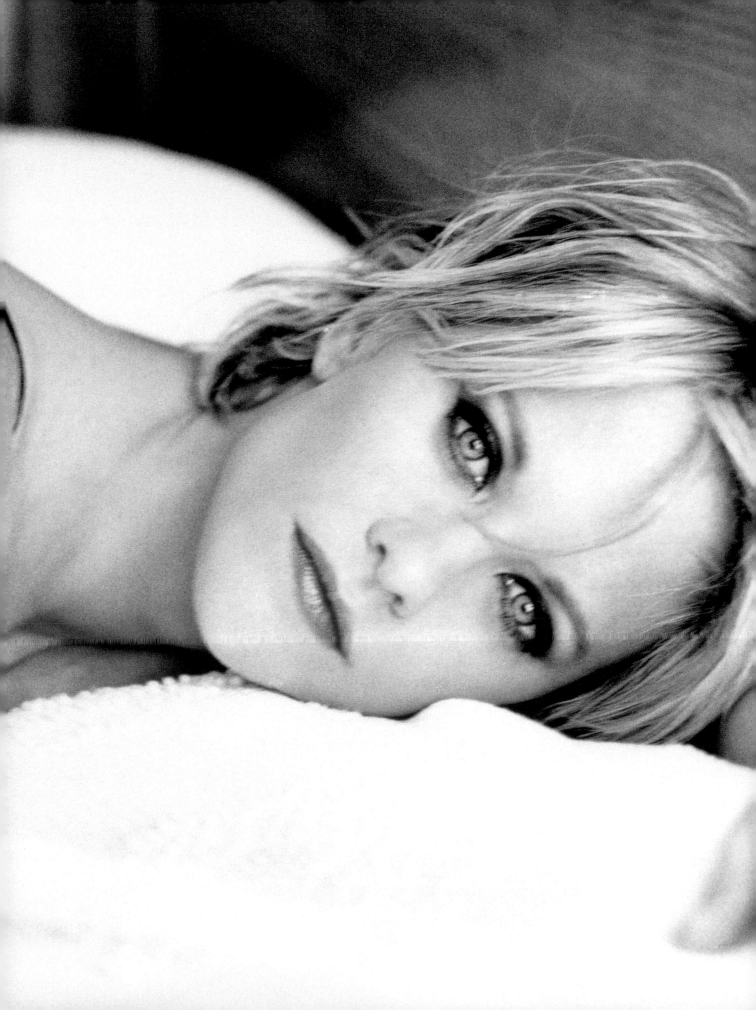

Carolyn Murphy

Few models are as successful as Carolyn, and much of her success stems from her chameleon quality. One of the pleasures of a makeup artist is aiding the process of transformation, and there are few people who make my job so easy. As a face of Estée Lauder, Carolyn demonstrates the transformative powers of makeup to women around the world, but there is a real woman behind those exquisite features, with a mind as impressive as her body.

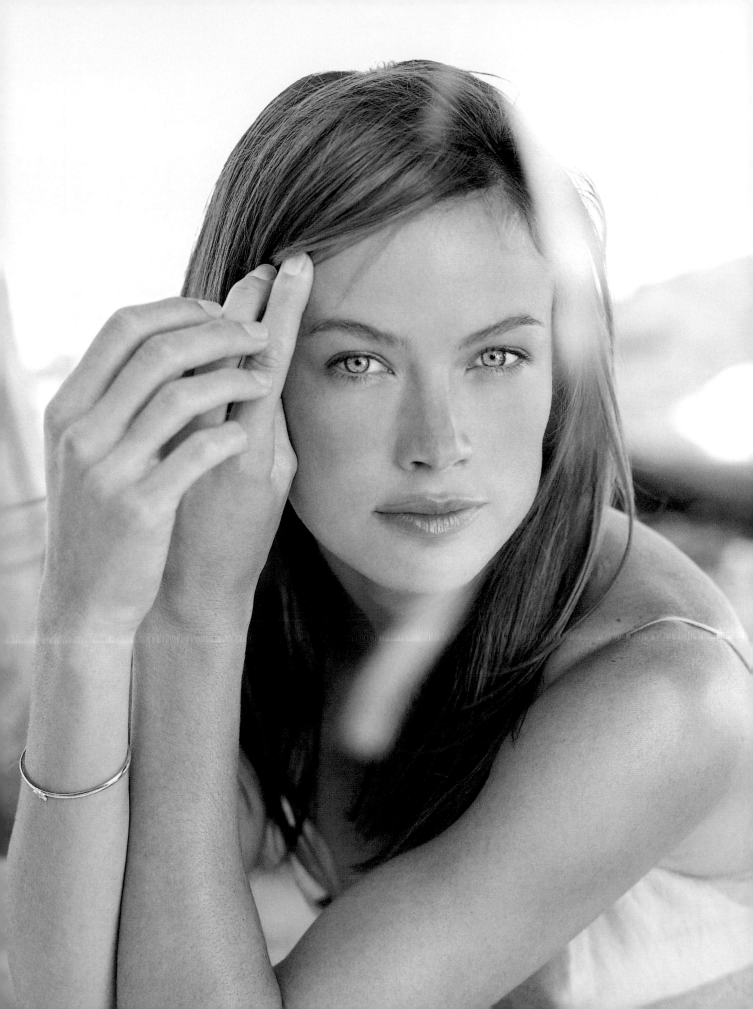

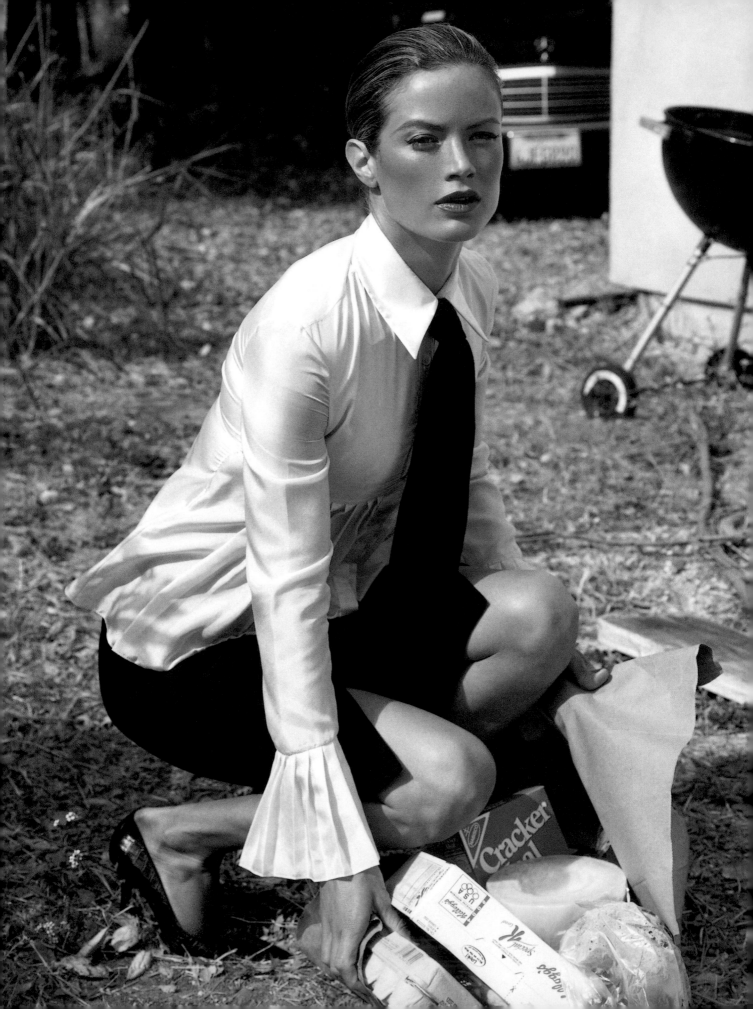

Where were you born? My family is from Virginia, but I was raised all over the place. My dad was in the Air Force, and my mom was in the Civil Service. My main home base could be considered either Virginia or the panhandle of Florida.

Are you pleased with how your career has evolved? It's crazy; sometimes I still don't believe it. I never expected to be the face of anything, let alone the face of Estée Lauder.

What do you think about makeup? I remember that I was fascinated with my grandfather's *National Geographic* magazines when I was young. It's interesting to me how men

What's in your makeup bag now? Concealer, hand cream, and lip gloss. Minimize, moisturize, dramatize: that's my motto.

What is beauty to you? Beauty is self-confidence. For me there is no single standard of beauty because true beauty arises from individuality. Beauty embraces differences.

How would you describe yourself if you were a disinterested observer? That's a good one. It sounds really horrible and insecure, but I probably wouldn't even take a second look. Perhaps that says something weird about my psychology, though I'd prefer to think of it as a sign of humility. If I

"When it's good, makeup can make you feel sexy and confident."

and women utilize makeup in other cultures, really enhancing their own ideals of beauty. It represents much more than just makeup as we think of it today. I wish women in our culture could see makeup not as a cover-up but as an enhancement and extension of their personalities. I certainly did when I discovered punk in junior high, even though that was just a brief phase. Now, I wear makeup depending on the occasion or my mood, and hopefully my makeup expresses that. My mother didn't wear a lot of makeup, but when she did, it was always a great red lip. That's my favorite look—a really great red lip, with everything else pretty clean.

How does makeup change the way you feel about yourself? I've had every kind of makeup experience—good, bad, and indifferent. When it's good, makeup can make you feel sexy and confident. Sometimes it can make you feel like a little girl, flush-cheeked and sun-kissed, like Sunset Barbie. You can use it to create different moods. One time when I worked with Herb Ritts, we did classic Hollywood glamour looks and I felt like I was an actress in a 1940s film. I love the role-playing of it all; you feel like you can leap tall buildings when you have great hair and makeup on.

project anything to people, I hope that they see a woman who is warm, approachable, and has a love of life.

What do you feel about the skin you're in? Do you follow a skin-care regimen? It's funny, but when I'm feeling my best it usually has nothing to do with external things like facials, which usually make me feel worse, because my skin breaks out afterward. I feel best when I'm drinking a lot of water, sleeping well, exercising, and taking my vitamins, especially calcium and omega-3, which are so important for a woman. Those are important things for me, and those are the things that make me feel like I have balance in my life.

Are you careful with your diet? I'm all over the place. I love trying new things, so if someone tells me the secret is red wine and dark chocolate, I'll try that, and it feels great. Then someone else says eat lots of salmon and greens. I'll try that, and it feels great, but when I get home I want Taco Bell. Ultimately, I know what makes me feel good and what happens when I listen to my body, when I fuel it with the best stuff, like green tea instead of a cappuccino every morning. "Everything in moderation" is the best rule for me, and that definitely includes dark chocolate.

Carolyn is known worldwide as one of the iconic faces of Estée Lauder, but in these photos she first reveals the face behind the corporate image, then shows her acting ability playing a desperate housewife, à la Cindy Sherman.

Do you exercise? Yes, I do. I was very active when I was growing up as well. I was a swimmer for eleven years. I practice yoga, and I surf, which is a big part of my life. Surfing revitalizes me both physically and mentally; it's like moving meditation.

What vices do you allow yourself—alcohol, cigarettes, junk food? I enjoy a glass of wine now and then. Dark chocolate. A beer. I've had my fair share of vices, no doubt, but I believe everything is allowable in moderation. When it comes to dieting, I prefer discipline to denial.

Every swan was once an ugly duckling. When did your transformation occur? Oh, God. Very late in life, when I was about twenty-four. I didn't really get to know myself until then, and I still don't completely know myself, so I'm in a constant transformation. I'm a work in progress.

Do you think that youth is wasted on the young? That's a good question. I don't think any experience is wasted if you learn from it, but youth is wasted if you don't take care of and respect yourself. You can be eternally youthful if your definition of youth is something that comes from the inside.

What is your personal fountain of youth? My daughter. As much as I complain about losing sleep, being a mother makes me feel like a big kid all over again. I have a new zest for life. My daughter is my partner, and she has opened my eyes to so many new and different things. I love being a woman, being in love, and being a mother—that's my fountain of youth. Everything else can go away. Those are the things that make me feel good.

What are the ten things you love most? My daughter, my boyfriend, my family, my friends, hot baths, the ocean, the sun, trees, dirt, flowers.

And which women do you most admire, and why? I love Cate Blanchett. I love Meryl Streep. I loved Carolyn Bessette Kennedy and Jacqueline Kennedy Onassis. I think what all these women have in common is strength of character and a distinct personal style. I also love my mother and nana, two women close to me. I admire any woman who expresses herself with passion, strength, and soul. Those are the most important qualities in life.

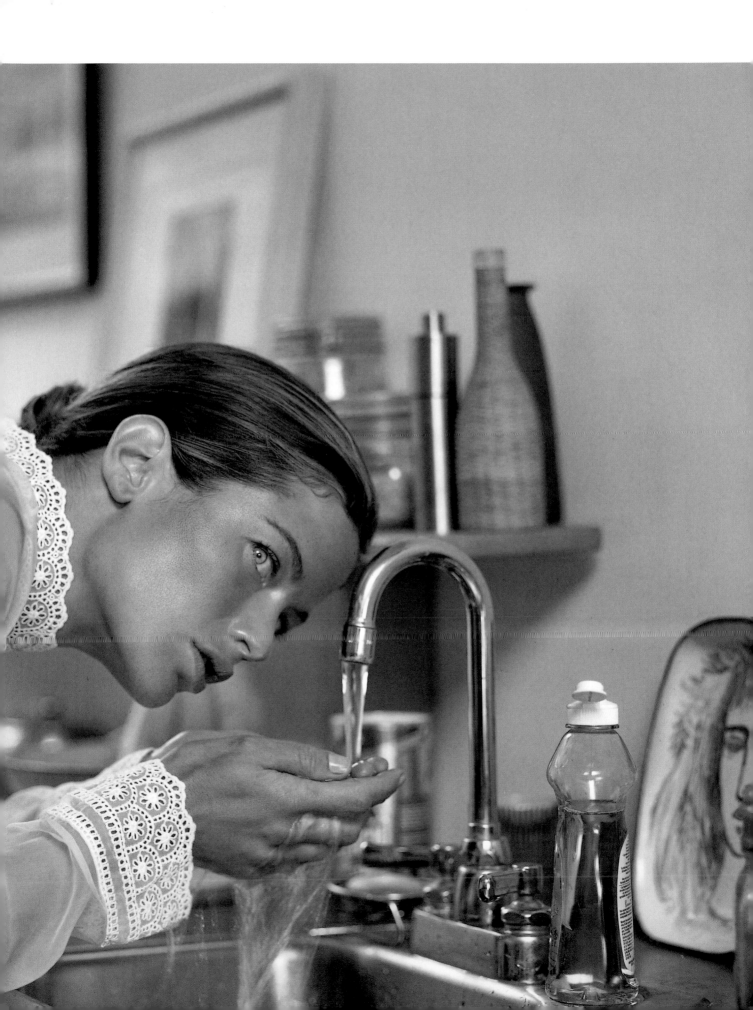

Annette Bening

Since she first played royalty in *Valmont,* Annette has grown into both a world-class actress and genuine Hollywood royalty. From *The Grifters*, *Bugsy,* and *The American President* to *American Beauty* and *Being Julia,* her range puts her in a category all her own. With poise, grace, and a self-effacing sense of humor, she is reminiscent of stars of old. As an actress and a woman, Annette will continue to surprise us for years to come.

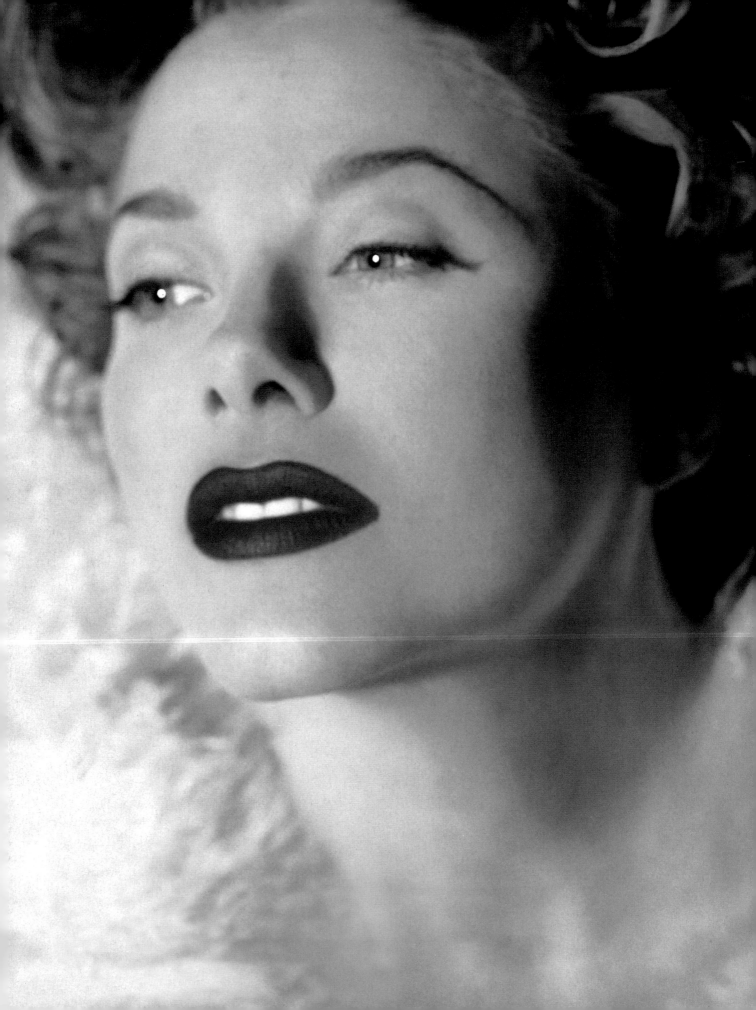

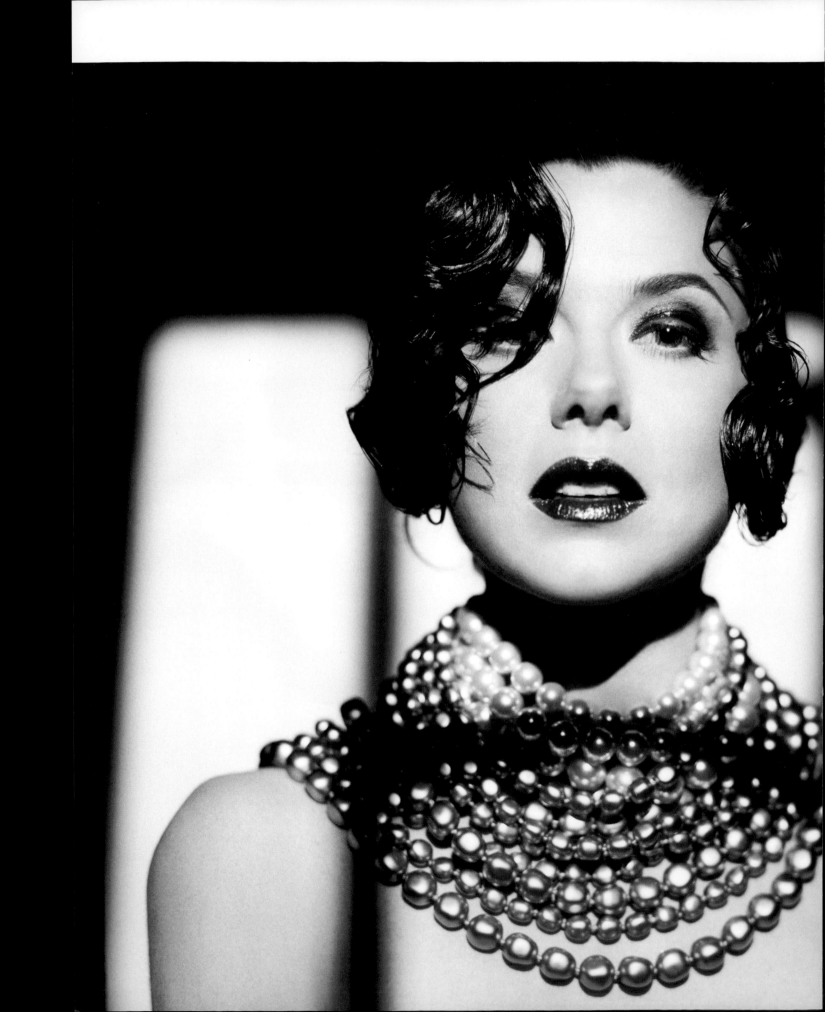

What is your definition of beauty? I think beauty is a simple thing, really. It's what is inside of a person. I think that's what ultimately comes through. Certainly, in a photograph, with lighting, makeup, and a camera that can be played with, what is considered beautiful can be explored. But in terms of my own personal feelings, internal beauty transcends what's external. I think the essence of a person comes across pretty quickly from the inside. There's a superficial side to all of us, how we look on the outside, but when you meet a person, that very quickly drops away, and whatever's going on inside that person is much more powerful.

Who are the women you most admire, and can you name some who have inspired you? Liv Ullmann is an inspiration. Also Vanessa Redgrave and Maggie Smith. I am a fan of an American movie actress called Gloria Grahame. I studied her when I worked on a movie called *The Grifters*. As far as American actresses, of my contemporaries, I would say Frances McDormand. I think she is a great actress and a great woman. What she's able to do in her work is extraordinary—she's an amazing talent. Ingrid Bergman, I think, was a great talent. Are you asking about classic actresses from the past?

Really, any of the women whose example inspired you to be a performer. I didn't really think about becoming a movie actress when I was just starting out. I was in the theater, and those were the people that inspired me. There was an actress-producer-manager-director named Eva Le Gallienne who started her own theater company in New York in the 1920s, and she was somebody who I always admired and looked up to. And there was a turn-of-the-century Italian actress named Eleanora Duse, a great stage actress, and a contemporary of the French actress Sarah Bernhardt. Bernhardt, of course, was an international theater star, the diva of all divas. She was famous for what they called her "thrilling voice." She had this incredible tone—there are a few recordings of her speaking and you can hear the timbre and cadence and passion inside of the voice, even if you don't understand the French. She was of the old style, the declamatory, kind of big and grand. She made numerous tours of this country, even after she'd had one leg amputated. She would travel in this incredible train, where she had her own private car, and tour the country doing her signature roles. Eleanora Duse was younger than Bernhardt, and her complete antithesis. She was completely natural and didn't wear makeup. That's what was so astonishing about her—she had no artifice. She would put her back to the audience

and speak her lines only as loud as was needed to be heard. And she was famous for working with her hands. Of course, when you're trying to describe theater actors it's tricky because it was the act of seeing them that was so amazing. It's not like a movie actor's performance, where it's more about the camera. That's what I would dream

act, more from the inside out, and so they explore the past history of the character and think about what the character likes to eat, what color the character would like, what animal he or she would be, and in what physical condition—internal things you can work with to stimulate the imagination. Then there's the outside-in approach, which asks: Which hat am

"Makeup can be an enormously helpful aid, as can the person who's applying it."

about as I was coming up as an actor. I didn't really watch movies and think, "I want to be a movie actress." It wasn't until I was older, when I was at college and in acting school, that I started getting interested in it.

These images of you are by Matthew Rolston, and I think it's some of the strongest makeup I've ever done on a celebrity without a struggle. You were such a great muse to me in those sessions, but I've always wondered how you felt about being painted so dramatically. Well, the photographs are beautiful. I'd forgotten about them because I hadn't seen them in a while, and I was flattered that you wanted to use them. I think they're amazing.

It was such a different time. I could never dream of pulling out that type of makeup to work on a celebrity of your stature nowadays. But you were always so willing, and I think the images turned out to be quite memorable. It's a joy sometimes to try as much as you can, to embrace whatever idea comes up, especially when it's with someone like you or Matthew Rolston. You say, "Let's play, let's explore, let's see what happens." As an actor, it's not about looking a certain way. One of the pleasures of being an actor is being able to be different things and look different ways. It's part of the job, so for me it's a complete joy, especially in a still photograph, to try to capture something that has nothing to do with my own life, but is outside of it.

How does makeup aid you in developing a character? It's interesting about acting. Some people act, and are taught to

I going to wear? Am I wearing high heels or red lipstick? Do I have pearl earrings? How do I feel in this tailored outfit as opposed to a bathing suit or a corset? I think most actors end up doing a combination of both, and makeup is certainly a part of that. If I'm wearing false eyelashes and thick black eyeliner, that's one thing; and when I'm stripped down to almost nothing, with no makeup, another feeling is created. Makeup can be an enormously helpful aid, as can the person who's applying it.

Will you tell me ten things that you love in life? My family is the first thing. That's most important—my four children and my husband. After that, it's all really very simple: taking walks, reading, those simple things are my essentials. I now have a dog, and I love my dog! I used to think people were insane when they fussed over a dog, and then we got this puppy a few months ago, and we're just besotted with him. He's a Newfoundland pup, so he's going to be one of the biggest dogs there is when he's fully grown.

One last question, Annette. What is your personal fountain of youth? I think it's what goes on in the most basic part of your life, meaning your relationships. In my case, with my children and husband, with my brothers, my sister, and my parents. And then, I feed myself with good books and good friends—not only my immediate family but my extended family as well—and also having time alone. I think solitude is very important. I love those quiet moments, or just taking a walk to clear my head. I enjoy those moments because I have a full life.

Annette is a brilliant actress with a highly expressive face. For these pictures, I gave her a classic Hollywood look—clean eye, arched brows, crimson-red lipstick, and individual eyelashes—then we went more extreme with a greasy black eyelid and a blood-red lip.

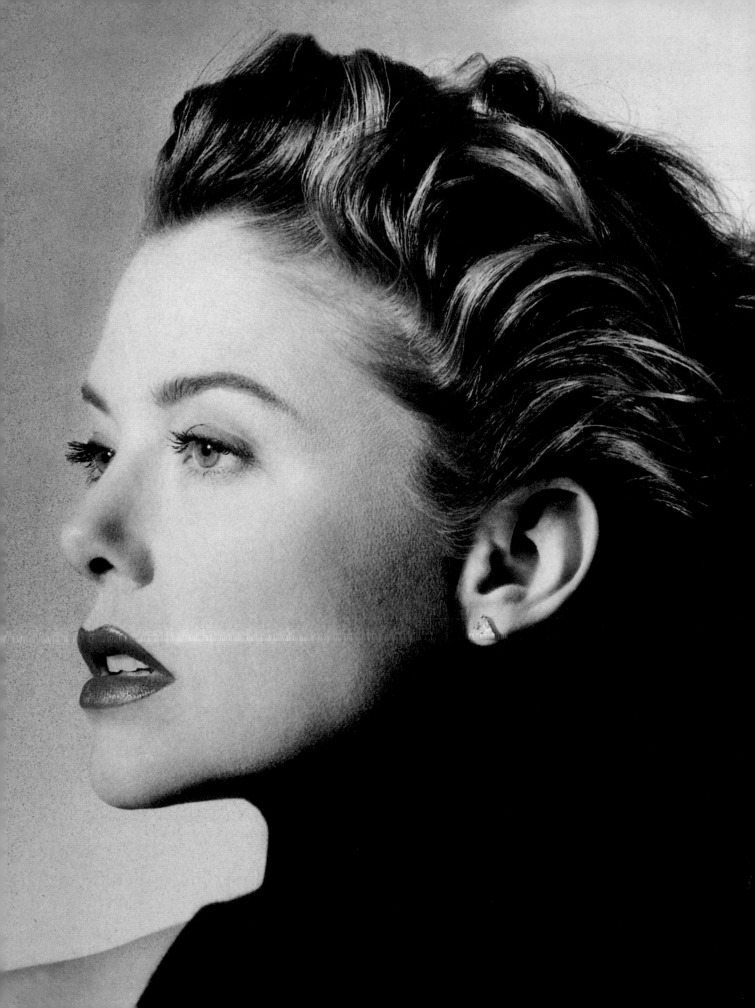

Cameron Diaz

There's something about Cameron. What do you say about the girl who has everything, or seems to? That she has enough energy to power a Mars mission, and a body other women would sell their souls for? Do you talk about her infectious, irresistible laugh, her incredible acting range, or her generosity? I admire Cameron for all of the above, but mostly for the fact that she has the same insecurities, and works just as hard for her beauty, as any other woman.

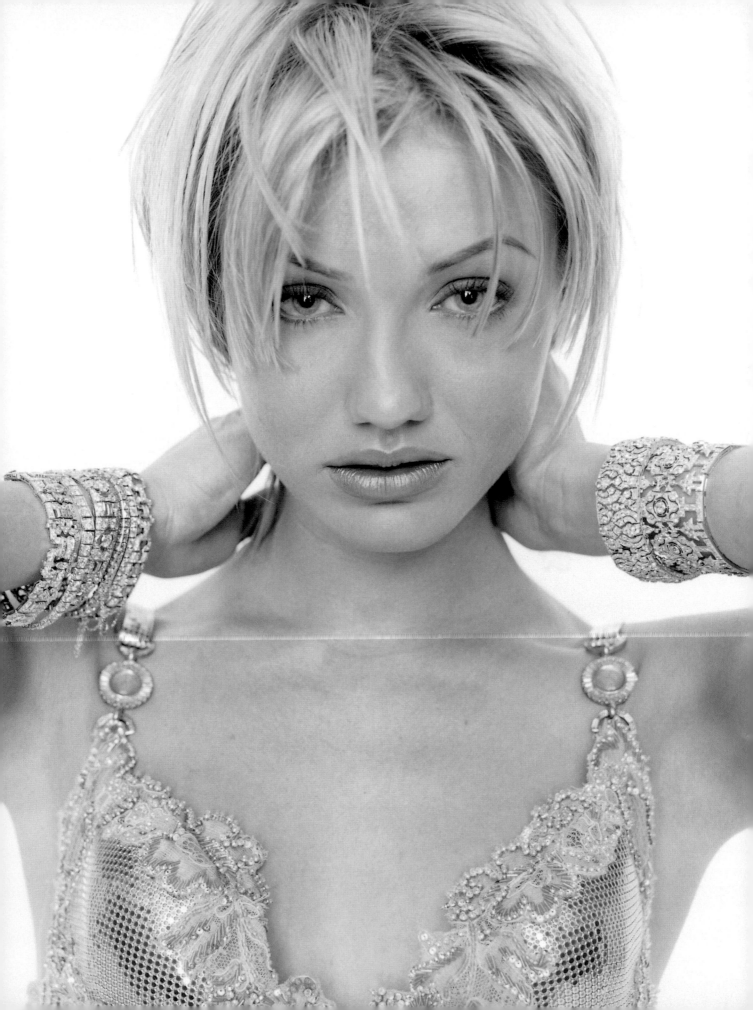

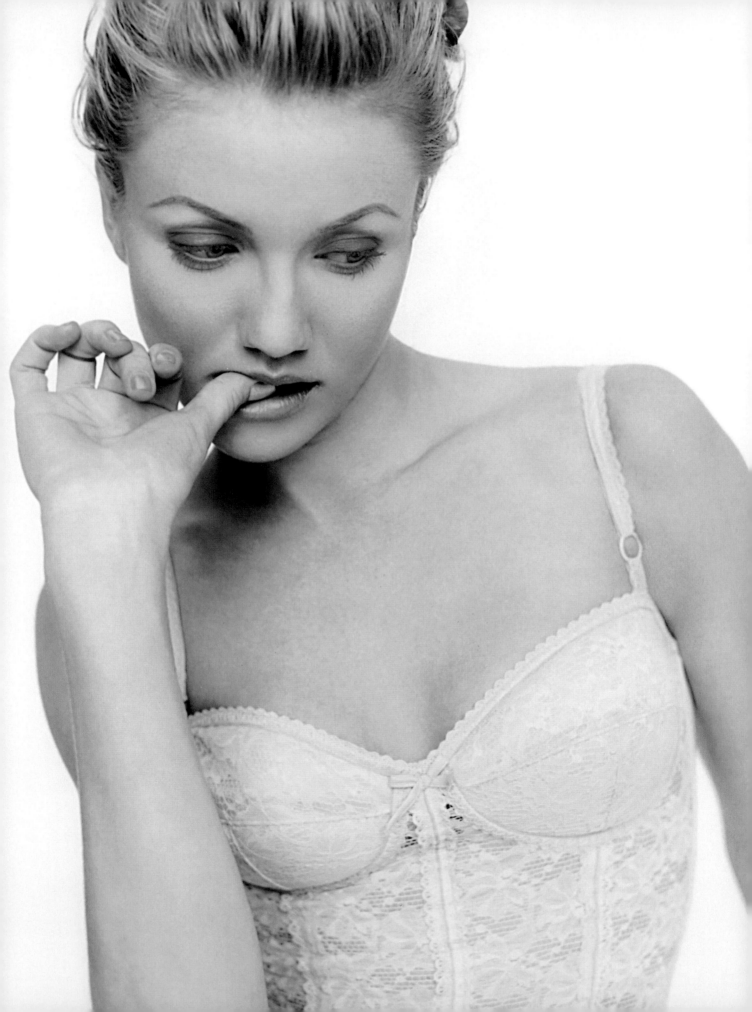

Describe yourself as though you were a disinterested observer. Now that's a hard thing. It's difficult to know what we really look like. When I was young I was really skinny, and I always imagined that people were saying, "That poor girl, she's so skinny. Do you think she's okay?" That was my self-image most of my life. I was also one of the tallest persons in my class, so I was always slouching to be down where everybody else was. It's uncomfortable being taller than everyone else. I always felt like people were going to feel sorry for me or make fun of me. So, as a disinterested observer, back then I might've thought, That girl needs to sit up, she slouches too much. Nowadays, I'd like to think someone who didn't know me well would notice my smile. I give everybody a smile, because I love to see them smile back.

Finish the sentence "Beauty is . . . " Beauty is what we give to other people. I often see people from across a room and without even seeing what they look like I can tell that they are beautiful because of the energy that emits from their cores, from their souls. It's a kind of

"I've always admired women who are at home in their own skin."

radiance that has nothing to do with what people think of as marketable beauty. People who possess a true inner beauty, their eyes are a little brighter, their skin a little more dewy. They just vibrate at a different frequency.

What do you think about makeup, and how does it change the way you feel about yourself? I love makeup. Love, love, love. Makeup is a wonderful medium, and completely artistic for me. It's been a part of my life in a major way since I was very young, watching my sister sit in front of the mirror and paint three different shades of eye shadow—gold, purple, and green—on her eyes. [Laughs.] She and her friends would make themselves up and sing in front of the mirror like they were in a rock video. Makeup is creative play. I love painting my face. It's a medium I've become very inventive with as well because over the years wonderful artists like you have taught me how to utilize makeup in its proper way, and not just to throw it on like a mask. Makeup is about enhancing what you already have. I use it very minimally. I'll do just that one little spot on my skin, or put on a little mascara and curl my lashes, or just a little bit of lip gloss and a tiny bit of color on my cheeks, just enough to make them look flushed. Some mornings, if I wake up in a bad mood, I'll put some lipstick on and suddenly I'll feel I can smile.

So what cosmetics do you carry with you as your basic necessities? I always have a concealer that works with my skin tone so that I don't even have to worry whether it's blended or not.

Cameron has very expressive eyes, and I love to play them up. Secure in her skin, she has confidence that allows her to carry off any number of looks, from green and purple eye shadow to a bronzed, sun-kissed face, glowing with health. Cameron is the exuberant, all-American girl.

I carry mascara and a clear lip gloss, and also a favorite blush I'm using at the time—red, pink, or nude—whatever I'm into at the moment. And usually a lipstick, a lipstick that I can use for my eyes, my cheeks, and my lips, depending on what I want to put on. And I always drink a lot of water because I think water is very cosmetic. I usually carry a light cream or something to moisten my skin, but I think water is really the best cosmetic because if my skin looks dry or tired, I drink a bottle of water and everything plumps back up.

Are you careful with your diet? I'm a Virgo, so I'm a compulsive eater. I'll eat the same thing for breakfast every day for three months straight. I'll eat the same meal every day when I find something that makes my body function smoothly. I eat three meals a day and only when I need extra

How do you care for your skin? Somehow, I always manage to wash my face, no matter how tired I am. I have to wash the day off. And my regimen changes constantly. Products last for a while but then your skin gets conditioned to them and you have to change it up a little bit. But there's always that one thing you hold onto, the magic potion of the moment, and if you wait long enough and come back to it, it works again just like it did the first time. I have a drawer full of those magic potions. I always drink a lot of water and try to get enough sleep. You can't survive without either of those.

What vices do you allow yourself? Do you drink, smoke, eat junk food? I think everything is allowable in moderation. You shouldn't deprive yourself of anything that gives you pleas-

"You shouldn't deprive yourself of

anything that gives you pleasure

as long as you don't hurt anybody."

energy will I snack between meals. I eat with the goal of balancing and sustaining my energy throughout the day. I don't eat much sugar: It whacks me out and sends me up and then crashing back down. I've never been on a specific diet. I'm tempted by fried food occasionally, but I always remind myself that greasy indulgence will show up on my face a few days later, and I ask myself, Is it worth it?

Do you exercise? Yes, I do exercise. I would love to do it every day. It's so important for the body to stay active. We're not meant to sit around and be stagnant for eight hours a day; that's not what we're built for. We're meant to be active. There's a lot of action involved in my work, but even if I don't have anything to do I'm still constantly moving. I rarely sit still, except perhaps at night for a few hours. I never worked out until *Charlie's Angels,* but now I do about an hour of exercise to build my muscles and increase my strength. After *Charlie's Angels* I felt so strong, and I liked it. It's empowering. I have so much more energy now than I did when I was twenty-two.

ure as long as you don't hurt anybody. Even if you just set yourself back a little, if it brings you pleasure in the moment and you don't overdo it, if it's just in moderation, I think you should fully embrace it. I don't think we should deny ourselves pleasure unnecessarily. If I feel like drinking, I drink. If I feel like smoking, I smoke. I'll smoke a cigarette and then I won't have another cigarette again for months. I don't like sugar that much, but every once in a while I'll have it. I love French fries. I don't eat them every day, but on that day when I want them, I will pull into the drive-through and get me some, guilt-free. I don't care. I just do it.

It's said that every swan was once an ugly duckling. Is this true for you? I was one way-ugly duckling. Oh, yeah. I had knobby knees and a dorky overbite . . . just plain gawky. People would mutter, "That poor girl. That poor, poor girl." I had braces and a really bad fashion sense. [Laughs.] I would say the first signs of change came when I was about seventeen, right after I'd started modeling.

What do you consider your most unique quality, and your fatal flaw? My most unique quality? That's a tough one— I've got so many! [Laughs.] Just kidding! Possibly my sense of humor because it allows me to go with the flow and adapt to different situations. I think one of my biggest flaws is that I have so many. It's hard to decide which one I want to expose, but I'd probably say my biggest flaw is that sometimes I'm just so passionate about things that I don't think about what I'm saying before I say it. I leap first and look second, and that doesn't always make for a smooth landing.

Who are the women you most admire and why? I admire any woman who embraces the particular phase of her life she's in at that moment and seems comfortable with it. I have always admired women who are at home in their own skin. Whether it's a young girl living it up, or a woman in her thirties making that transition from girl to woman, or a woman in her forties reaching further into adulthood, or a woman in her fifties or sixties who is approaching her twilight years. I admire any woman who understands where she's at and embraces her age, because that's a really difficult thing to do. Iman is a perfect example because she has embraced every phase of her life and we've watched her become the woman that she is today, and she's done it so elegantly. You can tell that she's found peace within herself. She owns it.

List ten things you love in life. I love my family, my friends, my lover, sex, food, water, nature, honesty, food, love, and kindness. Did I say food twice?

What compliment would you be happiest to receive? "That's a fine ass, beeyotch." [Laughs.]

And what are your thoughts on cosmetic surgery? It's such a tricky thing. I would like to say that it's justifiable if you do it for the right reason, but what's the right reason? Barring some major deformity, I don't think that younger women should have plastic surgery just because they think it will make them feel better about themselves. It's fucked up that we live in a society that doesn't accept people for who they are but for what they look like. You don't need to put on a different face for people if you just like the one that you have. Of course, after three kids, I will definitely get a boob job. [Laughs.]

Do you think there is a double standard in the way we judge the beauty of a mature woman versus that of a mature man? Absolutely. We essentially tell women that they can never age, while we tell men that they only get better with age. That's not only unfair, it's untrue. Time moves forward and we all move with it. It's unfair to expect women to stay as youthful as they were in the prime of their beauty. However, there's a whole industry that supports that mentality and we all buy into it. Every woman does. Nobody wants to look older—that's simple vanity—but I love aging emotionally. As you get older you gain wisdom and you feel better in your body. It's less effort to make decisions or to be happy because you have a confidence based on experience. That is the paradox of our standards of beauty: Men are encouraged to celebrate their life experience and women are encouraged to get Botox.

And do you think that still applies in this post-Madonna era? In 1980 I was eight years old. The ten-year period in my life from ages eight to eighteen was formidable in my development. I saw women being very powerful and possessing their sexuality, but also being very masculine. Then when I became a woman I realized I could embody all of those elements. I think that after the first wave of feminist women, a second wave emerged—call them equalists. They broke through all the walls, and allowed us to enter into a level where we were equal with men but we didn't have to fight to get there. We were still the women our mothers raised us to be. That's a nice balance because we are able to be women but be in a position of power and we have the feminists of that time to thank for that. We owe it to them to use our power responsibly. If you're in a position where you're successful, it's awesome to be able to share that success with other people, because nobody gets there alone. I certainly didn't get to where I am all by myself, and I believe you have to give something back.

What lessons will you pass on to your children? Just to have a good time. Do what makes you happy. That's how my parents raised me. They never told me what to do with my life. They always asked, "What do you want to do?" That was empowering and that gave me confidence and courage. Essentially, they told me, "You can achieve anything you want; you're capable. Follow your heart." I'd like my children to know the same things.

What is your personal fountain of youth? Laughter. [Laughs.] Definitely laughter.

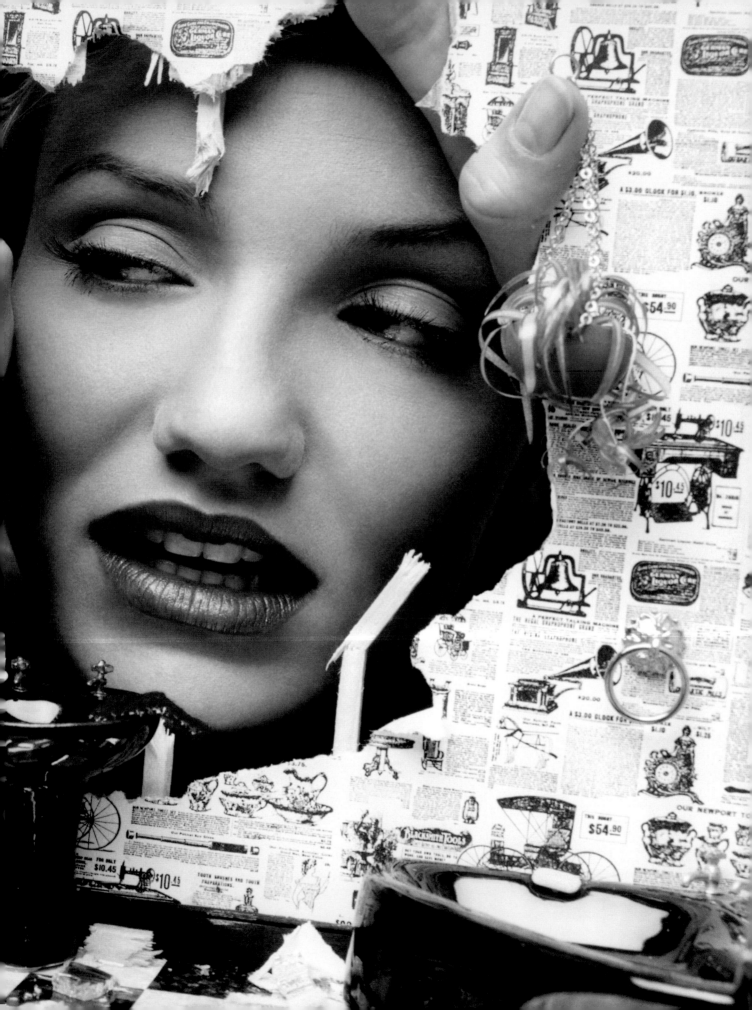

Brittany Murphy

Brittany, it is safe to say, possesses one of the most transformable faces in films. Her breakthrough role in *Clueless,* in which she is almost unrecognizable, was followed by a scene-stealing role in *Girl, Interrupted.* Her malleable features and acting skills have established her as one to watch in films such as *8 Mile, Uptown Girls,* and *Sin City.* Brittany is a risk-taker in the film roles she chooses, as well as in her approach to makeup, one of many reasons I love working with her.

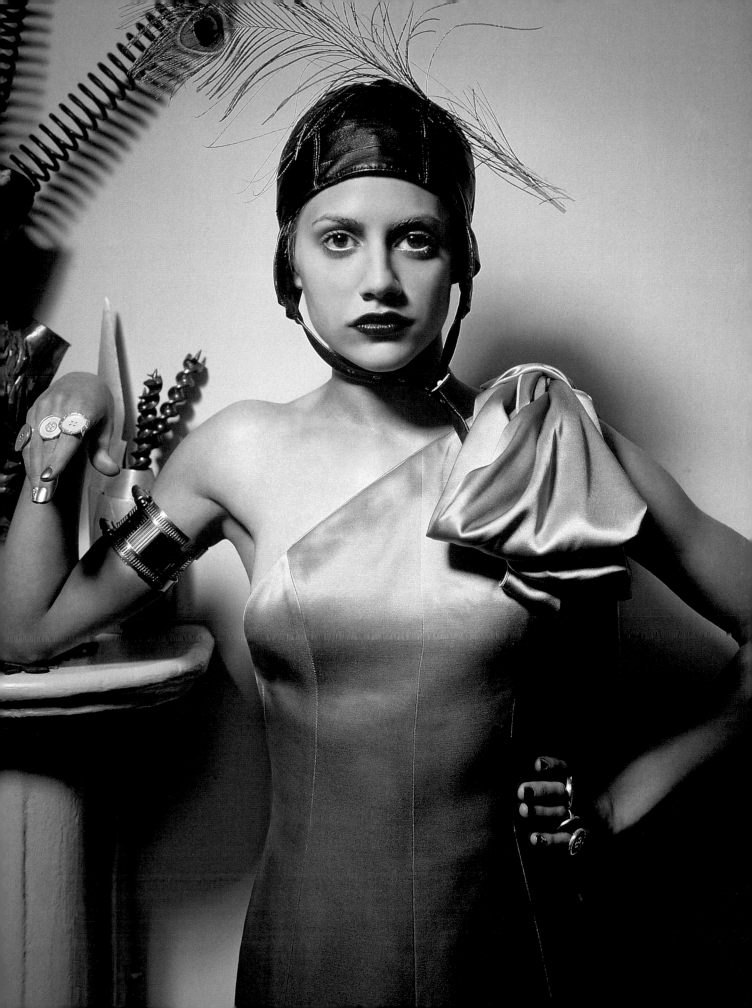

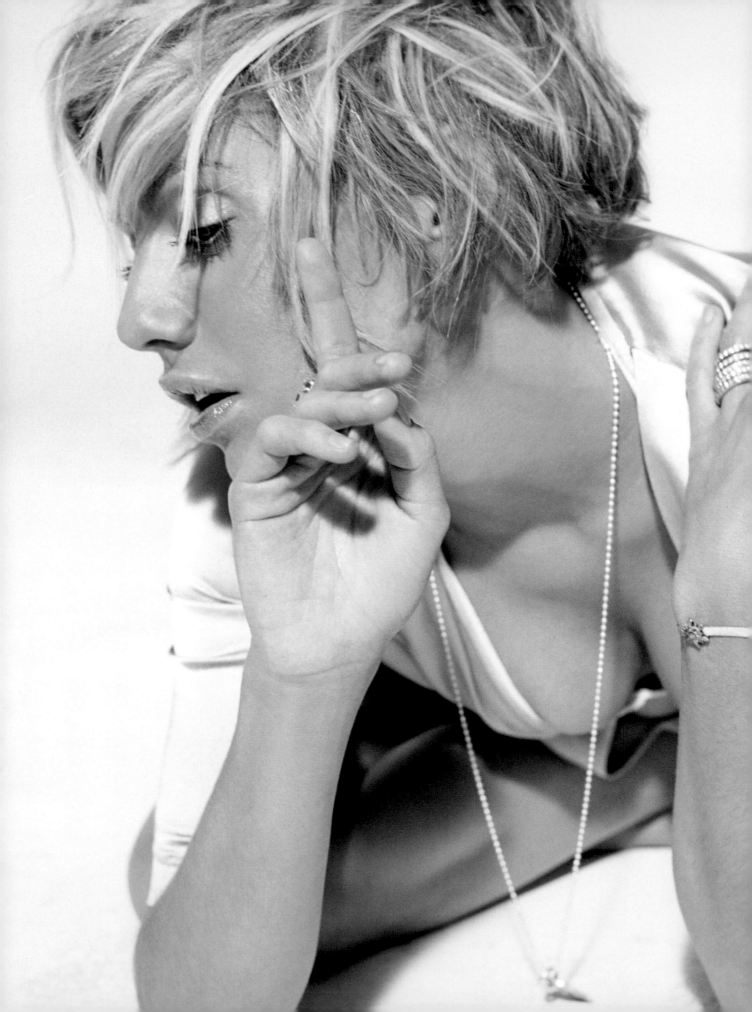

Do you remember the first time we worked together? I'll never forget it. I'd been an admirer of your work for years, but I never thought that I'd have the opportunity to work with you. I was just beside myself, dying to see how you would transform me. I remember looking into your eyes as you were putting on my mascara, and I felt like I knew you from lifetimes ago, your eyes told so many stories. We talked about music and all sorts of things—it was a very long day—and the next day you brought me a gift, a Joni Mitchell lithograph. It was one of the kindest things that anyone has ever done for me, and I'd only known you for a day.

You were a great subject because you gave me complete freedom, which was helpful because the whole idea of the shoot was to do you as a character. Yes! What was her name? Baroness Elsa Von something or other . . .

It was Baroness Elsa von Freytag-Loringhoven, a contemporary of Marcel Duchamp. Yes, that's it! The Queen of Dada!

It was great fun, but I was shocked that you requested me again on other occasions, because what we did that day was so outrageous and different. Most actresses aren't that adventurous, or that trusting. You bleached my eyebrows and put purple and green mascara on me, yet it was still very 1920s. You also put a little stamp on my face and used it as a beauty mark, I recall.

The baroness used to do that. She'd take stamps and use them as beauty marks. She wasn't the Queen of Dada for nothing, you know. It was unbelievable. You did all these outrageous things, yet it still looked beautiful. You made me look stunning and beautiful, but it was not me. I was someone else. You turned me into a work of art.

You were the perfect muse. Then we went on to other things like the shoot we did with the photographer Michel Comte for *Italian Vogue*, and that was a whole other thing. Like night and day.

You have a chameleon-like face that can make such broad transitions. We'd been working together for almost a year before I realized that you played the character I loved in *Girl, Interrupted*. I thought yours was the unsung performance in that film, and that you should have been nominated for an Oscar. When I realized it was you, I remember my head spun around, and I thought, Wait a minute. I am not usually so easily fooled. Thank you, you dear heart. All it

took was a little bit of padding and different hair. Daisy was a real person who passed away, and the strange thing about her was that she was an unsung hero in her own life, a very sad soul, but that's a whole other can of worms.

From the character you play in *Girl, Interrupted* to the one you play in *Sin City*, I love that willingness about you to transform. You must be a good observer to get inside characters so thoroughly. If you were someone else, a stranger, who was observing Brittany Murphy, what would you see? I'm stumped. I don't know how to respond to that question, but there's a quote that I love: "I am whatever you say I am." Sometimes I feel like a clown, and sometimes like a vixen, and other times someone really androgynous. It really does change with the wind, but that is the me that I have been living with my whole life.

What is your ethnic background? I am half Italian on my father's side, but my birth name is Murphy. Obviously Irish. So half Italian, a quarter Irish, and a quarter Slovakian. I was born in Atlanta, Georgia, and raised in Edison, New Jersey.

For the woman who is "clueless" about makeup, what do you recommend as the bare cosmetic essentials for survival? Moisturizer and lip balm.

Is that what's in your makeup bag right now? It's probably an embarrassment of riches. There's antibacterial hand refresher, which I also pat on my face occasionally. There's lots of lip glosses—I always carry lip gloss. And concealer. Because I am Italian and have somewhat deep-set eyes, sometimes it looks like I have dark circles even when I've slept for days. I have very olive skin naturally, and I haven't been in the sun in years, so I always have a tough time finding colors that are right for my skin tone. Japanese products suit my skin best because they have a lot of yellow. Then there's this little Deluxe Duo. It's incredible for cheeks and lips, and smaller than a lipstick. Deluxe and Prescriptives are the only two eyeliners I've found that stay on the insides of your eyes. I also like things that taste good, like Dr. Pepper's Bonnie Bell Lipsmackers. That's been in my purse, no matter what, for years!

What do you think about makeup and how much do you wear? Very little, except when I'm working, and then they generally schlep on a lot or, occasionally, none. There's a great couplet: "A little powder, a little paint/helps to make ya whatcha ain't." I really like that one.

Define beauty. Beauty is several things. The composer Erik Satie, on the beach. What's beautiful is very personal. My mom. A great man. Fantastic, hit-your-soul jazz, and dancing.

Every swan was once an ugly duckling. When did your transformation occur? I haven't had it yet. Stay tuned for further developments.

Do you consider yourself beautiful? That is just an awful question. No, it's not! It's a great question! It's just terrifying for me to answer. No, I don't. Sometimes I feel beautiful inside. Maybe that reflects on the outside, but I don't consider myself a beauty. I'm not unattractive, but true beauty to me is something much more, an interior quality. I think that you are beautiful. You're beautiful inside and out. I think that it's a tragedy when you see people who are physically beautiful but their insides are cold.

Are you careful with your diet? Not by your standards, I'm sure! My grandmother taught us to eat everything, just not to eat too much of any one thing. "Everything in moderation" was the rule. I have a soft spot for pork roll, which is something that's only sold in New Jersey. I don't know if you've ever had it: It's a bacon type of concoction, and I've eaten way too much of it in my short life. Imagine a sausage with two rolls on the side. You cut it open lengthwise, fry it, and then slice it into four little pieces. You order pork roll and eggs with cheese on a hard roll—it's quite a delicacy. It's very Jersey. You can't even get it on the other side of the tunnel. You won't find it in Manhattan. I love food so much. The only reason I deprive myself of the things I love is for work. I have never had a problem with weight, or even an imaginary weight problem. I've always felt comfortable in my skin. I didn't realize how rare that was until I was in my twenties and in Hollywood, where, unfortunately, a lot of people don't feel that secure. Because I grew up with so many people around, like four of us girls, cousins, all sharing one bathroom, it's just kind of second nature to me, feeling comfortable in my skin. So I love food. If it's around, I'll eat it. But always in moderation—just like my Grandma taught me.

Do you have a regular fitness routine? I danced for twelve years and then I quit cold turkey. I haven't done it since, and because of the irregular nature of acting, I haven't really developed an exercise routine, either. I lived to work for so many years that now, in my mid-twenties, I'm trying to shift gears and learning how to work to live. Sleep is so important. It's something that I've deprived myself of my

entire life. I've always had a thing about sleeping—I didn't want to miss anything—but once I'm asleep, I have no problem staying that way. It's the falling asleep that I have a problem with. I also have a terrible time waking up, but that's a whole other question.

There's something that a lot of people don't know about you: You are an incredible singer. You have an amazing voice, and you're a trained dancer as well. You have those qualities that we associate with movie stars of the old Hollywood studio system. I was formally trained in dance at the Verne Fowler's School of Dance and Theater in Colonia, New Jersey, but I never really wanted to be a dancer. I always wanted to sing and act and perform, but I didn't know which would come first. Acting ended up presenting

it was before, but it shows that genre films like musicals and westerns are evergreen as long as you have a fresh approach to them.

Who are the women you admire most, and why? My mother is my angel and my hero. She is the strongest woman I've ever met: feminine and adorable and intelligent and witty. I have two aunts: Tessie, the matriarch of the family, and Debba, who are like night and day, both fabulous, loving, and extraordinary in their own ways. My grandmother is a really stunning woman. Talk about strength! She's like the Rock of Gibraltar. You can't take that woman down. I come from a long line of strong, loving women who were particularly secure in their sense of self. I can't imagine growing up any other way. I'm grateful to be able to come home

"Sometimes I feel beautiful inside.

Maybe that reflects on the outside,

but I don't consider myself a beauty."

the first opportunity, so I did sitcoms on television for a few years, then I did my first audition for a film and that was *Clueless.* It was really a fortunate situation. I come from a working-class family with a great work ethic. I recently realized that I've done thirty films since 1995, and a year of Broadway in the middle of all that. I learned so much from the people I worked with, and I worked as much as I could. Then I realized that it was time to slow down. I suddenly understood why people in this business take holidays and breaks, because replenishing your soul is really important if your job requires that you give so much of it.

If the old studio system still existed, you'd be a triple threat with your training in singing, dancing, and acting. Do you think that system is something missing in Hollywood today? Yes, but I doubt that we'll ever see a return to that period, because the system had almost as many flaws as it did virtues. But I also believe that the success of films like *Moulin Rouge* opened the door for a revival and renewal of the movie musical genre. It will never be the same as

and have someone put me in my place in two seconds flat. Professionally, I have a great respect for the multitaskers and the divas. A few of my career idols are Judy Garland, Barbra Streisand, Diana Ross, and Madonna, because they've all shared so much of themselves with the world.

What is your most unique quality, and do you have a fatal flaw? Fatal flaw? That part I can answer a lot better than my most unique quality. I really don't know what my most unique quality is. I have a tough time being objective about myself. I'm definitely not generic, that's for sure. We're all snowflakes, baby. I'm quirky. Quite quirky. I just can't pick out any one particular quirk—I'm a package deal. I know that I don't judge people. I really don't—almost to a fault. I've never been a prejudiced person. One of my friends is trying to teach me to be catty. One of my best, and worst, qualities is that I am so trusting. I find people excessively and extraordinarily fascinating, but occasionally my judgment has been way off. My most fatal flaw is tardiness. I am the late Brittany Murphy. [Laughs.]

What is your view of cosmetic surgery? I just don't know. I've broken my nose twice, and I've never had surgery to fix it, but today you fixed it just using makeup. I can spare myself that surgery because now I know that if I put a little bit of powder in a place that no one else would think of it has the same effect. Still, I can't say that I will never go for the upgrade. Who knows what I'll be thinking twenty years down the road? I'm comfortable with my body as it is. I'd like to have children, and to be able to breast-feed as well, so I think I'll leave them well enough alone for now. As for my face, I'd be very nervous because it would be a nightmare for me not being able to move my face or to not have any expression. As an actor I'd feel like

"I come from a long line of strong,

loving women who were particularly secure

in their sense of self."

I was lying. It will take a lot to get me to the plastic surgeon. The thought of going under the knife frightens me. You are talking to a girl who'd rather wear contact lenses than have laser surgery, so don't go scheduling any face-lifts for me just yet.

List ten things that you love in life. Only ten? My mom. Music. These are in no particular order. Life itself. Free will. Family. Family of all kinds. That includes friends as well. Holidays. I love holidays, particularly Christmas. Stuffed artichokes, but only my mom's. Being an American. And being healthy. God! That's the one that makes all of this happen, I believe.

What is your personal fountain of youth? My insides. My insides tickle.

We've talked about you having children someday, and you've always said you wanted a big family. If you have a daughter, at what age will you allow her to wear makeup? I would hope that she wouldn't entertain the thought of wearing makeup, except for play and dress-up, until she was at least a teenager. I'd hope she would never feel the need to wear a mask or look like others. I'd like it to come from a place of uniqueness, and her makeup would be fresh and dewy with just a drop of lip gloss.

And finally, do you think youth is wasted on the young? Ask me in twenty years, and I'll give you a much better answer.

Brittany is constantly transforming, both as woman and actress. She's always game for taking on a new character, as is evidenced in the first photo, and I love being part of that creative process. The look we created for the photographs on the previous page and opposite we christened "The Bronzed, Blonde Goddess."

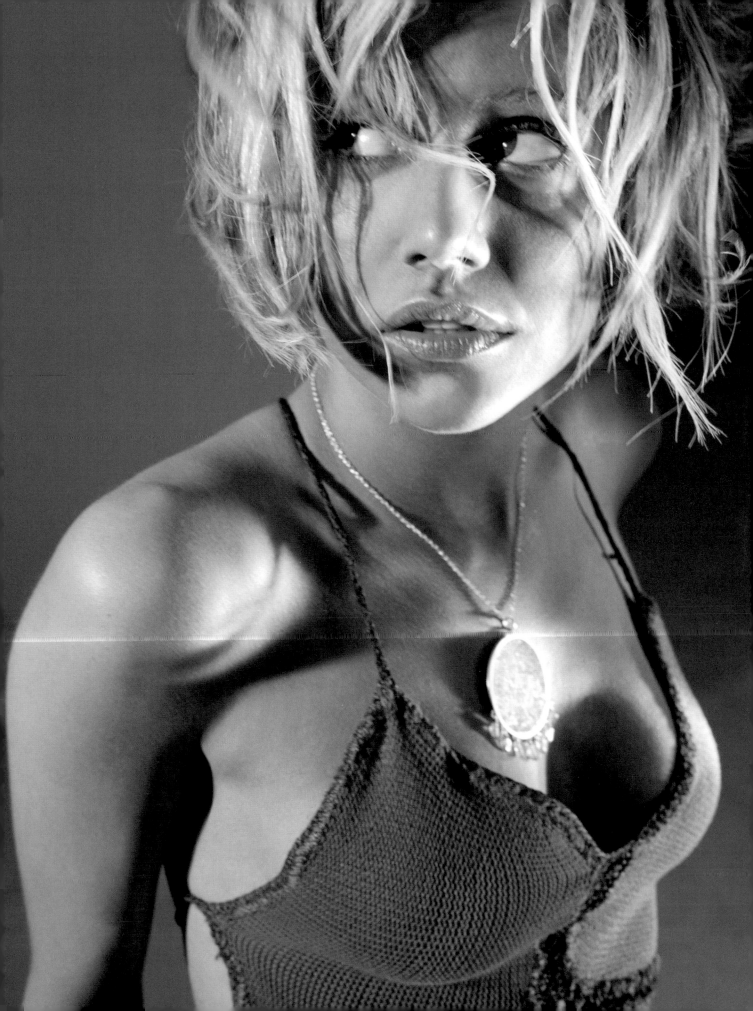

Rachel Weisz

Rachel became a model when she was fourteen years old and decided to pursue a life in acting while still in her teens. Born and raised in England, she made her Hollywood debut in Bernardo Bertolucci's *Stealing Beauty,* and is known today as an actress of incredible range. Her work in the films *About a Boy, Runaway Jury,* and *The Shape of Things* showcases a complex intelligence. She is a vixen and an intellect, and I love using makeup to blend the two.

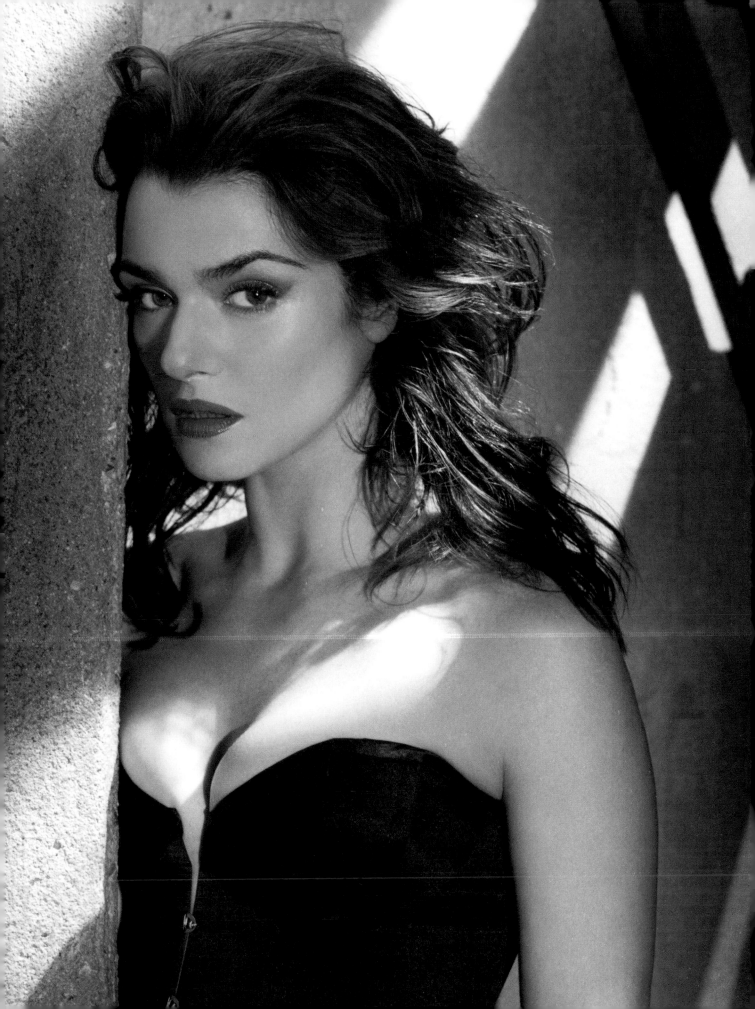

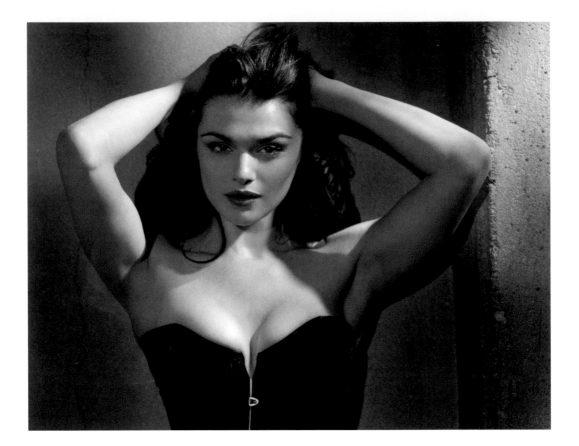

Will you define beauty for me? I know it's a cliché, but I think it has so much to do with what comes from the inside, from your attitude toward life and what you project because of it. If I'm miserable, I know that I don't look pretty. Genetics can arrange your features in a pleasing way, but if you're not happy, it shows in your face. Beauty radiates from the inside outward.

Who are the women you most admire, and why? As an actress, Debra Winger immediately comes to mind because she's ballsy, vulnerable, emotional, and funny. Unfortunately, she's taken a hiatus from acting for the last few years. Samantha Morton, I think, is the great actress of my generation. Her talent is absolutely untouchable, a good example of someone who projects something from inside of her that's so radiant. I would name the writer Virginia Woolf, for her incredible mind and imagination, and also for the fact that she probably invented the idea of stream of consciousness in her novels. She's been a big influence on me, in terms of access to characters, because she gets right inside people's heads. And, finally, my mother, Edith. She's a pretty inspirational woman, especially for someone who grew up in the '50s, because she was a feminist before feminism

existed. She treated my dreams and work as things very sacred, and really stood by me. You need a mom like mine to get on in this tricky world.

How do you feel about makeup? Do you wear it a little, or a lot? If I am wearing makeup, it has usually been applied by someone else. I'm pretty ambivalent about wearing makeup for my own comfort, but it is a necessary part of the job, and I think I've learned to appreciate good makeup when it's on my face. I remember the first time we worked together—your makeup was such a revelation to me. I knew that you were very experienced and had a myriad of styles, but what you did still surprised me. I couldn't see where the makeup began and where it ended. I love makeup when it looks like it's been rubbed on with fingers and has seeped into the skin somehow. I thought it was just beautiful because I couldn't really see the makeup, but I knew it was there. It became part of my psyche.

Thank you, that's very complimentary. I think it's wonderful when the illusion makeup creates is so subtle that the person wearing it doesn't feel made up but instead feels enhanced by what makeup reveals. You do that beautifully.

You seem to know a lot about makeup. Does that come from your modeling years? Maybe, or just having really bad makeup put on me a few times too many. Makeup is like acting in a sense. Both are incredibly hard to do without showing the machinery behind the illusion. In a really brilliant performance, you don't see the acting, and with good makeup I think it's the same idea. The way you did my makeup was so subtle that it became invisible, like a seamless illusion. I've got very strong features, and it was very liberating to be in front of the camera with nothing but a makeup-enhanced, clean-scrubbed face. I guess I haven't had the right role yet where I really need to use makeup to get inside the character.

you follow any specific skin care regimen? If I get enough sleep, I'm fine. If I'm stressed and tired, my skin falls apart. It's a pretty simple formula—listen to your body.

What are some of your basic cosmetic essentials? I use Laura Mercier Secret Camouflage. I've used it for years. Sometimes I use a tinted moisturizer, SP factor 40 or so. I love cream blush that makes you look like you have apple cheeks, like you've been out walking in the cold. A little mascara. I haven't really been using lipstick. And I don't use much powder. I like blotting paper. It blots your skin instead of coating it so it doesn't get all clogged up.

"I love makeup when it looks like it's been rubbed on with fingers and has seeped into the skin somehow."

Do you have an exercise regimen? I alternate between yoga, which is low impact, and doing really hard running. I like a balance between the yin and yang.

Are you particular about your diet, or do you eat everything in moderation? I think moderation is the best thing. If you forbid yourself certain things, it's usually counterproductive, because eventually you'll rebel. I've never been a stick-thin person anyway. I'm quite shapely, as you know.

It's a lovely shape, at that. It's because I have quite a large appetite.

I love that in a woman; it's so unexpected. Mine can be a bit much sometimes. I can out-eat most men. It's alarming.

Men find that attractive. It's other women who find it alarming. And what do you think about the skin you're in? Do

List ten things you love in life. My boyfriend, apples, fresh earth, hugs, chocolate, documentaries, street theater, horses, great views. I think that's nine—let's say hope for the finale.

What is your personal fountain of youth? What keeps you young in spirit? It's odd that you'd ask that, because the film I just finished is called *The Fountain*. It's about the search for the fountain of youth. The first thing that pops into my head is my girlfriend Susan; having an old friend to talk to really keeps you grounded and young at heart. But in a larger sense, I think youthfulness comes from always feeling a sense of wonder at life's infinite variety. I think wonder is the greatest feeling in the world.

Wonder is a great fountain of youth. It's like Joni Mitchell said, "Happiness is the best face-lift." I think cynicism, which is the opposite of wonder, is fatal to the spirit. It's vital to keep wonderment alive.

In these photos, Rachel is like a woman in a noir film. She could be dangerous, or she could be in danger—a siren with killer curves. With sculpted eye and seducer's lips, she is a vixen, the kind of woman that makes men forget their mothers.

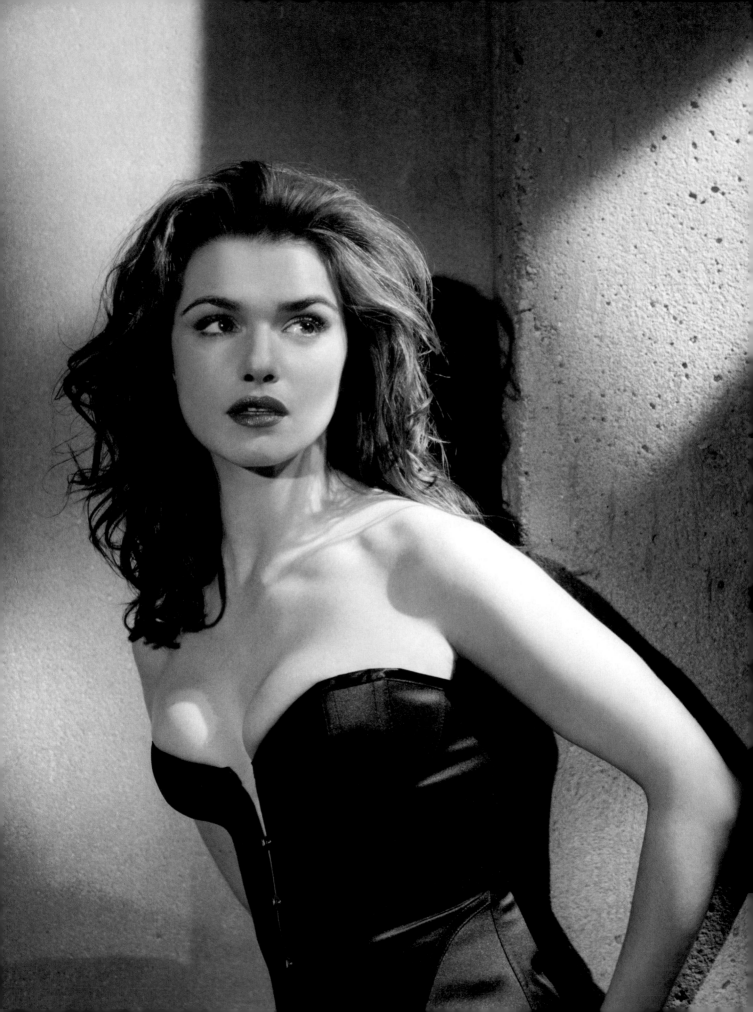

Lindsay Lohan

What I love about Lindsay is that she is still having fun. We met on a *Vanity Fair* shoot, and I was immediately struck by how beautiful she was without makeup. Her work in *The Parent Trap, Mean Girls,* and *Confessions of a Teenage Drama Queen* have made her a star, but she is as down-to-earth as she was on the day we met. Lindsay's auburn hair and freckles are part of her charm, making her the youngest woman and only redhead in this book.

How would you define beauty? Beauty is grace and confidence.

What do you consider your most unique quality, and what do you consider your fatal flaw, two things that could help to define you? Being honest, my freckles, and hair are my most unique qualities. Stubbornness is my fatal flaw.

List ten things you love in life. Family, love, trust, loyalty, friends, peace, honor, respect, faith, imagination.

And what do you think about makeup? Makeup is wonderful. It's fun to play with it. I wear it sometimes, but not usually in the daytime, unless I'm working.

"I learned to accept and appreciate what nature gave me. That's when the transformation began."

So how does makeup change the way you feel about yourself? It adds confidence and makes me feel sexy.

What cosmetic products do you carry with you as your basic necessities? I carry eyeliner, a good bronzer, and some Chapstick.

What do you think of your skin, and how do you care for it? My skin is holding up fine so far. My regimen is simple: cleanse and moisturize.

Are you careful with your diet? No, I eat what I want. Life is too short.

Do you exercise regularly? I dance and I shop. Sometimes yoga can be fun.

What are your views of cosmetic surgery? Whatever a person wants to do, that should be his or her own choice.

Who are the women you most admire, and why? Madonna, because for all of her success she has been able to retain her individuality; Ann-Margaret, whom I find so inspirational; and Marilyn Monroe—no explanation needed.

Do you remember having an awkward stage growing up? I think as I grew into my own skin and became comfortable in my mind and body, I learned to accept and appreciate what nature gave me. That's when the transformation began.

From the moment I met Lindsay, she reminded me of a young Ann-Margaret—a kitten with a whip. The look I like best for Lindsay is fresh-faced, freckled, and sexy. Bronzed, glowing skin looks amazing with her Titian-red hair.

Dolly Parton

If Dolly didn't exist, someone would have had to invent her. From her Nashville roots to her blond roots, Dolly is pure country. One of the hardest-working women in show business, she has a heart as big as her bosom, and a self-effacing sense of humor that is never at someone else's expense. From Dollywood to Hollywood, Dolly projects a warmth and familiarity that is as inviting as a country kitchen and uniquely her own.

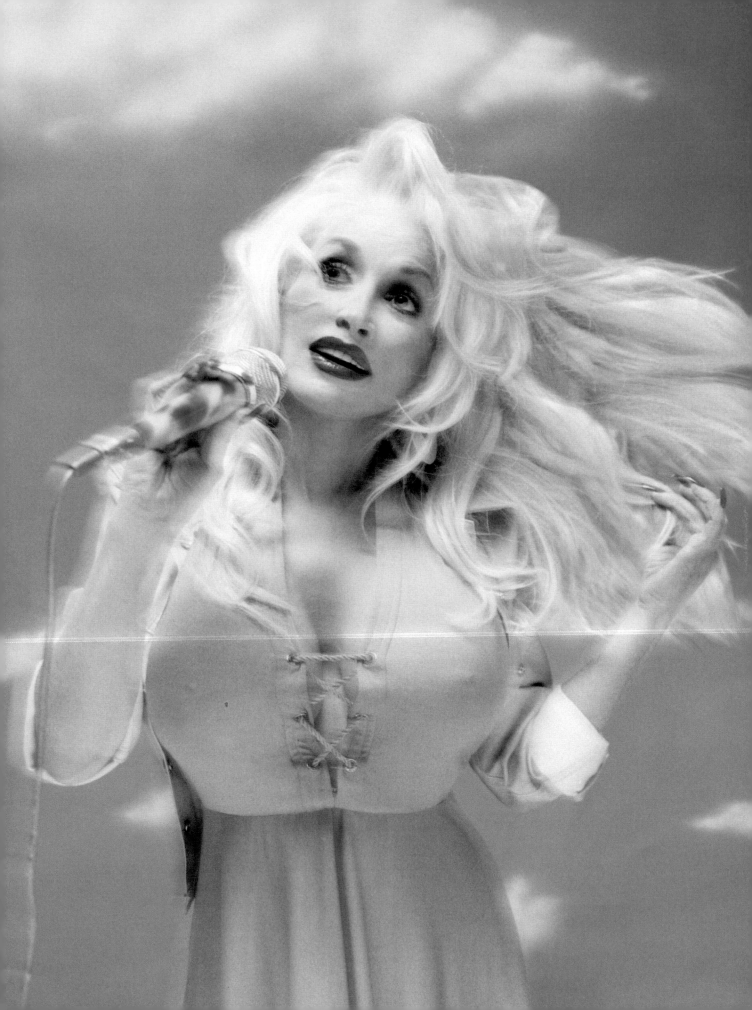

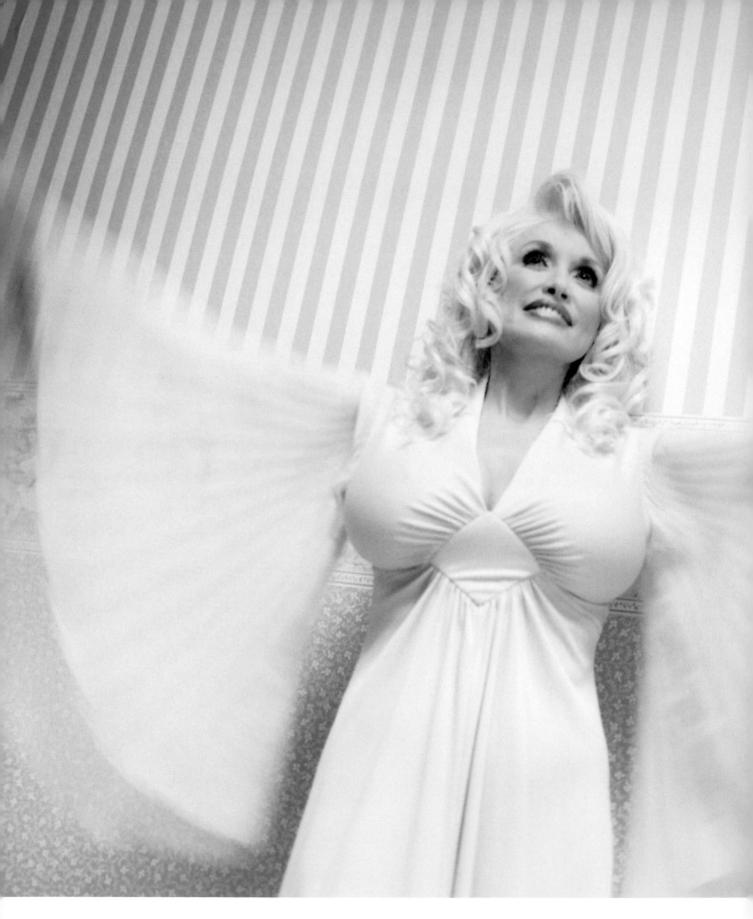

Dolly loves her all-American Southern looks and playing them up with lots of makeup. Understatement is simply not a part of her image, unless you speak of the exquisite delicacy of her songwriting. When doing her makeup,

Hey Paul,

Sorry I didn't have time to sit with you, so I just wrote up my own overview of beauty, my thoughts and feelings on it. I think it's the better way to do it as far as I'm concerned; and anyway, I need to save all that stuff for my own book. (Ha!)
Love,
DOLLY

I was brought up very poor in the backwoods of Tennessee, but even little country girls dream of being beautiful. I used to improvise using polk berry stains on my fingernails and toenails, lips, and cheeks. It worked great. Sometimes I would use Merthiolate and Mercurochrome for longer-lasting stains on the lips (harder for your Daddy to rub off. Ha!). I used to take burnt kitchen matches, after they'd been struck, moisten them with my tongue, and use them on my eyebrows and to make beauty marks. They worked great, too. It just goes to show that a country girl with a desire to look better will always find a way to do it. My friend Minnie Pearl used to say, "Any old barn looks better with a coat of red paint." And I agree.

The only two things I ever stole in my life were a box of crayons and a tube of red lipstick. I was only a small child then, and got caught both times. But I wanted radiance and color even then. I am truly a girlie-girl. I've always said, "It's a good thing I was born a girl or I would definitely have become a drag queen."

I don't always clean my face at night like they tell you to. It all depends on what the night was like. I don't always do my dishes at night, either. I think it's important to have fun and enjoy the moment. But I always clean and moisturize my face in the mornings before I start a fresh new face of makeup.

One of my favorite sayings is "Beauty is only skin deep, but ugly goes clear to the bone." I do believe that beauty radiates from within. Pretty can be only superficial, but true beauty is when you have enough of both. How great is that —beauty from the inside out.

People often ask me why I always seem to glow and I say, "If I'm shining, I hope it's with God's light." I think a joyful heart and a good attitude certainly add to any face of beautiful makeup, carefully applied. And the essence of kindness and goodness beats any old perfume, anytime.

I don't mean to wax spiritual or philosophical, but I truly believe that true beauty combines it all.

I highlight each individual feature and focus on making sure it works as a cohesive whole. These photographs capture the Dolly we all know—fun, colorful, and vivacious—a true American icon.

Naomi Watts

Naomi is a "looker"—and an actress to look out for. Relatively new to American films, she captured the attention of critics with her performance in David Lynch's enigmatic *Mulholland Drive,* wowed audiences in *21 Grams,* then scared them silly as the heroine of *The Ring.* Stepping next into pumps previously worn by Fay Wray and Jessica Lange in Peter Jackson's updated *King Kong,* Naomi firmly seals her membership as part of Hollywood's elite.

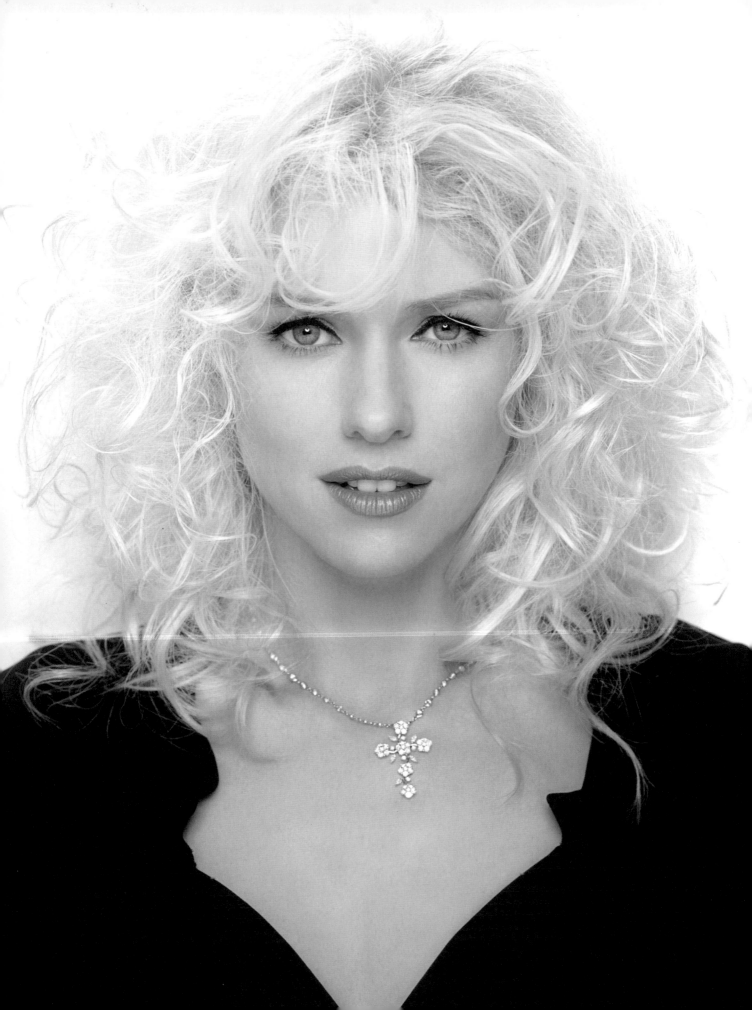

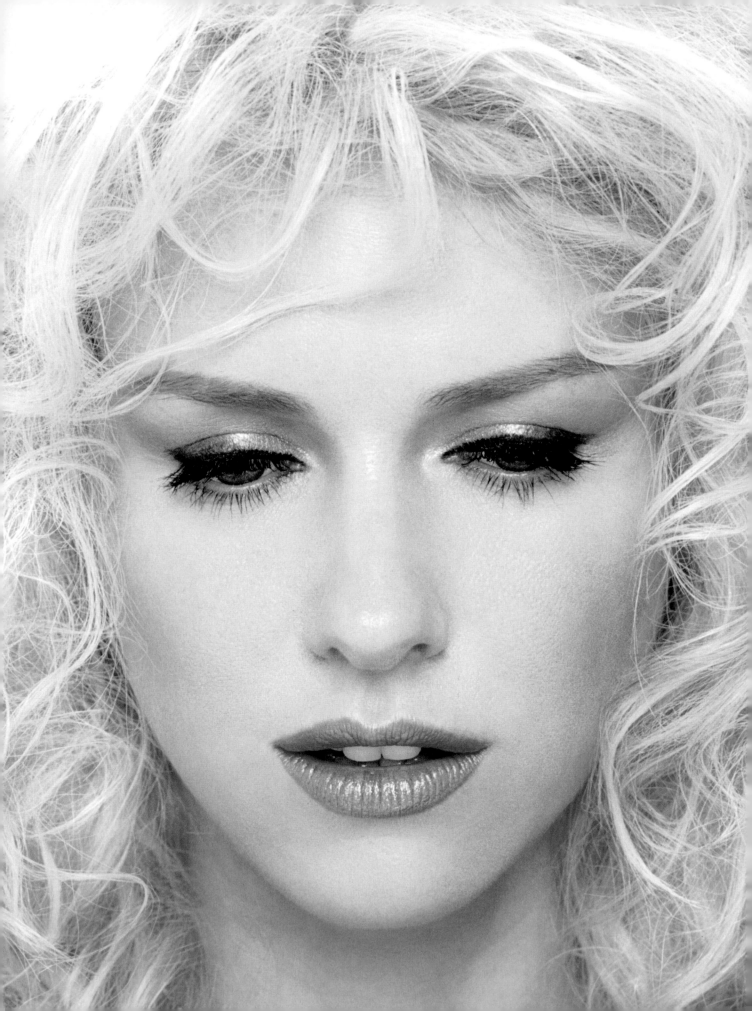

What is your definition of beauty? That's tricky. There are many ways to define beauty. It depends on whether you're talking about aesthetic beauty or a deeper, more internal kind. To me, being beautiful is about having flaws and going beyond the strict aesthetic we were always taught to emulate. When I look at a face, it's the imperfections and the asymmetry that I find beautiful. Perfection is distancing, cold, and, frankly, boring. Looking beautiful on the outside has to do with feeling beautiful on the inside: there is nothing more beautiful than a woman comfortable in her skin, and at peace with herself.

Who has been the biggest influence in your life, and why? My mum, no contest. She's always had extraordinary taste

about the business in Los Angeles then, and how does it compare to today? The main difference is that nowadays I spend more time in the trailer and less time in my car. [Laughs.]

Is there an actress from the old Hollywood studio system whose work inspired you to take up acting? There are many I've been inspired by: Kate Hepburn, Grace Kelly, Audrey Hepburn, Elizabeth Taylor, Ava Gardner, Greta Garbo, Bette Davis, and Ingrid Bergman.

In your current role as Ann Darrow, the beauty who tames the beast in *King Kong*, you are filling shoes already worn by Jessica Lange and Fay Wray. Did you have any hesitation about taking on such a well-known, iconic role? Of course,

> "It's the imperfections and the asymmetry
>
> that I find beautiful. Perfection is distancing."

in all things, be it fashion or art or furniture. From the age I could walk and talk, I was dragged around to flea markets and vintage shops. She was my introduction to style and presentation. As a person, I admire her for her bold, steadfast opinions that she is not afraid to share. She has a conviction that inspires me.

What do you think about makeup? And do you use it much in your private life? Makeup and hair are instrumental in creating a character from the ground up. They are great tools that get you closer to the truth of a character. The visual is always key; it goes hand in hand with the more internal work I do in developing the character's mental and emotional parts. Personally, I hardly ever wear makeup, as I'm not very skilled at applying it.

You recently reminded me of the first time we met. I believe it was on an AT&T commercial directed by David Fincher. Since then, David has become an established movie director and you are a bona fide movie star. What do you remember

there is a huge amount of fear and intimidation at the prospect of playing a role formerly played by Fay Wray and Jessica Lange—two screen legends I greatly admire—but it's often fear and its challenges that drive my creative choices. The ten-year age difference between me and Lange and Wray when they played Ann Darrow made me wonder if I was the right actress for the part, but Peter Jackson has created a more modern Ann, a reflection of today's modern woman who is less victimized and more autonomous than her predecessors.

How do you find peace of mind? Being near water.

Can you list ten things you love in life? My dogs, my house, sharp cheeses, good red wine, flat shoes, time with friends and family, all day in bed, a rainy day in a gallery, laughter, and a soy latte from anywhere but Starbucks.

Lastly, what is your personal fountain of youth? Good humor and sunscreen.

Naomi is relatively young as an actress, but she has a beauty that is timeless. Her eyes are incredibly expressive, almost intuitive, so when I make her up for the red carpet I keep them barely nude. But in still photos, I love the way she looks in silver-grey eye shadow and lots of black eyeliner.

Joni Mitchell

Joni is a woman on my mind. I've been a fan of her music and a lover of her looks for as long as I can remember. We met at the Matthew Rolston studio in Hollywood, and we bonded over the buffet before we'd even been formally introduced. Joni arrived fully made-up—she was accustomed to doing her own face—but when it was explained that I was there to do her makeup, she washed her face and put herself in my hands, an act of faith that sealed our friendship. We spoke in the Brentwood home where Joni has lived for more than thirty years, a warm, eclectic blend of influences reflecting the individualism that is her defining quality.

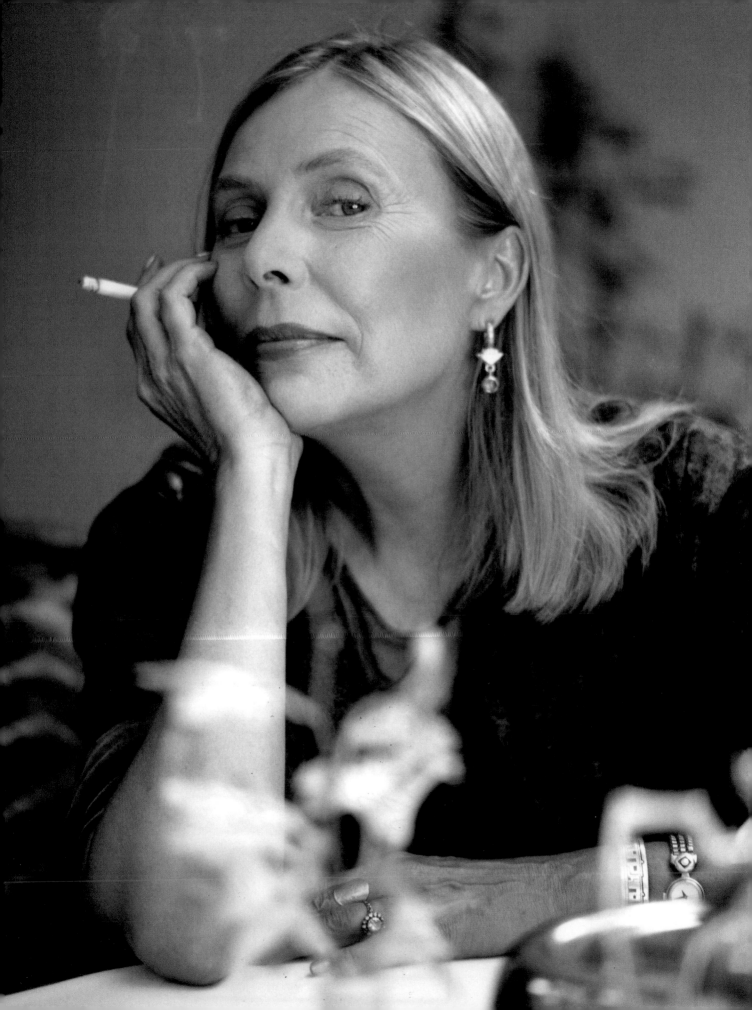

Can you remember and talk about some of your biggest makeup influences? I started going to public dances when I was about twelve—it was right about the time that rock and roll first came alive—and I met a street kid who danced his way into my neighborhood. The girls around him were really tarted up, they may have been only fourteen or fifteen, but the makeup they used was quite garish. Blue and green eyeshadow were the norm; they had a conspicuous makeup line at the neck. Sometimes I would paint my face that way, but it never really suited me. When liquid eyeliner became the rage in the 1960s, some older girls decided to paint my eyes up like Brigitte Bardot. You'd have thought it would work, because I had good bone structure and all, but somehow it didn't. It was like a lie on my face. I'm kind of a guileless female, and that kind of makeup is synonymous with guile, so on me it was a kind of contradiction. I was in London during the extreme Biba makeup period. That was too much for my face also, but I did come back with false eyelashes. It was David Crosby, during the fresh-scrubbed California girl period of the 1960s, who convinced me to scrub my British Mod face and go back to the no-makeup look. It was very liberating. I stuck with that look long after the hippie movement was over. I became accustomed to the liberty of not wearing any makeup.

What do you think about makeup? How does it change the way you feel? Watching the Motion Picture Academy pay tribute to Sophia Loren at the 2004 Oscar ceremony, I was struck by two things. First of all, they took this fine actress and instead of showing her best dramatic moments, they showed her kissing every leading man in Hollywood. But more important, in the close-ups, what you saw was the history of makeup. You watched as they tried to diminish that wide, sensual mouth. You could see the lines where it was painted to make it look smaller because large mouths like that were not in vogue at that time. Instead of enhancing her beauty, the naturalness and the uniqueness of it, they tried to reduce it to some vague ideal. In other words, they painted the face of the time onto her in spite of the individuality of her features. You know, I never liked makeup much. It didn't seem to suit my face. It made my eyes look hard. My lips had high color anyway, and I just preferred the convenience of not wearing any. I didn't have time when I was on the road to be hours in the bathroom before we went to the airport, so no makeup was more practical. And when I did find myself in situations where my face was to be painted by a stranger, usually they didn't assess my face as an individual but headed for the paint pots and went straight into painting the contemporary look on me, whether or not it suited me. So the fads in makeup kind of annoyed me. Before I started working with you, I would usually say, "No makeup, I'll do my own." Since working with you, however, I was struck by the fact that you were immediately able to find the line on my upper eyelid that enhanced my eye. I would have said there isn't such a line. As a painter I know that if you do anything too extreme on the upper lid, it makes me look like the woman in the comic strip "Terry and the Pirates," or a Mata Hari type, you know, an evil spy woman. But you went straight to the areas and to the features that could stand enhancing or a slight exaggeration, and you were never heavy-handed. You are a beautiful face painter. Also, you incorporated products that I had discovered for myself, which was nice. At one time, not so long ago, only whores painted their faces. Ladies of the aristocracy did their own hair and stayed out of the sun. A suntan was not chic, but rather the hallmark of the day laborer. Ladies pinched their cheeks for color before a social encounter, especially with a gentleman. I think the whole concept of makeup is to excite or to simulate excitement. If you're sexually aroused, theoretically your cheeks go flush and your lips plump up and become redder. So the whole concept behind lipstick and rouge seems to be to mimic the flush of sexual excitement, but being perpetually in a state of seduction always struck me as peculiar. Do you have to seduce everybody? Shouldn't that be more of a private dance?

But do you use many cosmetics? Do you carry any makeup basics with you? Nowadays, I use a little blush, a little concealer, a dash of mascara, a little color on the lips, and a light coating of powder if I'm wearing foundation, to make it less shiny. And that's it. I don't like to think about what I look like. I'm an artist; I'd rather concentrate on what I feel.

How do you take care of yourself? Are you careful with your diet? I take guidance from my mother, who has remained beautiful and virile all the way into her 90s. She doesn't take any herbs or vitamins, but believes in eating seven small portions of fruit and seven small portions of vegetables a day. Living in a northern climate, she's not adverse to meat, either. She also drinks a lot of milk, so she has very strong bones. I probably don't drink enough water or milk. I wouldn't say that my eating habits are spectacular. Sometimes for breakfast I just dive right into bacon and eggs and pancakes.

And do you have an exercise regimen? I have a tai chi routine that I try to do. I don't exercise enough to be buff, just

enough to keep my joints oiled and my metabolism up. I probably could do more, but I'm addicted to painting, so I'm sitting on my duff for fourteen hours a day. I'm so taken away by the creative process that sometimes I almost forget I have a body. I can be really negligent about self-maintenance.

For as long as I've known you, you've been a smoker. It seems like such a natural thing for you. When did you start? I've smoked since I was nine years old. It was a grounding herb for me as a child, a secret pleasure. I'd ride my bike out into the bush, sit there, light up, and watch the birds fly in and out. I was in heaven. It's been a companion and a solace to me. My mother is always on me about it, but I love it. I am a confirmed smoker.

How do you take care of your skin? Mostly I use Oil of Olay products: their body lotion, night cream and Olay Complete, which has a mild sunscreen in it for day. I use their Age Defying cleanser for my face. Nothing will alter the fact that I've been here sixty years, but they keep a little light exfoli-

loose at the *Vanity Fair* Oscar party or a formal event and I'm full of mischief. I'm like a kid in church; I want to giggle. I'm mischievous after all. That's the way we partied in Saskatchewan. Slightly rowdy.

How do you define beauty? You can look at beauty in different ways by putting on different hats. There are women my age who have obviously had face-lifts. Seeing them, I've thought, Maybe it's time. I've gone to the mirror and lifted my jawline up as it would be after a face-lift, then let it drop back down. But when I lift it up, it doesn't match the rest of it. In a way, it looks better with the jowls and everything. There is a look that you get in your sixties, and if you're a healthy, happy version of that look, that's beautiful. If you try to contrive the jawline of a thirty- or forty-year-old, but your hands are all liver-spotted and crinkly, the moment you put your hand up to your face, as you would in the course of an evening, your wrinkled hand next to that tight little jawline looks ridiculous. So now what, do you start sewing your hands? To me, the whole idea of it is really one of the

"The whole concept behind lipstick seems to be to mimic the flush of sexual excitement."

ation going. It's a pretty simple regimen. For me, the best products are not necessarily the most expensive ones.

How do you feel about aging? How has it affected you personally? Nowadays, I'm content to be loved by my animals and my friends. I enjoy being middle-aged. I have grandchildren. I'm happy. People say I look good, and I think the reason is because I am happy. You have a certain radiance if your spirit is healthy.

One of my favorite lines that you've written is "Happiness is the best face-lift." It's a truism, like "Who you gonna get to do your dirty work when all the slaves are free?"

Can you describe yourself as though you were a disinterested observer? Describe myself as a stranger might see me? I don't think I can. What woman, under what circumstance? I mean, give me a couple of drinks and cut me

modern tragedies, that so much emphasis is put on something so superficial, and that people can be so unhappy that they do that to themselves. I think it is symptomatic of a greater problem, which is not being addressed: that people are entering into middle age in some kind of spiritual void, and by spiritual I don't mean religious. Their spirits are depressed. Only a depressed spirit would go to one of those butchers and let him cut her face all up and stitch it into some macabre resemblance of youth. Plastic surgery nullifies the character that shows the patterns of people's lives—how much they've laughed, how much they've grieved. This surgically altered look has become so commonplace that no one seems to see it as grotesque. There's no wisdom in this culture, no love of character.

Why do you think cosmetic surgery can tend toward such extremes? It's the stigma of growing old. Why is youth so precious? Youth is a period of life insane with hormones. Why do we want to extend this insanity or incorporate it into our lives?

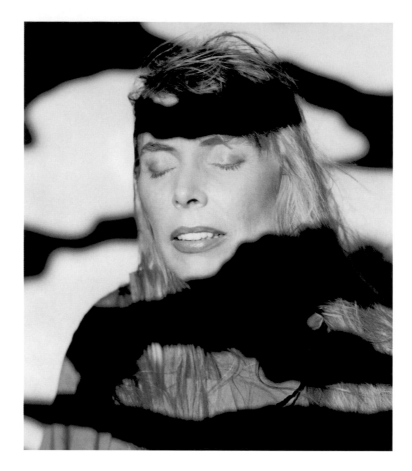

I mean sex is nice, it's beautiful under the right conditions with the right person, but why do we want to be objects of sexual desire every moment of our lives, as if sex is all there is to life? Nobody's that sexy.

Who are the women you most admire, and why? I admired Katharine Hepburn for her individuality and self-confidence, which gave her the ability to age gracefully. I admired Esther Williams as a child. I joined water ballet because I wanted to be graceful in the pool like her. I met her when I was in my thirties. It was a gathering with all of old Hollywood in attendance, and in the middle of the evening, I heard her voice rise up out of the crowd, saying, "Bullshit. He likes me fat. And he likes me thin. And he likes me at home." I found myself pulled from my seat as if by invisible strings. I stood up in the restaurant and gave her a solitary standing ovation. I was still young, but I thought, Okay, I don't have to go in this macabre direction. She didn't. I guess it comes down to the man you choose. If he likes who you are, then you'll have to do some inside work, not some outside work. If you're trying to hold your man with face-lifts and all that, what are you really trying to hold onto? There's something wrong with

the fact that we've been told that wrinkles are an imperfection. They're not an imperfection, they're an inevitability, a result of living. In Asian culture, the way lines pleat on the face tells a lot about the person's character. If you were to see a baby born in its sixth month, all its lines are there. I saw a baby born three months prematurely, and his face was full of lines, and the lines were very like his grandmother's. By the time he was three months old—which means when he should have been born normally—there wasn't a line in his face. So, the lines in our face seem to be predestined. We think we earn them, but it's as if the body knows what grief is in store for it. So their emergence is not the tragedy that we think it is. We're in cultural error, thinking it's some kind of calamity when the wrinkles appear. Speaking from a middle-aged perspective, as a grandmother and an older woman, I think that if you have a place to put your tenderness, and a heart willing to receive it, then you're beautiful.

Joan, can you tell me ten things you love in life? I love sitting on the porch of my house in British Columbia with my caretaker, Hans. His dream was to live where the moun-

tains meet the ocean. My dream was less defined, but we love that place, and because of me, he can live there, and because of him, I can live there. I love to paint. It shuts off all dialogue in my head for prolonged periods of time, which I need for mental health, because I've too active a mind. It's the best form of meditation I know. I can't sit idly and meditate at the same time. Painting makes me happy, and allows me to feel relaxed and productive. I love dancing. I love my friends. You and I have been friends for a long time, and old friends are gold. I've made some new

thirty-odd years later, and although there was a period of adjustment, the relationship is now grounded and healthy, which gives me great joy. My two grandchildren, Marlon and Daisy, give me great joy. I feel my relationships are in good order.

What, to you, would be the ultimate compliment? My favorite compliment that I ever received came from a blind, black piano player named Henry. He said, "Joni, you make raceless, genderless music." That's my favorite compliment.

"There's something wrong with the fact that we've been told that wrinkles are an imperfection. They're not an imperfection, they're an inevitability, a result of living."

friends recently, too. I've found a few places where I like to eat, and I go alone and invite conversation. I feel a sense of community when people come up to me with their children. I've made a neighborhood out of an impersonal town, and that's something that I need to be happy: a sense of extended community. Yoga and exercise make me happy. I love to swim. I love color, whether in music, painting, or in people. My home is very colorful. I love my animals. They make me feel like a preteen. I sleep with two cats and a dog and when I wake up and see all those cheerful faces, it's a joy. In my lifetime, I've lost things and then regained them, which always makes you appreciate them better. I had polio at nine and lost my ability to walk or stand. There was no guarantee that I would ever do either one again. So, standing and walking again, I've celebrated my legs in dance. I lost my daughter when I was twenty-one, and got her back when I was in my fifties,

What is your fountain of youth? What keeps you young? Joy. I'm blessed with some really fun-loving friends. We play pool. We have outings every once in a while. I can go anywhere with these guys and know that we will be having a good giggle all night long. You're one. I have friends with a capacity for fun, and a great capacity for joy. I've taken them to Saskatchewan, where I come from. We go walking in the country and it's full of revelations for them. My best friends are like happy children. That's not to say that we don't have adult down days, but we buoy each other up. I remember seeing a documentary on a group of middle-aged Israelis who had grown up communally from early childhood, and, huddled together for a group portrait, they all looked like they were about seven years old. The benefits of prolonged friendship between a group of people are the comfortability, the inside jokes, and the hard teasing that comes from a strong bottom line. All of that is a joy to me.

These photos capture the Joni I know and love—wise and reflective on the one hand, joyous and playful on the other. For a woman of her accomplishments and intellect, and her strikingly unique looks, natural makeup—with features well defined—is best.

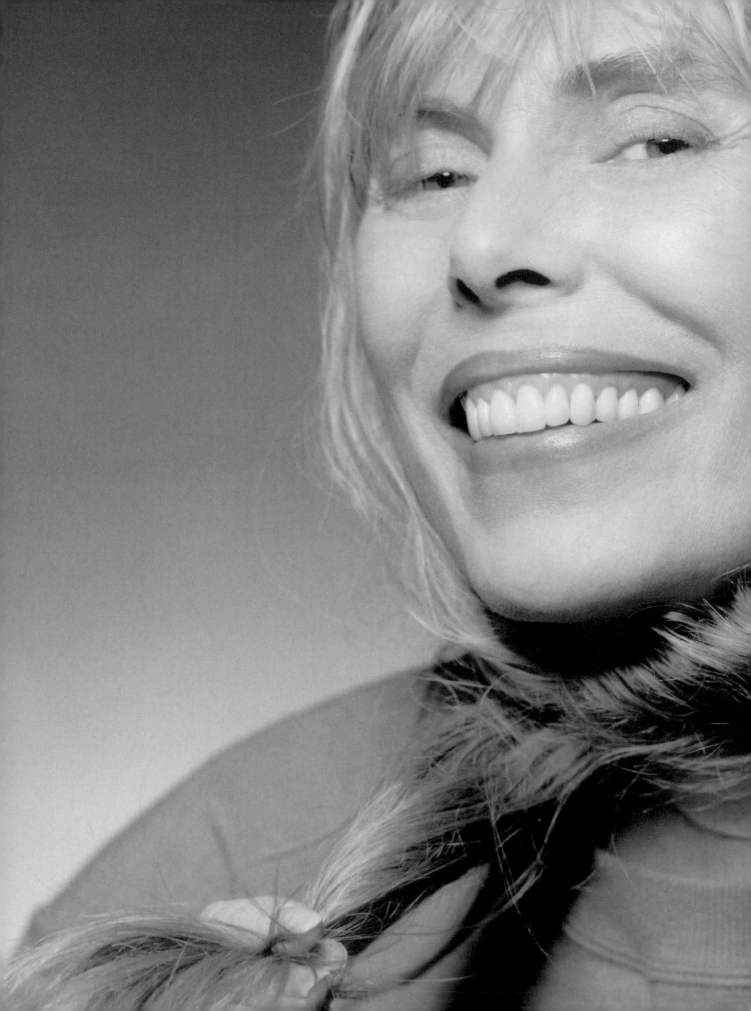

Pamela Anderson

Stripped of highly styled hair and makeup, Pamela's face is virtually flawless, the ideal canvas on which to create an infinite number of sensational looks. She has graced five *Playboy* covers, more than any other woman in the magazine's history, and her work on the television shows *Baywatch* and *V.I.P.* made her an international superstar. Pamela may be the female sex personified, but the staying power of her mystique is so much more than meets the eye.

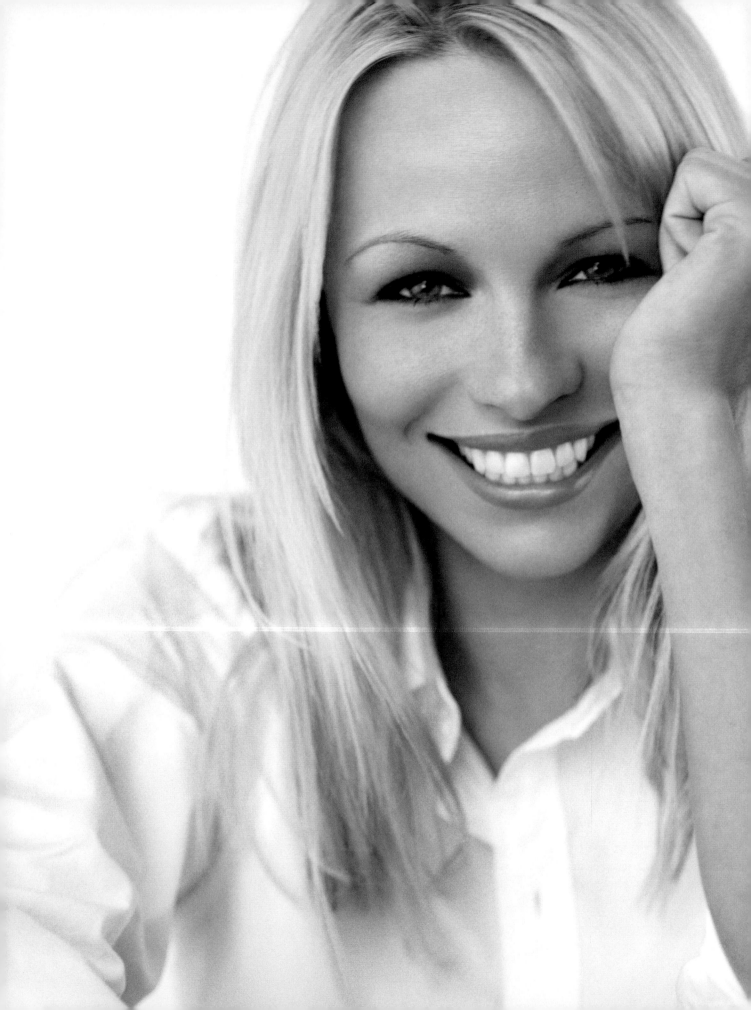

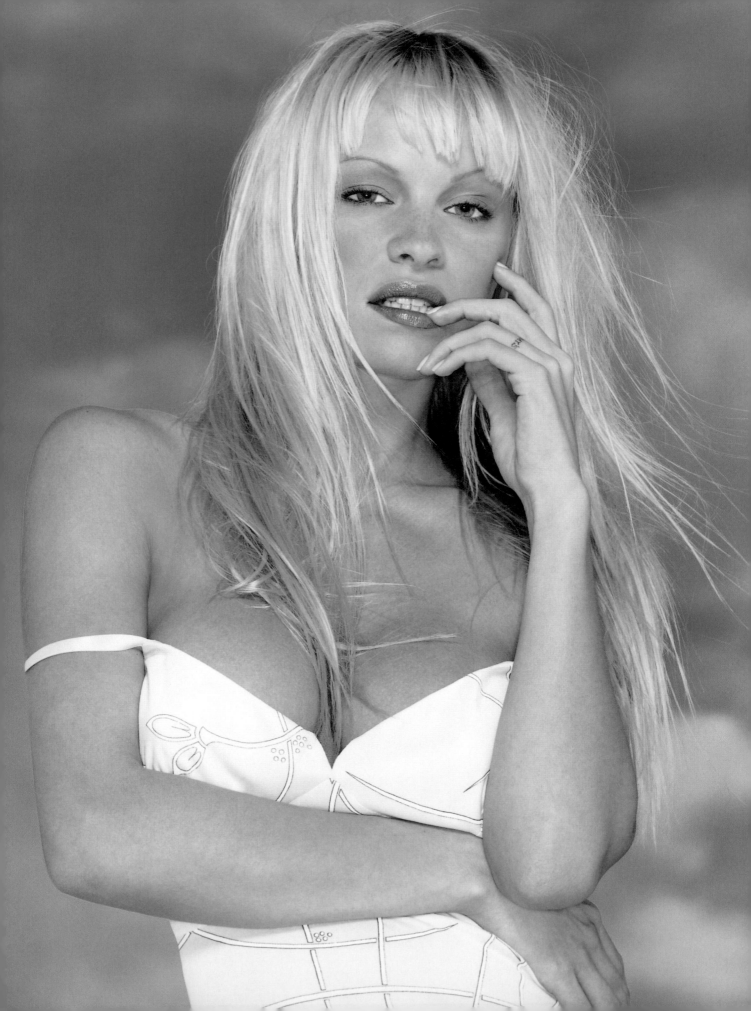

Pam, can you define beauty for me? Beauty comes from being true to yourself. It springs from diversity and uniqueness; it is the willingness and confidence to be different while everyone else clings to the same old thing.

What makes you feel sexy, and what do you find sexy in others? Fearlessness is the answer to both questions. The ability to make your own decisions, to take risks, and to take responsibility for your actions. I also think a sense of humor is a beautiful quality in anyone.

What are your thoughts on makeup? How much of it do you wear in your day-to-day life? I hardly ever put makeup on

not quality. I'm really a drag queen trapped in a woman's body, but I'm growing. [Laughs.]

You have such beautiful skin, which is why I usually just enhance your lips and eyes. How do you keep it looking so youthful? I really don't think about it, but I probably should start paying more attention to these things. I'm a little conflicted though. You see, my mom always told me, "Once you start using those beauty products, what happens when you stop? Will you always need them?" So, at an early age, I swore I wouldn't buy into all that commercialization in the cosmetics world. It all felt like some kind of conspiracy. Fortunately, all the women in my family have great skin. So

"I love doing photo shoots where I don't really look like myself."

myself, but I really enjoy wearing it. I'm not too skilled at applying it, so I like to go to photo shoots and let you professionals work your magic on me. When I've got good hair and makeup on, I just have to go out. You can't waste good hair and makeup! So what time is that reservation tonight?

How does makeup change the way you feel? It's an enhancement, something that amplifies your personality and makes you feel a bit more confident. You definitely act differently when you have a little makeup on. Like in today's shoot— I feel like a character in a Fellini movie. I love doing photo shoots where I don't really look like myself. I love the whole transformation. I remember the first time that we worked together—it was for the cover of *Details* magazine. I was eight months pregnant, and feeling it, and I remember thinking, Great, I get to wear makeup, and false eyelashes, and be glamorous for a day. It seemed like all you did was put a little lip gloss and bronzer on me and throw me to the wolves. Of course you worked your magic, and I did look flawless, but I must admit I was disappointed because at the time I still thought good makeup was about quantity,

I honestly just grab whatever is around. My philosophy is wash your face every night and drink lots of water. I'm blessed with good genes.

List ten things in life that you love. My children. My family. Friends. Adventures. Animals, of course. Champagne. Being wild. Chocolate. Sex. And the way the sun feels on my skin when I'm at the beach.

What is your most unique quality? And what is your fatal flaw? I think my most unique quality is either my sense of humor or my fearlessness in trying new things. My fatal flaw is that I'm too much of a romantic.

How do you feel about aging? I actually like the aging process. When I'm sixty, with no teeth, surrounded by cats, that's when I'll say, "Oh, there you are. I knew you were in there somewhere."

Is there anything in life that you have always longed for but never attained? Not so far.

Pam is like a Barbie Doll come to life. The look we did for Playboy *is probably the one she is most comfortable with, but I was amazed to discover how beautiful she is without makeup, and I'm happy she allowed me to do a more natural look on her for our other photographs.*

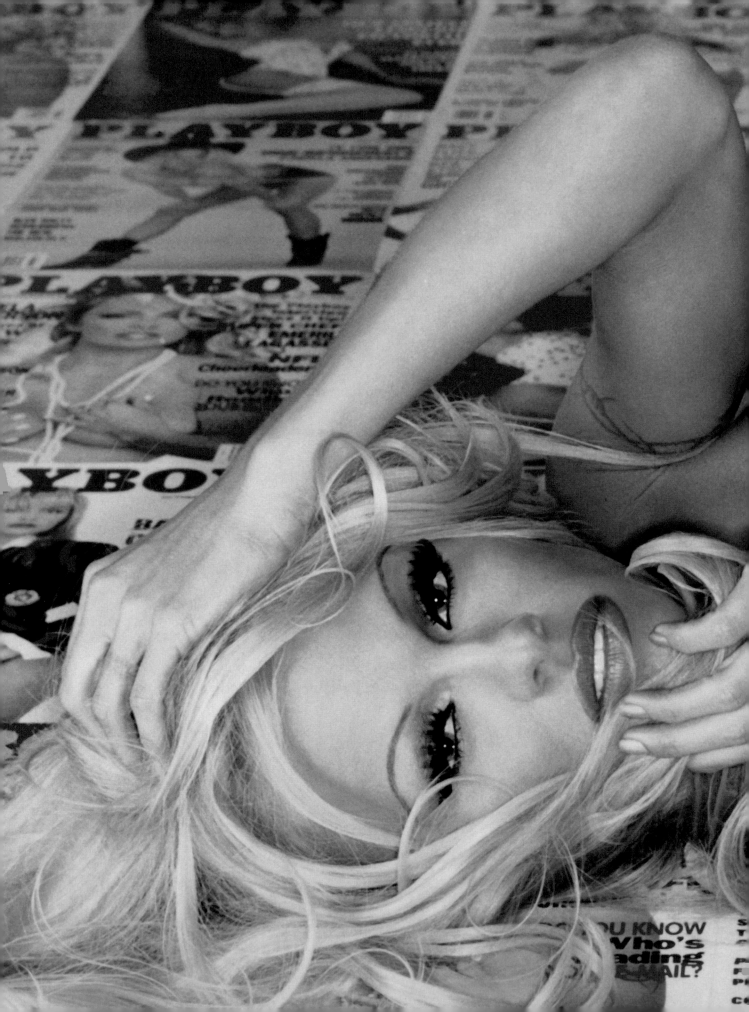

Pam Grier

Pam Grier is her own category. She evolved from blaxploitation goddess to cult-film diva, then went on to surprise almost everyone but those who know her best by becoming a fine and affecting actress in films such as *Jackie Brown* and on the Showtime series *The L Word.* Soulful in the deepest sense, and earthy in the best way possible, Pam is a woman who marches to her own drummer and leaves the tinsel and glitter for others. The color of fresh hay or the sun-dappled coat of one of her beloved equines is the gold that glitters for her.

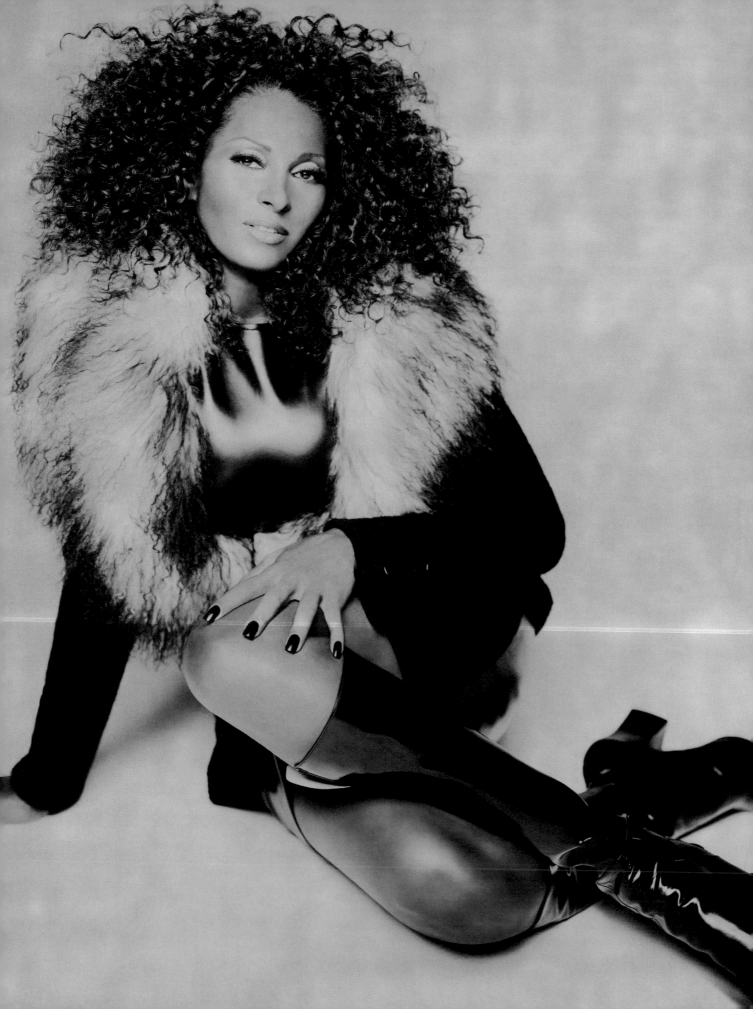

What is beauty to you? Beauty has never been superficial for me or topical. It's always been from within. If your frame of mind is healthy, the end result is the creation of beauty. And it encompasses mind, body, and a good beer.

What do you think about makeup? Do you wear it a little or a lot? Both. I wear it a lot to cover my bug bites, cuts, scratches, and bruises from working on the farm. I use it a little to feel pampered, and at work [on Showtime's *The L Word*] they often put on a lot because you're under a lot of lights on television. The lights diffuse your makeup and make you look washed out, so you have to wear a lot of it.

Which women do you most admire, and why? The women whom I most admire would be the late Shirley Chisholm, for her intelligence; Serena and Venus Williams, who've managed to survive and succeed despite immense obstacles, both racial and political; Margaret Thatcher, one of the most influential political women to ever run a country. I wish she was running ours. Meryl Streep, for her drive and success in seeking out different types of roles—like *Sophie's Choice,* her most brilliant piece of work—rather than take what was handed to her. I don't think anyone, any woman, any actress or actor has come close to that level of performance. I love Joni Mitchell. She is the absolute

"I think external beauty comes from being

artistic and creative and how you celebrate

or manifest your inner beauty."

How does makeup change the way you feel about yourself? It always makes me feel like I worked hard to earn this, to sit here and be pampered and made up. It puts me in work mode when I put on my makeup. I think, Okay, it's time to go to work, it's time to not use the word fuck, it's time to be graceful and be cognizant of others. It reminds me to show my best self, to put my best face forward, as it were.

For a weekend trip, what are the makeup basics you take with you? La Mer moisturizing lotion and moisturizing cream. If I can't find that I'll go for Nivea or Clinique. For good exfoliation, I like Clinique Clarifying Lotion 2. For dry areas I use Fashion Fair Brown Blaze Glow. I think it's a powder cream. And for drier areas, I use all MAC. I live in a flat range area in the high altitudes of Colorado. The air is very dry, so I need a lot of extra moisture. I can wear MAC as long as I have a good moisturizing base.

Didn't you tell me your mother is an Estée Lauder fan? She loves Estée Lauder, and she loves her makeup. We were just at the Lauder counter the other day. Estée Lauder was the epitome, one of those great classic women.

bomb. I have her old vinyl, and her latest CD. She is brilliant, a great poet. I admire Oprah Winfrey for her ability to be savvy and aggressive and still maintain her femininity. There are a few more. I love the fact that Beyoncé is so talented and maintains her femininity, and the fact that at the 2004 Super Bowl she sang the anthem brilliantly while everyone focused on the negative incident [with Janet Jackson]. I admire people who give something back or try to effect change—people like Oprah, Ellen DeGeneres, Rosie O'Donnell, or Angelina Jolie. I feel my loneliest when I don't see people being as charitable as they could be. You are planting a seed when you give, and it costs so little compared to what you receive in return.

Why did you choose to live outside of Hollywood and the show business community? I don't think Hollywood was invented for me, a woman of color. I think it was meant for the icons and their offspring and it always felt like I was imposing on Hollywood. I always wanted to work and live in different places, anyway. I need that balance. Growing up, I lived in both rural and urban environments, because we were a military family. I got to see the best of all

worlds, which instilled the confidence in me to know that I didn't need to live in Hollywood to be a success. I like living here in Colorado. I like the smell of winter, and the rains of summer. We have these little thundershowers every afternoon that cool everything off. I do miss the beach, so whenever I go to Los Angeles I try to stay near the ocean. I love to hear the waves crashing on the shore.

How did you get involved in acting? I originally wanted to be a filmmaker, but I sort of fell into a role because there was a vacancy. This was in the early 1970s. I thought that after the first two or three roles with these producers that I would go back to film school, but it seemed like the audience really liked my ambition onscreen, and what I was trying to say. I was a product of the era, a child of the women's movement, trying not to be marginalized because of my sex or the color of my skin. Most of us are multiracial, but if your skin is brown, there's a stigma. Nowadays I like that I can go unrecognized because it allows me to observe people, so I can build characters for my work. I love watching people and talking to them and watching their responses: "You're taller than I expected," or "You're short," or "You're much prettier in the movies." I say, "You know what, you're right. You're honest. I'm dusty right now. My eyes are puffy. I have an allergy." It's important to keep in touch with reality in this business.

What do you consider your most unique quality? I am very empathetic. I overreact when I see roadkill, or when I see people get hurt. I care a lot about life and living things. I can watch TV and see someone suffering a tragedy and I'll start sobbing for someone I don't even know. I empathize, I feel for them, because growing up I saw a lot of things and lived through a lot of things, and frankly I never thought I'd live past thirty. I thought one of four things would take me out: a fast car, an allergic reaction, a snake bite, or a jealous boyfriend. But I'm still here.

And your fatal flaw? I'm sometimes too generous, a soft touch.

Every swan was once an ugly duckling. When did your transformation occur? It never did. Let's be honest here.

I respectfully differ with you on this topic. You are stunning. You're biased because you've touched my face. Take someone like Iman, she has really fine African features. She's Somalian, isn't she? There's a swan for you.

So you've never really felt beautiful, only beautiful in character? It's hard to describe the words for beautiful because it encompasses so much. In my family they taught us that as long as your eyes, ears, mouth, legs, and arms worked, you are beautiful. Then as I became more knowledgeable, I realized that even if I didn't have any arms or legs and was in a wheelchair, my heart would still be beautiful. So when it's down to that, it's about a beautiful soul. I think external beauty comes from being artistic and creative and how you celebrate or manifest your inner beauty. Animals celebrate their beauty by the fur they grow, their feathers or plumage, their scales. Fish, frogs, horses—every animal who is healthy has a beautiful design, grows a beautiful design, creates a beautiful design, and that's also what human beings do. Take makeup as an example. I think some people make the mistake of thinking that if you paint your face, you're shallow and not really beautiful, but that's not true. You are being creative to reflect your inner beauty. Makeup and clothing are your plumage, your stripes, your horse's mane and coat. Like my palomino mare, she gets dappled from the sun and shows her beautiful color, but if she wasn't healthy, she wouldn't dapple. She would be pale and dull, and her coat would not shine. Beauty comes when your interior and exterior selves are in harmony, whether you're a horse or an actress.

What ethnicities are in your bloodline? Everybody. We're African-American, Indian, Spanish, Filipino, Chinese, and European. We don't know exactly where my grandmother came from, either French or French gypsies, but it's quite a cross section of bloodlines. I really enjoy our family gatherings. We have so many wonderful people in our family, and strong ideals. Basically we're all for keeping mankind strong and educated.

How do you take care of your skin? I think the key is cleansing. It's very dirty here and very windy. There's a lot of dirt and pine dust off the pine needles and dog hair and horse hair. You have to work hard to keep your skin clear and avoid bug bites, mosquitoes, and spiders. For bug bites I apply Neosporin and as a repellent I use the Avon Skin-So-Soft. I even use it on my horses and dogs.

Do you exercise? Well, I need cardio and also to work my legs and shoulders, but you know what? You throw an eighty-five pound bail of hay, and you'll get your workout. Spend an hour cleaning horse stalls or loading up trailers, or just walking a horse, and you'll get some good exercise. But your mind needs to be exercised, too. I just started yoga.

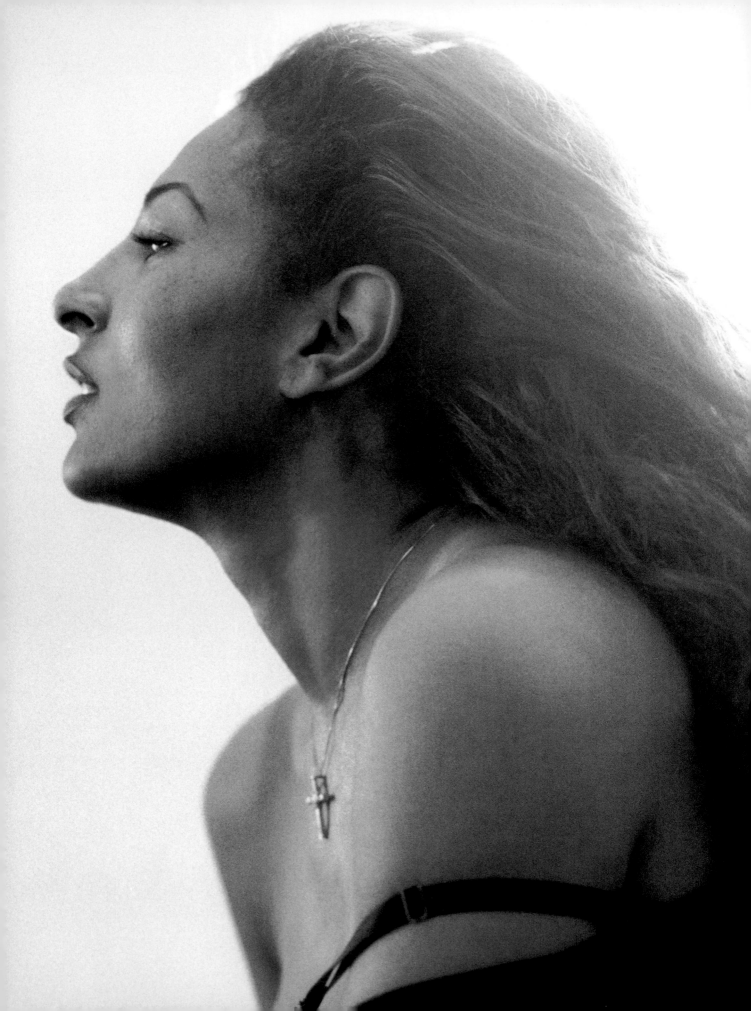

For exercise I've used Pilates, cardio, weight machines, free weights, horses, dogs, and my sister's twin boys. They're three years old and they'll keep you running.

Do you follow a special diet regimen? When I want to gain weight for a role, I have a program; and when I want to lose weight for a role, I have another program. I keep it balanced by eating protein with low carbs for weight loss, and when I want to gain, I add more carbs. My exercise routine varies, but I do the same amount of exercise regardless.

What are your views on cosmetic surgery? I think it's great. It's an individual issue, a physical aesthetic that is a personal choice. Cosmetic surgery brings comfort to people with deformities and birth defects. And for those others with nothing drastically wrong with them, but who feel that straightening their noses or making their breasts larger or smaller will improve their appearance and outlook, that's their personal choice. In our society we've always embraced the

> "Makeup and clothing are your plumage,
>
> your stripes, your horse's mane and coat."

prevention and cure of maladies, but now we also pursue self-fulfillment, and we didn't have that one hundred years ago. I think this progression is very positive for all parties concerned. It's a positive personal choice.

What do you love most in life? I love my family and my circle of friends. Then there are my dogs, my horses, all my animals, and my horse trailer. My boyfriend is probably wondering where he fits in, but he knows he's in the low part of the food chain. I love my barns. I treasure my keyboards and my set of drums. And my *Star Wars* pinball machine. I had pinball machines before I had furniture. And I love being an American in a land where you can study many faiths and religions, where you can see the entire world's population and cultures in one place. I'm reminded daily how great it is to be living here. So basically, it's family, friends, animals, and this country.

What is your personal fountain of youth? I possess a natural curiosity, and being curious is what keeps you young, keeps you growing. I'll park my truck and watch buildings or bridges under construction. Architecture amazes me—perhaps I would have gone in that direction if I'd had the funds to go to college and pursue it, but I put myself through school instead. It was a difficult time, but I made do with what I had and retained my curiosity, so now I learn about trout ponds or more about my horses. Curiosity is my fountain of youth.

I've been captivated by Pam Grier since I was a teenager, so meeting her and doing her makeup during the promotion for her film Jackie Brown *was like a dream come true. In the opening photograph, by Matthew Rolston, we paid homage to her look in* Foxy Brown, *but with a contemporary edge.*

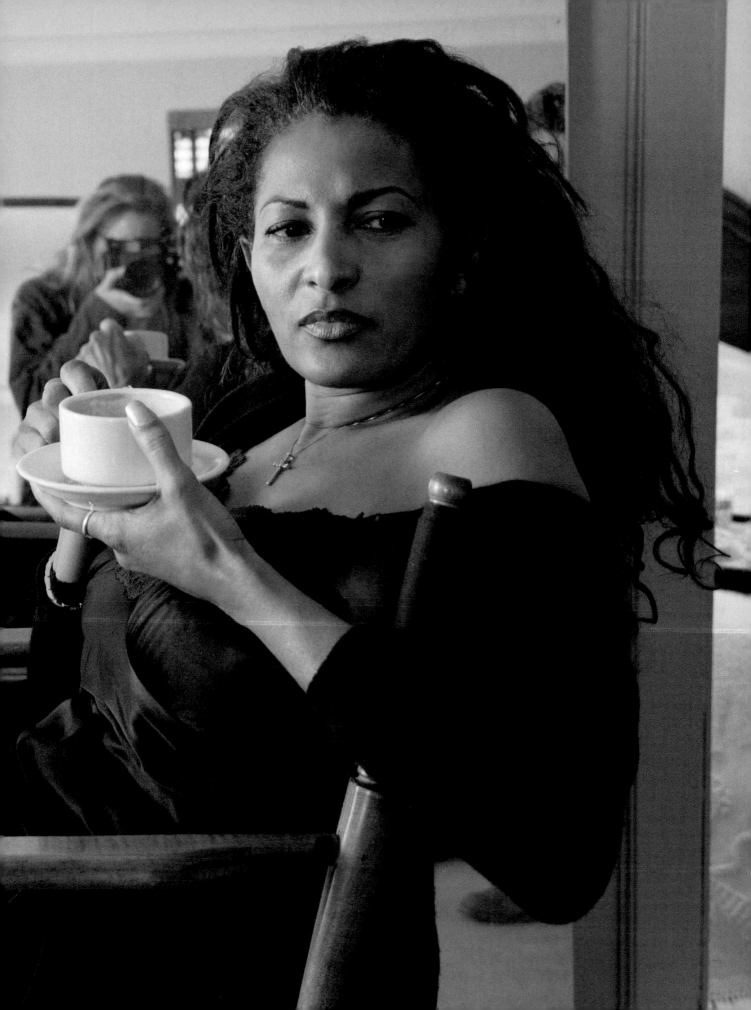

Britney Spears

Britney is a sensation. Since her debut, she has sold hundreds of millions of albums worldwide. Her shows are sold out months in advance, and young women hang on her every move. Britney is attached to her Southern roots, but has developed a style all her own. Whatever she chooses for her future, Britney will be a force to be reckoned with for years to come.

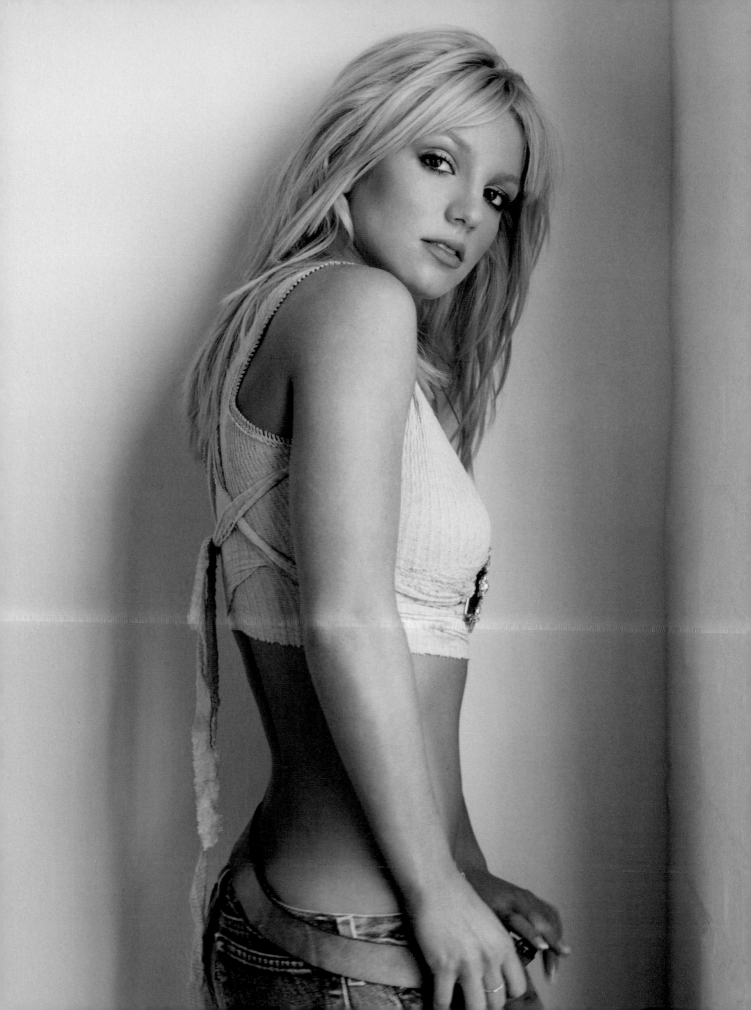

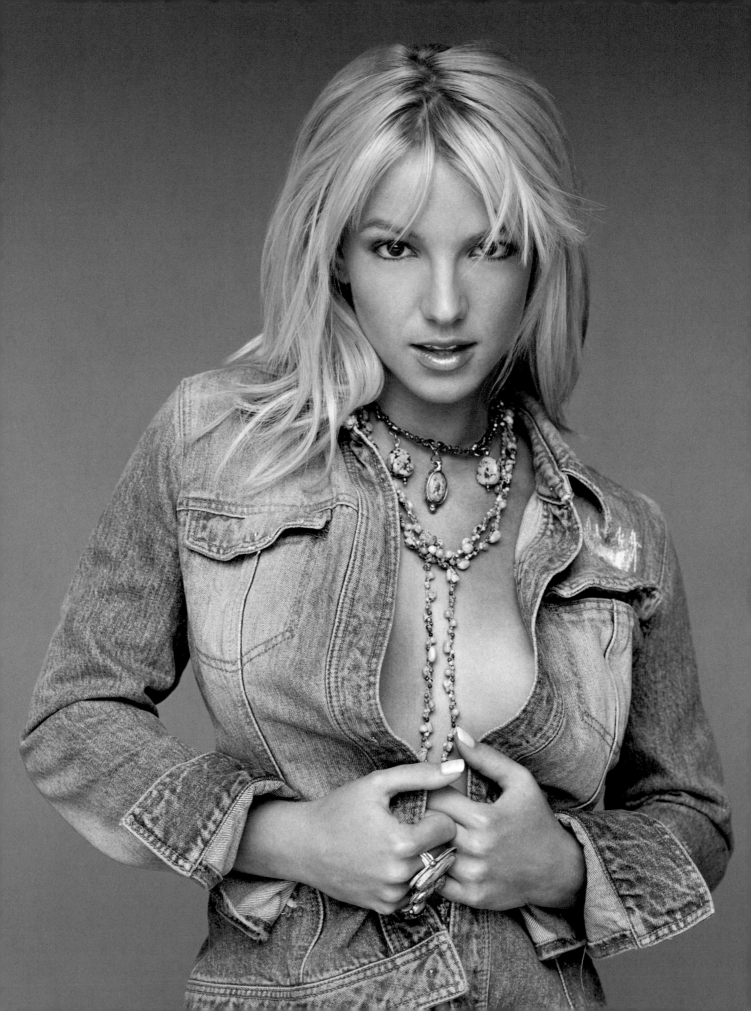

Who are the women who have influenced or inspired you, and why? There are many inspiring women, but two who really stand out for me are Jennifer Lopez and Madonna. The way their careers have evolved, and the way they project themselves is inspiring to me. I think a lot of men and women are intimidated by them because they are such strong women. I love the way Madonna expresses her personal journey through her music, and I love Jennifer Lopez for her style, beauty, and immense talent. They are both positive examples for young girls and women alike.

What do you think about makeup? What role does it play in your work and private life? I love makeup. It is an artistic form of expression, and for whatever mood you're going through, it makes you feel beautiful. It's an expression of how you're feeling at that moment in time. I like

"I love dramatic makeup because it

makes you feel like a different character."

all different kinds of looks—smoky eyes, angelic, sassy, or innocent. I love big lashes for shows, really going all out, like Cher. I love dramatic makeup because it makes you feel like a different character and a different person for that role.

Brit, how would you define beauty? Beauty comes from the inside, but I think sometimes you need a little makeup to help it along. I know that sounds horrible, but it's true. Beauty is really a feeling that you get. Like when you walk into a room and you see two people. Both could be physically perfect and have the exact same makeup on, but one person will have more of that rush and feeling of what is going on inside. It comes through on the face, a light that just glows. That's what I think beauty is.

How do you keep in shape? I do sit-ups, a whole lot of sit-ups. I like to run on the treadmill, and I usually do three sets of fifty push-ups with my knees bent on the ground. That's my usual workout, but when I really want to get into shape I usually box. I go to boxing class and work it like Hilary Swank. [Laughs.]

Can you name ten things that you love in life? I love babies. I love dogs. I love bags. I love music. I love the sun. I love shoes. I love mascara. I love to laugh. I love to cry. And I love art.

And lastly, what is your personal fountain of youth? I think children put everything in perspective. They bring you back to what is important in life, and take you outside of yourself. If you can live through them and not be so concerned with yourself, I think that's a healthy balance. Of course, my first love is music . . . and kisses from my husband.

Britney is the embodiment of a contemporary pop princess, with a freshness and spontaneity that make her hard to resist. She loves makeup, especially to play up her eyes, which tell so much about the mood she is in.

Christy Turlington

Serenity, warmth, and openness are Christy's defining qualities. As the face of Calvin Klein, she seduced us with her almond-shaped eyes and languid sensuality. As a supermodel, she was always most down-to-earth, ready to put her reputation on the line for the right cause. And with her yoga line, Mahanuala, Christy has staked out a path to health and beauty that provides equal emphasis to inner, spiritual growth as well as to outward physical perfection.

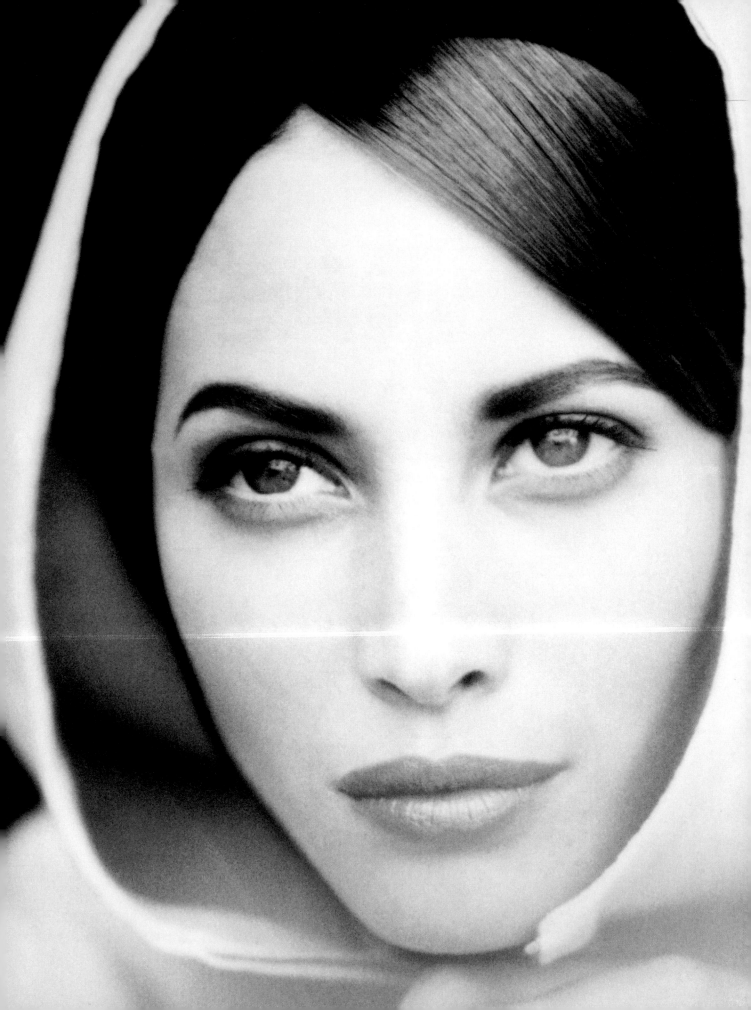

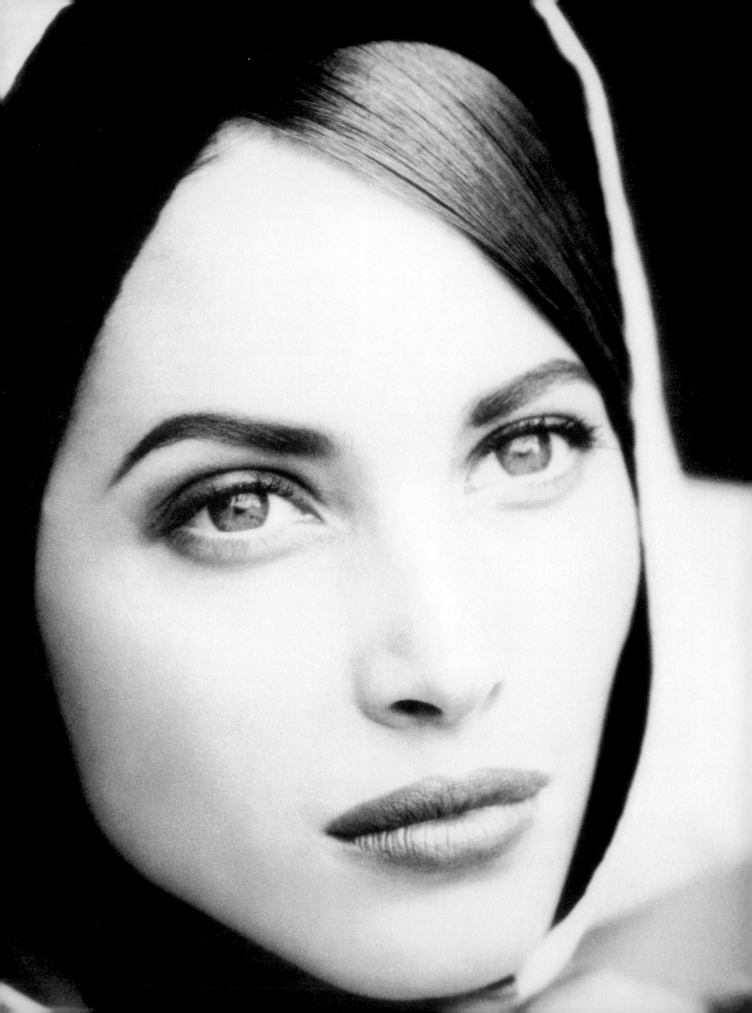

You've worked with the legends of fashion. Who was the first photographer to have an impact on your career? Arthur Elgort, whom I met when I was fifteen, in 1985.

When did you know you'd made it? When I was on the cover of British *Vogue* in 1986, shot by Patrick Demarchelier. The first *Vogue* I'd ever bought was a British *Vogue,* so it was really cool to be on the cover only a few years later.

Eileen Ford, founder of the Ford Modeling Agency, represented you for many years. What was the best advice she ever gave you? To finish college.

didn't really begin a regular practice until much later, around the age of twenty-six. At that time, I decided to reorganize my priorities, and yoga simply became one of them. Yoga helped ground me, it helped me quit smoking, and it helped me focus on taking care of myself—both physically and spiritually. Since then, yoga has influenced nearly every aspect of my daily life.

What are your basic cosmetic necessities, and how much makeup do you wear? I am a big believer in "less is more." I like to look—and more important—*feel* healthy. I suppose a great and natural moisturizer is my essential foundation.

"I welcome evolution in all of its forms, including aging. I feel better now than I have ever felt."

After years of smoking, you have now become an anti-smoking activist. Why, when it has become so politically incorrect, do you think people are still seduced by the lure of tobacco? It is hard to remember just how dangerous smoking actually is for you—especially for women—when it's glamorized in fashion photography. When smoking is paired with these beautiful women in so many glamorous images, it's easy to romanticize it.

Do you think the industry should adopt a more responsible attitude toward smoking? How do you feel when you see a cigarette used as a prop in a photograph? American magazines have become a lot more responsible about not using or showing cigarettes as props in their editorials. But the "people" pages of parties and social events are often filled with cigarettes. People often seem to include their cigarettes in these images, which I think is even more irresponsible than having cigarettes in editorial photos.

You have a yoga line, Mahanuala. How did you become interested in yoga, and what do you gain from your practice? I took my first yoga class when I was nineteen years old. I

How do you feel about aging? I welcome evolution in all of its forms, including aging. I feel better now than I have ever felt, and I hope that with continued experience and adventure I will continue to evolve and grow—that's part of the beauty of aging.

What kind of women do you most admire, and why? I admire women who continue to challenge themselves. I like to see women become more and more interesting and experienced over the years. My mother is one of these types. She continuously welcomes any and all opportunities to travel to new places and try new things.

List ten things you love in life. My family, my dog, yoga, live music, spicy foods, traveling to new places, horses, walks on the beach, a great novel, and a good cup of chai.

What is your personal fountain of youth? Yoga.

Complete the following sentence: "If I knew then what I know now, I would have . . ." Gone back to school sooner because it so inspired and influenced my life today.

Christy's facial features are so exquisite that they were copied on the mannequins used in the Metropolitan Museum's Costume Institute in New York City. These pictures by Peter Lindbergh affirm the fact that Christy looks stunning from all angles.

Scarlett Johansson

Comparisons to female icons of the old Hollywood studio system abound whenever Scarlett walks a red carpet. She has Ava Gardner's spunk and Kim Novak's ambiguity. Since we first met, I've thought that were Alfred Hitchcock still alive, she would be his perfect muse, so for our shoot we did her as a Hitchcock heroine and, at her request, as a boy. Transitioning from vixen to boyish, Scarlett proves herself the perfect chameleon.

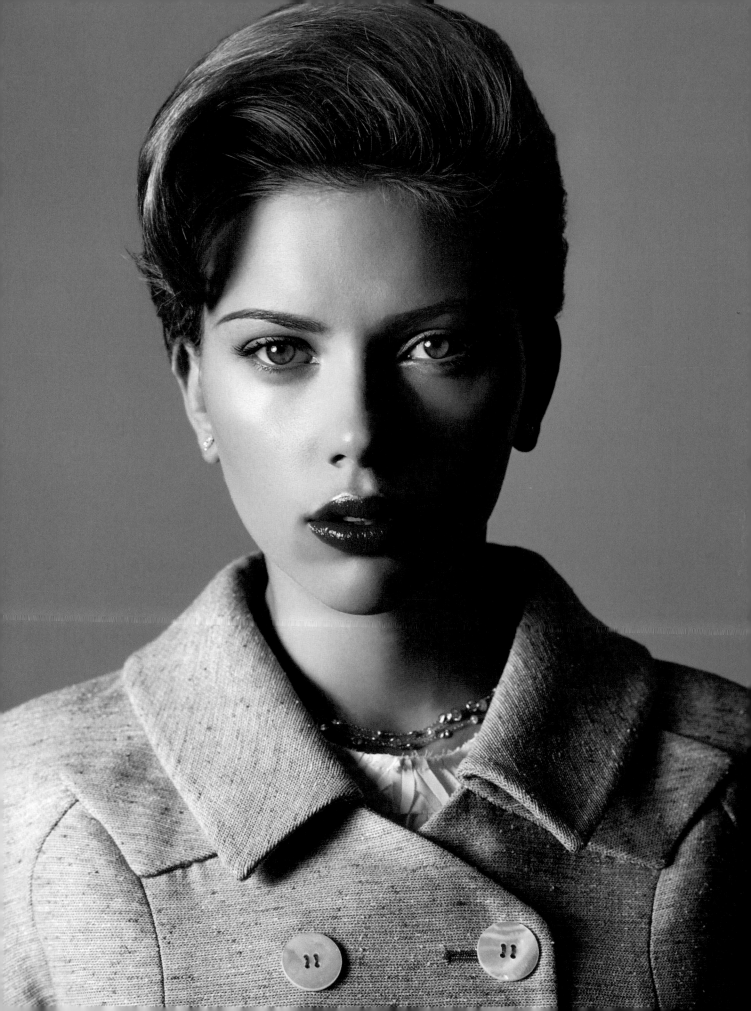

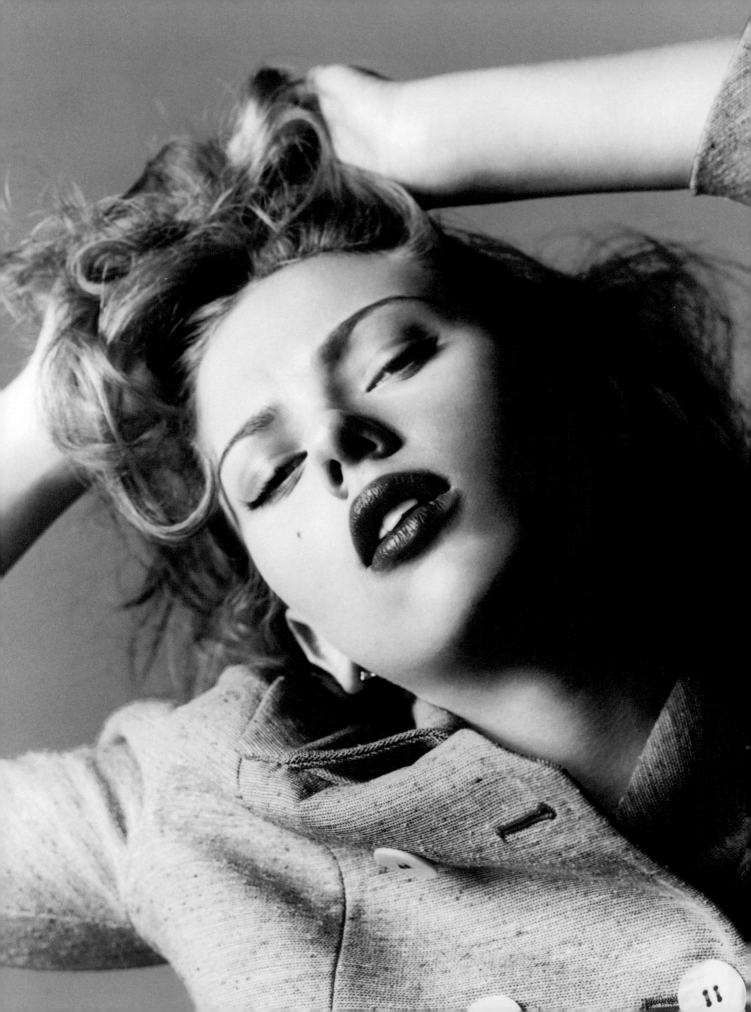

First of all, I want everyone to know that it was your idea to have this manly look, which I think is so great on you. Thanks for the idea. What was your inspiration? People tell me that I am so feminine; that everything about me is so feminine, and I always think, No, not really. And what stops me is that I know that a lot of times I look at myself in the mirror and I think that there's something rather boyish about my face or that I look like a prepubescent boy, some mornings, especially when my eyes are kind of swollen. I just thought that it's really funny to kind of play with that idea of being, sort of this androgynous beauty. I think it's very sexy and it makes people question their sexuality. I just thought it would be a cool idea and I knew you could pull it off.

I was the coolest. I really love makeup. I have tons of it, and I love applying other people's makeup, too. It is so therapeutic. I could literally spend hours applying my own makeup, and sometimes I do.

And so how does it transform you? Dramatically. If I am feeling glum, or even when I am sick or blue, I like to apply red lipstick, then for the whole day I feel better about the way I look and feel. It's amazing what putting on a little blush can do. If you're unhappy with the way your skin looks or you have dark circles under your eyes, it makes you feel so much better to put some makeup on. Some girls cake it on and hide behind their makeup, but it's all in the way you use

"I could literally spend hours applying my own makeup, and sometimes I do."

Aw, thanks. Can you describe yourself for me as though you were a disinterested observer? Who, that girl over there? She seems pretty comfortable in her skin. Outgoing. Lively. She's a live one.

That sounds like something I would say. But at times I'm also very much a loner, you know. If somebody saw me on a train or something, they'd think I was a quiet person in her own little world. The funny thing about being an actor is that these bursts of different people and different characters keep coming through you all the time. If they hadn't invented movies, we'd probably all be institutionalized. [Laughs.]

Give me your thoughts on beauty. Beauty is intangible, and makes you feel a connection to whatever it is you're staring at. It inspires a childlike amazement in a person.

What do you think about makeup? Do you wear it when you're not working? I've watched my mother apply makeup probably since I was three years old. She always wore a lot of makeup, especially eye makeup. My mother is very beautiful and when she was younger she would draw eyelashes under her eyes and that sort of thing. She would always look like Cher to me. Then, when I was about eleven years old I started to wear glitter and blue lipstick and I just thought

it. A girl I knew in high school told me that she didn't feel safe without eyeliner. It was the first thing she did in the morning even before she brushed her teeth. Kind of weird, isn't it? For some people makeup becomes part of their identity. Like, unless I draw my eyebrows on, I don't feel like myself.

Who are the women you most admire, and why? I used to think that Judy Garland was the most beautiful woman I'd ever seen. Something about her face just held you there. There was tragedy in her face, a tragic beauty. I loved to watch her when I was a child.

Why did you admire her so much? I don't know. It was just everything about the way she looked. I think as a young girl, your first feelings of sexuality, the first people you are attracted to are women whether you're gay or straight. I think it has something to do with your mom, and finding your femininity. I would almost say I had a childish crush on her. It was her vulnerability. Those big brown eyes. Her face was just timeless. She looked like a lost soul.

Can you tell me ten other things you love? My family, my best friend Jessica, my two cats, gherkins, chocolate, New York City, the fall, my mom's emerald earrings, my teddy bear Cuddles, and making movies.

What is your most unique quality, and your fatal flaw? I try to be honest with myself and with other people. I'm always honest with people. It's hard to say something like that about yourself, because good qualities are things that other people should recognize in you. When you start to recognize them in yourself they become fatal flaws. I'd say my fatal flaw is that I don't give myself enough credit. I tend to be hard on myself, primarily because I want things to be perfect. You need to have a reality check every now and then.

What is your personal fountain of youth? That's hard to say because I'm only nineteen. I look at somebody like my mom, who's so enthusiastic about life, and I think the thing that keeps you young is reminding yourself you only live once and to keep renewing your annual passport to Disneyland.

I'm re-reading Bette Davis's autobiography, *The Lonely Life*, and she talks about when she first came to Hollywood. I was always fascinated by her because she didn't look like the standard Hollywood beauty.

Well, she talks about that, but the studio heads were determined to transform her *into* something. They didn't know what, exactly, so they tried everything. They put her through the works. They were mainly concerned that she didn't have any sex appeal, while all she kept saying was, "All I want to do is act." Yes, it soon becomes all about the image, then maintaining the image. It's the same for men too, but not as pronounced. I was talking to an actor yesterday who told me, "This is the first photo shoot I've done in two years. I just kind of like to hide out," and I thought, Women could never

"I think the thing that keeps you young is

reminding yourself you only live once."

My mom goes crazy over egg creams and I'm never more enthusiastic than when I have a tuna melt. It's enjoying the little things in life that keeps you feeling young. [Laughs.]

Do you think there is a double standard in the way we judge the beauty of a mature woman versus that of a mature man? Absolutely. I think it's a really outmoded concept, but it's something that's hard to change because it's so deeply ingrained. Not that that's true; it's just the way society sees it. It's much easier for people to look at Paul Newman or Sean Connery or Robert Redford and say, "He's a gorgeous older man." But when you apply the same standard to a female, suddenly the scale shifts downward. I think it's kind of gross the way society finds it so difficult to see older women as sexy—and I mean older, not Demi Moore. Everybody talks about how great she looks "for her age," but Demi isn't old. She's young. Now let's talk about Sophia Loren—there is a mature, beautiful woman for you.

do that and still work. When an actress goes into hiding like that, people forget about her. It's not the same as Johnny Depp, who can live in France with his family and come and go as he pleases. What woman can do that—Diane Keaton? Not even. There's nobody like that. Sean Penn, Benicio Del Toro, Leo DiCaprio—they can do that. Women can't do that.

Do you think that that's part of the double standard? Yes, absolutely. Women sell products. They need to sell themselves. Men can be remote and people say, "Oh, he's so mysterious." With women they say, "She's such a snob."

What is the ultimate compliment? There's nothing better than when somebody says, "You're a good person." Or "You have a kind heart." It shows that somebody does recognize something in you that you only hoped would come across. The best compliment is when people say that you affect them positively. That always makes me feel good.

Scarlett is a makeup artist's dream. Young, beautiful, and always open to trying new things, Scarlett has an ambiguity that seduces you but keeps you guessing, which was partly the inspiration for these photographs, suggested by the early-'60s Hitchcock film, Marnie.

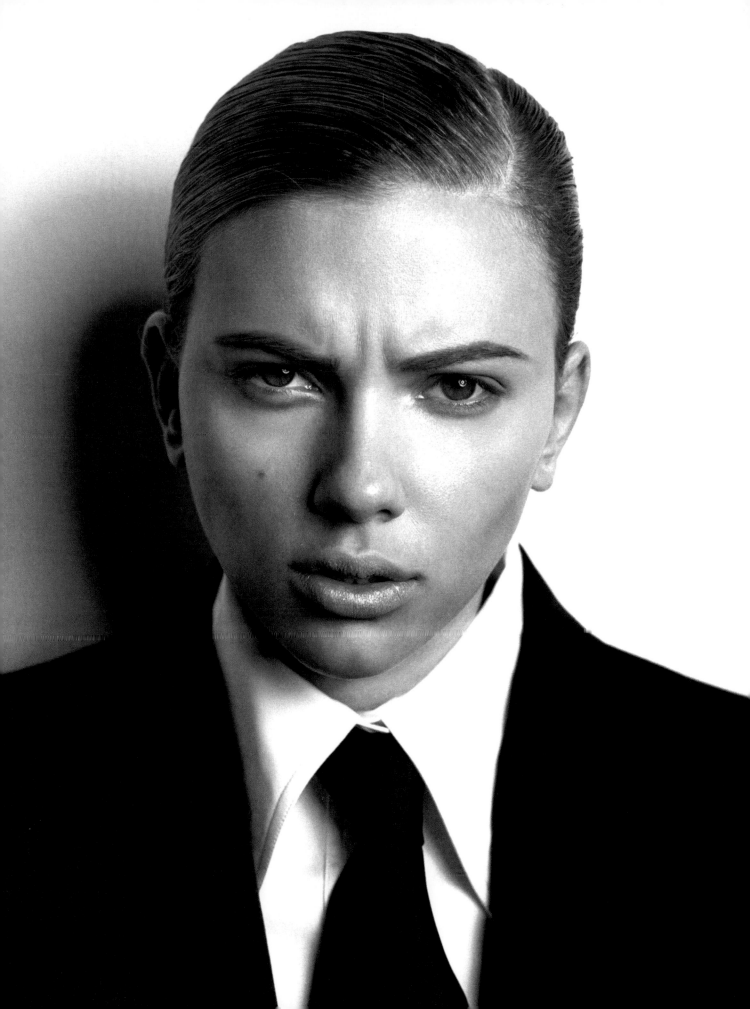

Michelle Pfeiffer

From my first glimpse of Michelle descending a staircase in the movie *Scarface,* I was mesmerized by her understated elegance and smoldering sensuality. Her pale olive skin is virtually poreless, and her piercing green eyes look right through you. But there is real blood in her veins and real passion behind that impervious beauty. Michelle never takes her gifts for granted, which is what always brings me back to her—as a woman and an actress.

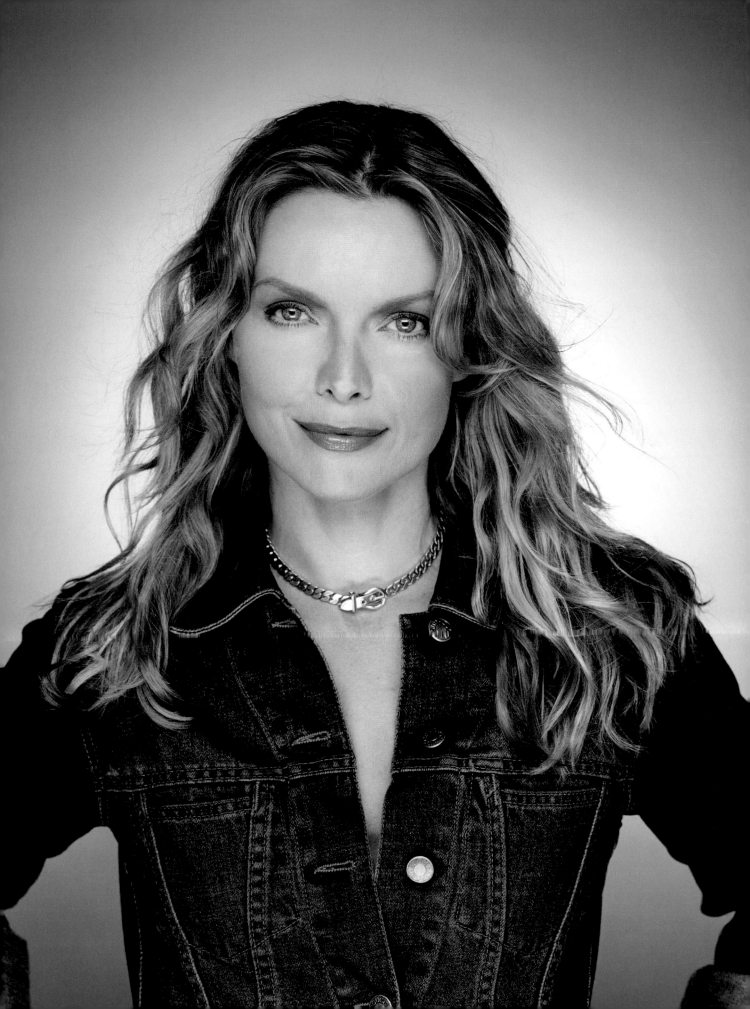

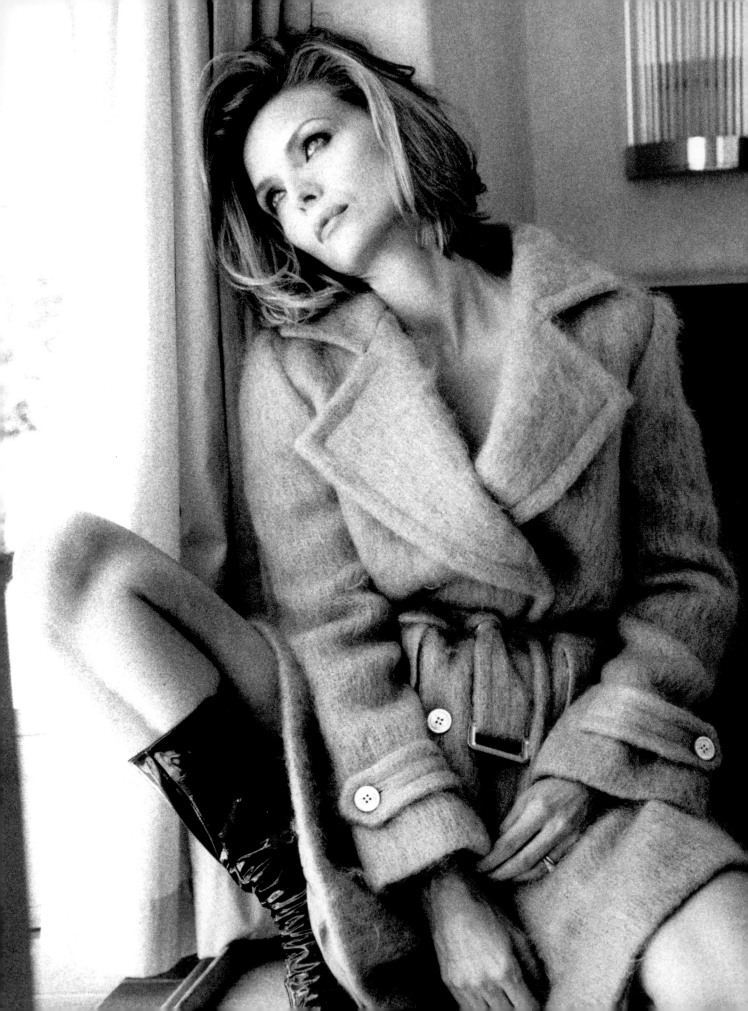

What is your definition of beauty? That's a really tough question. It's so personal and unique for each one. I think beauty is when people are in full celebration of who they are and not trying to remake themselves into a facsimile of someone else who they think they should be. I sat next to a young woman the other night who had features that on another face could have been plain or ordinary. But she was so comfortable in her own skin that she was, by far, the sexiest and most interesting woman in the room.

What do you think about makeup, and what do you carry as your basic necessities? I don't really wear makeup in my day-to-day life. So my basic necessities, and these are pretty basic, would be concealer and probably an eye pencil. A black or brown eye pencil. As a matter of

"I think beauty is when people are in full celebration of who they are."

fact, I just did my makeup with the eye pencil and liquid base you gave me the last time I saw you. I'm not kidding. I think it might be a new bottle of base, but it's the same Estée Lauder products that you gave me.

I'm glad you still love it. I do.

What do you think of your skin and how do you care for it? I just try to keep it clean. Mostly I use products made for sensitive skin. If I even look at something harsh I get a rash. I use very mild things, and the fewer the better. I don't have a complicated regimen. I just wash it and wear moisturizer with a sunblock in the daytime. I also have regular facials. I know what I eat is important and it really shows up in the way my skin looks. Exercise also makes a big difference. All of those things combined. I think your attitude and outlook are really reflected in the skin you're in. It all contributes to it.

Are you careful with your diet? I'm really careful with my diet, and I hate it. Because I just want to eat everything. [Laughs.] I have a huge appetite, and I love food. And I mean food, not just desserts. I love food, so I just try to eat well.

And how do you deal with temptation? You find things that are satisfying but less harmful to minimize the damage. You have to make sure that you have good healthy snacks around so when you feel the urge to nosh on something you won't dive into a bag of Doritos, but you'll actually have something that satisfies your cravings for something salty and crunchy.

Do you exercise a lot? I do aerobic work on my own and then I have a Pilates instructor who keeps me together so that when I go running on my own I don't injure myself. She helps me keep my body healthy and strong. But you need to do an aerobic, fat-burning program as well, especially as you get older and your metabolism slows down. Especially when you love to eat the way I do. For some people the Pilates is enough, but not for me. I need both.

You'd never know it. You have a great body. Thank God for the treadmill, that's all I can say.

I've been in this business for a long time and whenever your name comes up, women always ask me how you appear so effortlessly confident. Thank you, that's very nice. Well, I hate event-type situations because, in truth, I get very anxious. I really don't like it. So I only go when it's important. And when I do go, because I am already anxious, I try to dress in something that is really comfortable for me. A couple of times I've made the mistake of squeezing myself into something ridiculous, and you always end up paying for it the whole evening because you're so uncomfortable. I think that's why I wear suits a lot; I tend to under-dress for events.

What do you consider your most unique quality, and your fatal flaw? My most unique quality? Maybe the fact that I have no idea what my most unique quality is. [Laughs.] But my fatal flaw is both my curse and my blessing, and that's my perfectionism. I think it's the key to any success I have achieved in all areas of my life, but it can also be the undoing of me and those around me. I'm learning when to stop, to let things be when they are good enough. "Good enough" is beginning to become a part of my vocabulary because you have to pick your battles and learn to prioritize, especially when you have children, a career, and a bunch of other things going on in your life.

And who are the women you most admire, and why? My grandmother, because she raised five children all alone during the Depression. Then when they were all grown she threw her sewing machine in the back of her little truck and drove to California. She remained single and continued to support herself until she died. She taught me that women can be strong and independent, and that if you stay true to your own sense of right and wrong, it doesn't matter what other people think of you.

Can you list ten things that you love in life? My husband. My children. My family. My electric car. Oil painting.

Are you painting in oils again? Yes, I started doing it again after a long break. I've been at it again for about two years now. I'm really staying with it this time. It's just been my salvation. I've also taken up knitting, which I love. Reading. And I also enjoy doing crossword puzzles. Hot baths, Saturday night at the movies—with really bad popcorn. Is that ten?

I've lost count myself. One more for good measure. I guess a trip to New York City. I just love it there.

So do I. It's always so alive. I'm sure the old saying, "Every swan was once an ugly duckling" was never true for you. I definitely felt like an ugly duckling when I was younger, because I was always the biggest girl in class. I was a tomboy. I used to beat up the boys. Apparently, I was a loudmouth as well, because I was always in trouble for talking in school. I wasn't one of those little petite girls with the ringlets and the pretty dresses. I think I probably improved a bit when I entered high school, but it wasn't like I was the prettiest girl on campus. There was always another girl who would beat me out for the boy that I wanted.

What is your personal fountain of youth? My children. Children can keep you young and age you like nothing else at the same time.

Do you think there is a double standard in the way we judge the beauty of a mature woman versus that of a mature man? Hello! Hell-o!!

I know it seems like such an obvious question. I think most women get it, but it doesn't seem to be on the radar for the rest of the planet. I think real women all over the world feel it. I remember when Sean Connery—and this was some years back—was on the cover of *People* magazine's "Sexiest Man Alive" issue, and he was sixty at the time. I looked at that and thought, We have a loooooong way to go before a sixty-year-old woman is going to be on the cover of *People* as the "Sexiest Woman Alive." They don't even have that for women, do they? There is no "Sexiest Woman Alive" issue. It's always the men. Maybe it's time to do something about that. First we'll get the cover and the title, and then we'll work on the age.

Michelle is a versatile beauty. Her cool confidence and inner fire are a potent combination, and she can pull off any look from natural, to smoky eye with a pale lip, to full-on, movie-star glamorous.

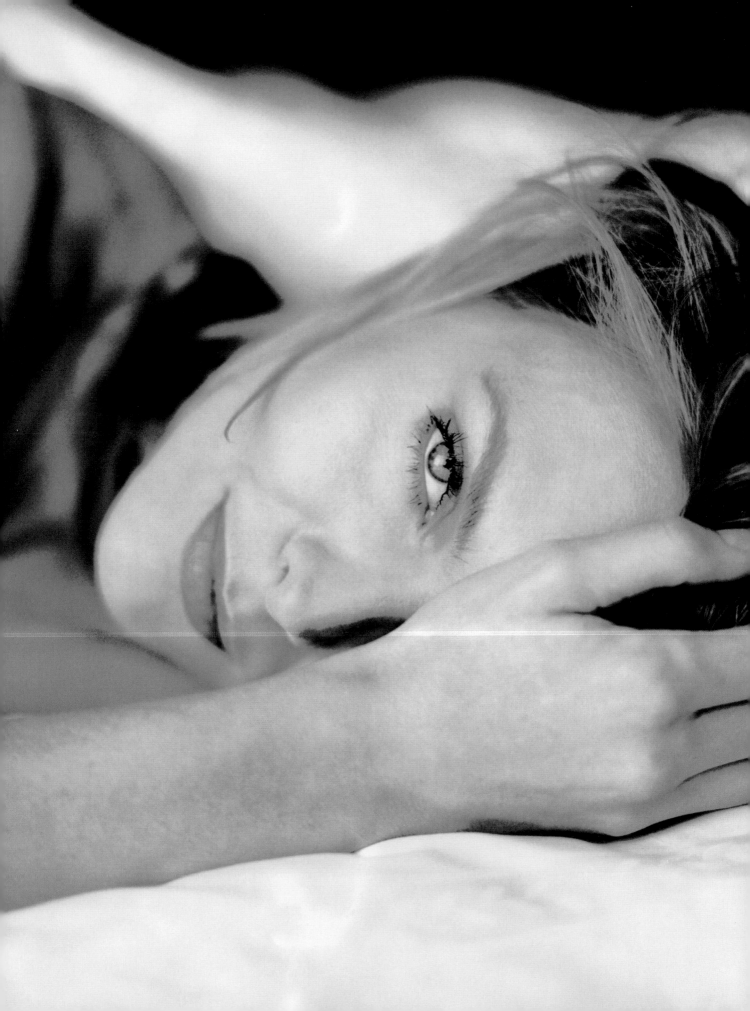

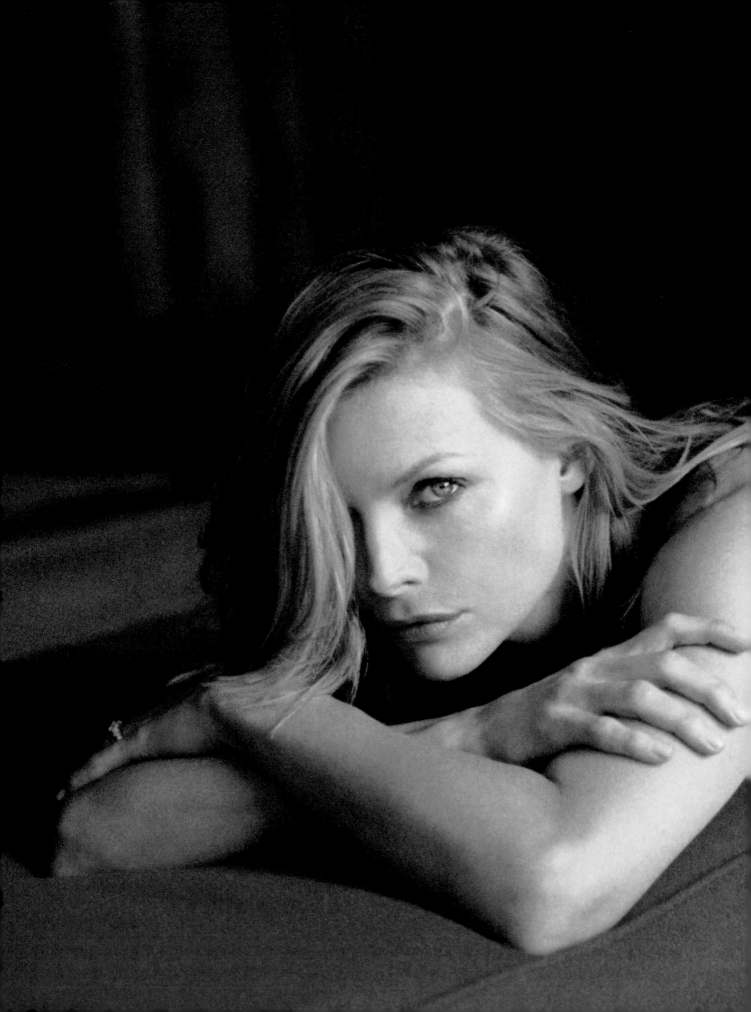

Kate Hudson

A triple-threat talent, Kate's smile literally lights up a room. A compelling screen presence, she has an innate style that combines a hippie sensibility with high fashion. And of course, there are those incredible genes. Kate added another dimension to her beauty when she became a mother, but she is still a young woman, and her multifaceted beauty and talent will delight us for years to come.

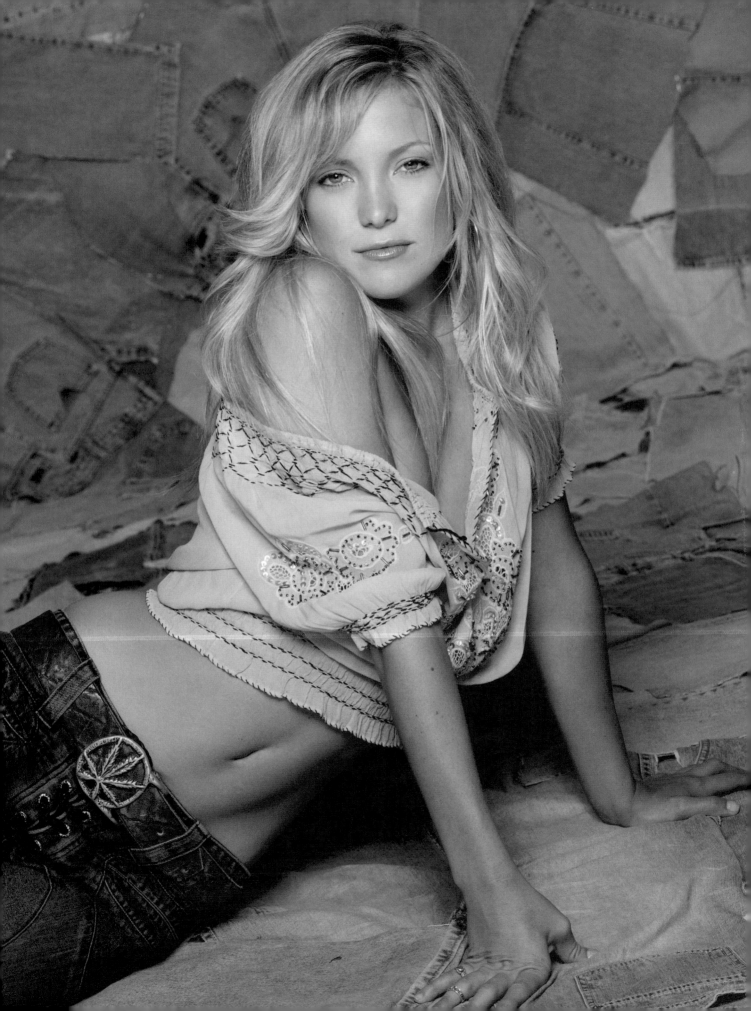

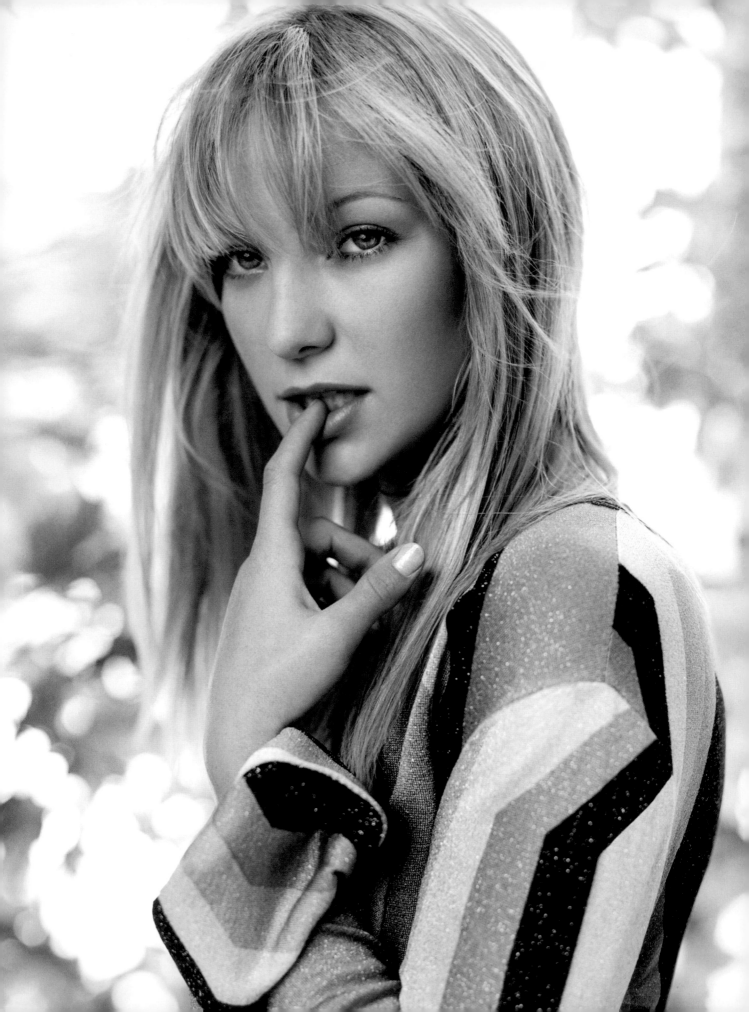

Your mother had a very distinct look when she was your age. Growing up as Goldie Hawn's little girl, at what age did you first discover makeup? This is a good question for my mother, but if I had to guess I would say very young; probably when I first learned how to use my hands. I was always in the makeup chair—that was my big thrill. Tom Case, who has been my mother's makeup artist on films for years, would say to me, "Kate, you can use my makeup box, but only if you put everything back." I'd sit in the makeup trailer putting makeup on all day, and I always made sure to put it away so that I would be able to go back and use it again.

And what was your mother's reaction? Well, you know, it was blue lips and red eyes; not exactly a beautifully made-up face. It all came to a smashing halt the day I put makeup

What vices do you allow yourself? Do you drink, smoke, eat junk food? Are such things allowable in moderation? All of the above. Tobacco, alcohol, junk food. I can't lie—I've done them all. I quit smoking, but I still like a cigarette every once in a while. I used to smoke so much. I'm not a big drinker but I do like a drink. And I love junk food. When I was pregnant I was eating salt and vinegar chips and ice cream. I ate pints of ice cream. I didn't gain sixty pounds by eating carrots, that's for sure.

How did you adjust to your first pregnancy? I've always wanted to embrace everything in my life so that when I'm older and it's my time to go, I'll know that I lived my life to the fullest. I wish everybody could experience pregnancy the way that I did. I was never happier. I was a big, jolly, pregnant

"Whether it's subtle or extreme, makeup should enhance what nature has already supplied."

on our Maltese. My mother came home and the dog had on green eye shadow and pink lipstick all over its white fur. [Laughs.] Yeah, my mother was cool about letting me experiment with makeup as a child, but when I got into my teens, she wouldn't let me wear it at all. I did love watching her put her makeup on, though. I loved watching the whole transformation. It was the '80s, and she always had the greatest Alaïa outfits, and she always did her own makeup when she went out. She'd put on her mascara and I was just transfixed: "Oooh, lashes." Mascara changes everything.

How does makeup change the way you feel about yourself? It makes me feel beautiful. Of course it all depends on who's applying the makeup, but whether it's subtle or extreme, makeup should enhance what nature has already supplied. It's a form of self-expression.

What is your regimen for skin care? I try to wash my face morning and night, but it doesn't happen all the time. I love all the oil-based products, like washing your face with oil, but I try to switch it up. I have no strict regimen, really.

lady. Put a beard on me and I could've been a Santa Claus. I would laugh so hard. I've never laughed more than I did at that time in my life.

How did you deal with the changes in your body? I didn't think about it really. I worked out until I was in my eighth month. Then, I just embraced it.

Do you like to exercise? I work out a lot and I do it because it makes me feel good. But I do have spurts where I get lazy. But I think it's very important to maintain a good body. If you do the upkeep, it keeps everything up, including your ass. You know what I mean? [Laughs.]

Explain beauty for me as you define it. I look at beauty as spirit and energy. Sometimes the most beautiful women in the world don't inspire me, but a woman who steps out with spirit and confidence is my favorite thing in the world.

Who are the women you most admire, and why? I admire every woman who has a husband, a family, and a job, and

who keeps all those things in balance. I admire any woman who can do that successfully.

List ten things that you love in life. My family, my husband, and my beautiful boy. My brothers and my parents. The sun. Any water, from a lake to an ocean or just soaking in a bath. Sex. That might go before the water. Wine, and I enjoy a good drink. A nice wine and a good Scotch. Music. Can't live without music. Music is everything. That might go after sex. Friends, and intimate social gatherings. Lip gloss. Beautiful things in nature that you can look at, like flowers!

And what are your views on cosmetic surgery? I have a friend who claims I'm the last furrowed brow in Hollywood, and I'd like to keep it that way for a while, but I don't have a problem with people making those kinds of decisions for themselves. Nowadays people are much more open about such things. I draw the line when I hear about young girls getting Botox and things like that, however. But a little collagen here and there? If it's available, why not? When taken to extremes, it shows a real level of insecurity, and I think that is a problem with some women today. It would be healthy if women who choose to do that would first ask themselves why they feel they have to do that.

Do you think there is a double standard in the way we judge the beauty of a mature woman versus that of a mature man? No, because men and women are different. I think there's something to be said for people who age gracefully and don't try to relive their twenties and thirties. If you are happy and confident at any age that is what you exude to other people. My mother is a great example of that. She doesn't want to be forty again. She wants to be fifty years old and she's ready for her sixties.

Is there one special thing your mother taught you that you hold dear to your heart? There's so many. We're very close and I'm still learning from her. The connection we have is very rare, and I never take it for granted.

I first met Kate when she was doing the publicity for Almost Famous and we clicked immediately. In these photos, she personifies the West Coast lifestyle with clean skin, flushed cheeks, and the pink, peachy tone of a true California girl. The first photo in this series is the epitome of "The Natural Look."

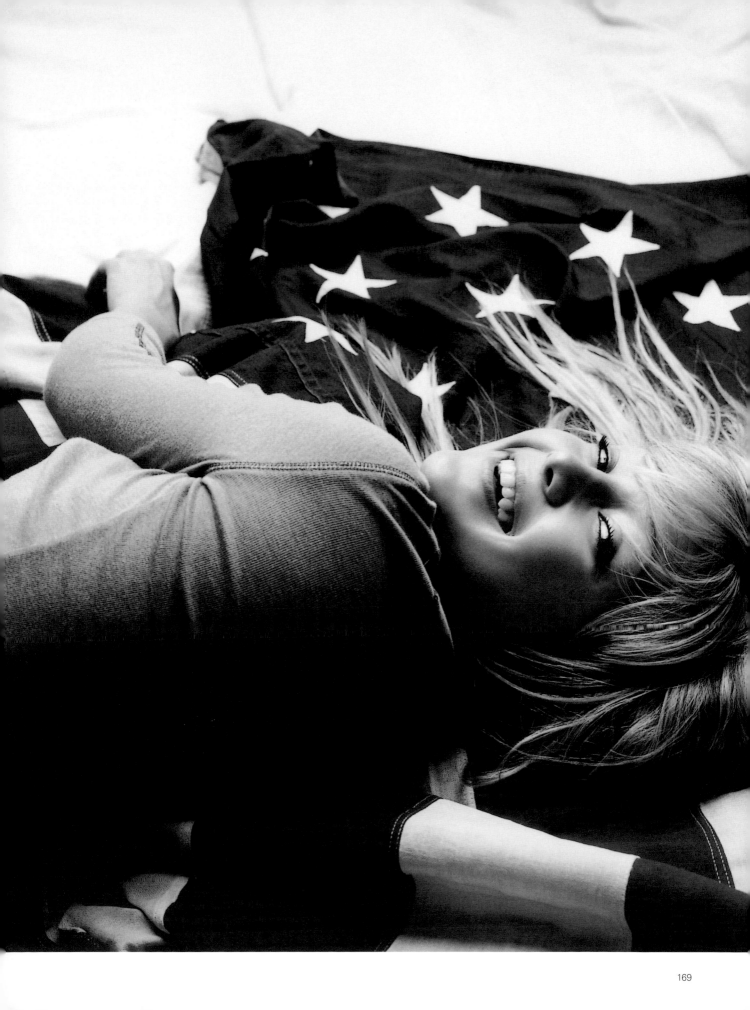

Lisa Marie Presley

Despite having one of the most public childhoods of anyone, celebrity or otherwise, Lisa Marie Presley still managed to forge her own unique personality, and has achieved success on her own terms. Now a mother with two children of her own, as well as a bona fide rock star, Lisa disarms you with her candor and no-nonsense attitude. Her androgynous beauty combines elements of both her parents, but the spirit that illuminates it is purely her own.

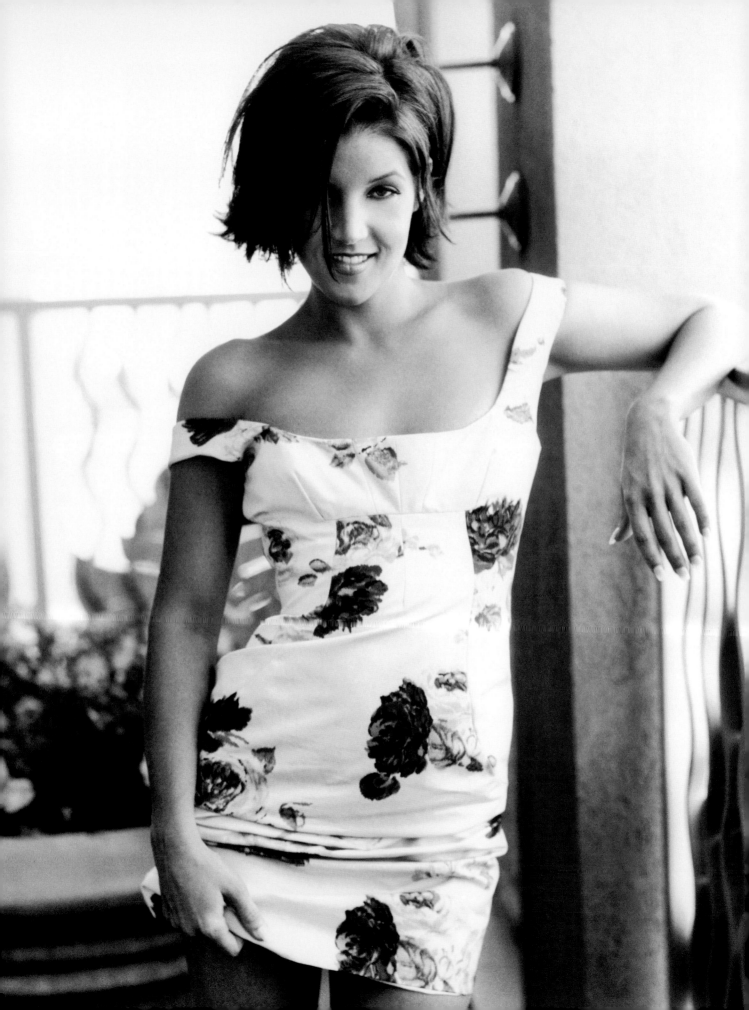

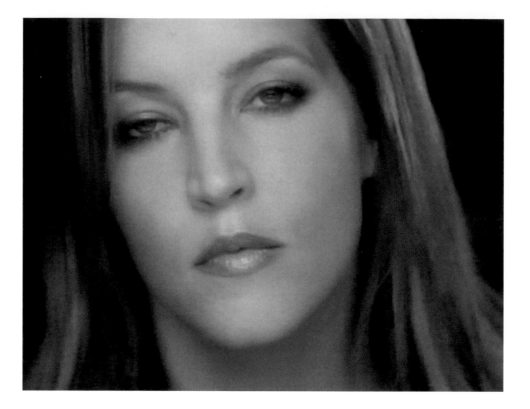

What do you think are the biggest misconceptions about you?
Where do I begin? There are so many. [Laughs.] Everything
I see in the magazines is false. I am pretty straightforward,
so what you see is what you get. I put my heart and soul into
the words and melodies of my music and am pretty candid
in my interviews, so there shouldn't be any misconceptions
left about me. I really am very honest, probably too honest
for my own good.

**Then can you describe yourself as if you were a disinter-
ested observer?** An androgynous, unpretentious nightmare.
[Laughs.]

So how would you define beauty? I believe it's something
that comes from within, and has nothing to do with exter-
nal things. Beauty is when a person's soul shines through
and illuminates.

**With two such strong, iconic parents as your influences, did
you have any trouble forming your own identity?** I have

always had a strong sense of self, so that's never been a
problem for me.

**Are there parts of your character or personality that you
attribute specifically to your father or your mother?** There
are so many, but to be specific, I think I possess my mother's
strength and my father's sense of humor. I think I inherited
my father's looks as well, but every now and then people
tell me I look like my mom.

**Now that you are a mother yourself, do you see reflections
of your own personality in your children?** We all have the
same sense of humor and a good built-in bullshit detector.
We get that from my dad.

What values would you like to pass on to your children?
Good ethics, integrity, and the courage to be who they are.

Can you name ten things you love in life? My children,
my family, my friends, my lover, music, Guinness, travel.

*As long as I have worked with Lisa, doing her makeup has always been a dream, because she is open to new
ideas, ready to try new things, and can usually get away with any look. A modern take on the classic '50s
vixen—crimson lip and individual lashes to bring out her sparkling green eyes—seems made for her.*

Japan and Hawaii are my two favorite places in the world, and I like good champagne to enjoy when I get there.

And how about makeup? Let's talk. I love makeup, you know that. I have drawers of it at home. I don't really use it in my private life, but when I'm working I love to pile it on. [Laughs.] Done well, of course.

Which cosmetic products do you carry with you as your basic necessities? My Japanese eyedrops, MAC Spice lip liner, and Eve Lom lip balm.

Who have been your biggest makeup influences? Was your mother one of them? Yes, my mother was definitely a strong influence, but I've also learned a lot from working with you,

Skin Care and Jurlique. Epicuren is great too, and I'm loving the new Estée Lauder Thousand Dollar Cream that you gave me.

Can you name some women who have inspired or influenced you? There are so many, and they are so diverse. Meryl Streep and Jessica Lange come to mind immediately, both for being absolutely fearless in their craft. When I was a teenager I was inspired by Pat Benatar, Ann and Nancy Wilson of Heart, and Debbie Harry, all for the exact same reasons. Fearless women are my inspiration.

What first attracts you to a person? Honesty.

What do you consider your most unique quality, and what's

"I love makeup . . . I have drawers of it at home. I don't really use it in my private life, but when I'm working I love to pile it on. [Laughs.] Done well, of course."

as well as with Kevyn Aucoin, who was an absolute genius.

And what is the best cosmetic trick you've learned over the years? Using Preparation H under the eyes for puffiness.

Do you follow any special diet or exercise regimen? Clean and healthy are my two basic food rules. These days I try to follow a pretty strict vegetarian diet, which seems to work best for me. And for exercise, I do some cardio every day.

Do you allow yourself any vices? My vices are red wine and occasionally champagne, and also sugar-free chocolate.

What do you think of the skin you're in? What is your regimen for skincare? I'm a pretty basic, no-frills type: I wash it and keep it moisturized. I try to do monthly facials, and I love masks. I prefer natural products like Eminence Organic

your fatal flaw? Again, honesty is the answer for both. It's a good trait, but it can also turn around and bite me in the ass sometimes. [Laughs.]

What is your personal fountain of youth? Scientology, for giving me the tools to stay focused, and my sense of humor, which allows me to laugh at the absurd.

Is there something specific about Scientology that keeps you strong and youthful? Scientology—scientifically, spiritually, and thoroughly—unburdens me of myself and others.

What compliment would you be happiest to receive? Thank you for not selling out and for being yourself.

How would you like to be remembered? As a pirate, with integrity.

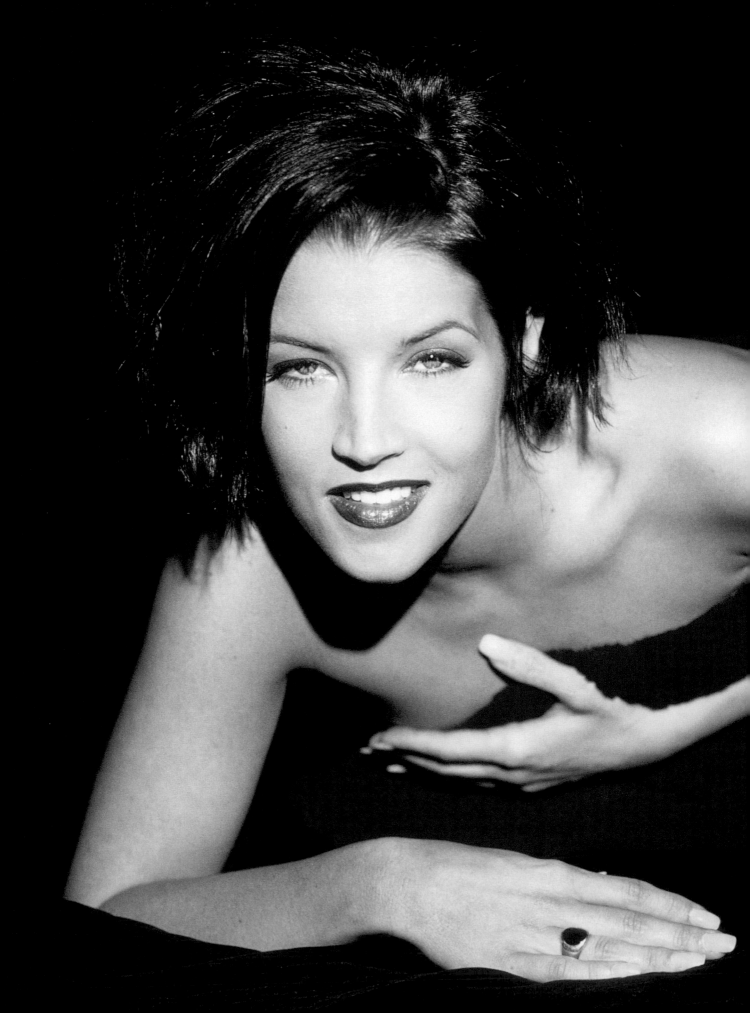

Iman

There are many myths that surround her, but the Iman I know is a warm, generous woman with a strong business acumen and a great sense of humor. From Africa to America, she has blazed her own path as a model, designer's muse, wife, mother, author, and entrepreneur. We spoke in Iman's spacious Manhattan office, decorated with African art and contemporary photography, from which she manages her extensive business empire.

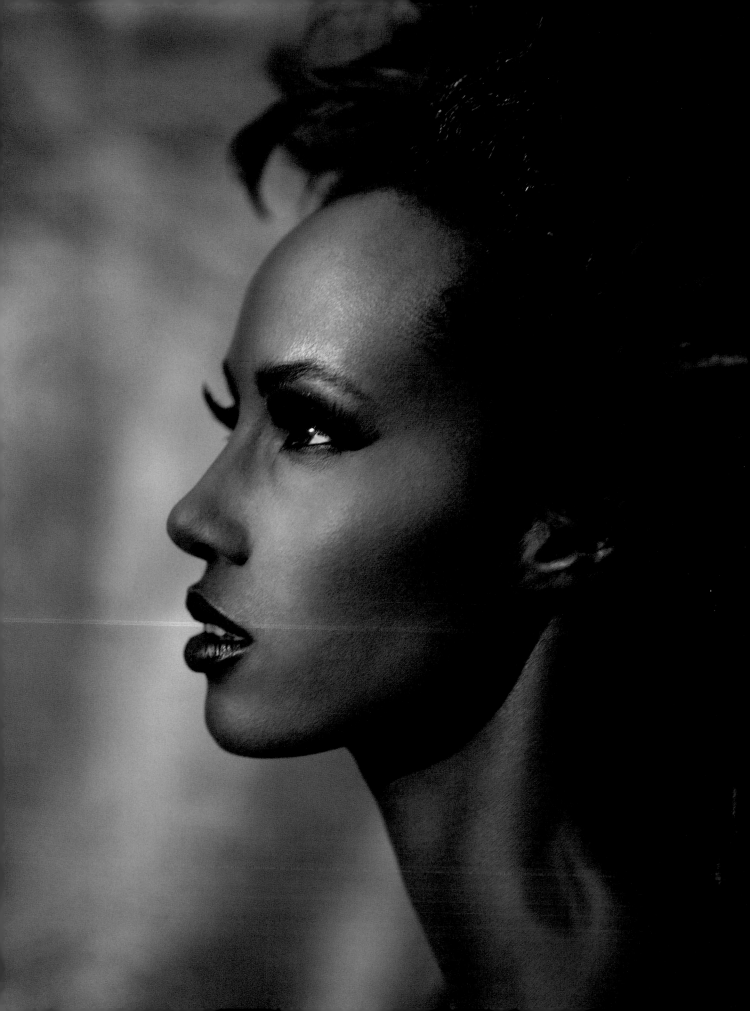

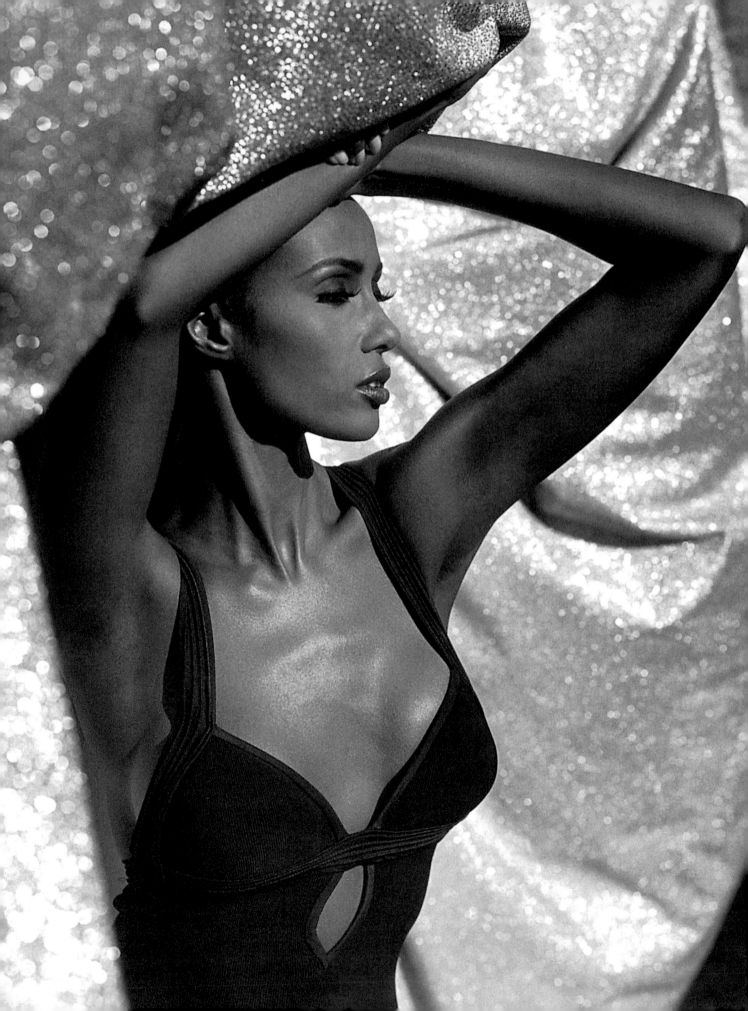

Describe yourself as though you were a disinterested observer. Elegant. Classic. Graceful.

How would you define beauty? Unattainable.

You are one of the three subjects in my book who were also in Francesco Scavullo's beauty books published in the late '70s. You were quoted then as saying, "There are no beauty secrets." Do you still stand by that answer? There still aren't. There is a unique beauty in all of us, and there really are no secrets. The real secret to being more beautiful is to find happiness and contentment in your own skin, but we all have to find that out for ourselves.

You live in New York City now, but you spent a brief time in Hollywood, pursuing a film career. Did you feel that Hollywood understood you or were you treated as something more exotic? I was treated as an exotic being. They didn't know where, or how, to fit me in, and it's all about the fit in Hollywood. Anything outside the box, they have a hard time with. And in fashion, everything is outside the box. Girls who become the most successful in fashion are usually not the most beautiful.

"There is a unique beauty in all of us, and there really are no secrets."

How do you feel about makeup? I've always loved makeup. It has an element of transformation, but it's a double-edged sword. It empowers you, but it can also hold you hostage. Some people feel that they cannot leave the house without makeup on, and that's being held hostage. For me I can take it or leave it. But I've always looked best with a little bit on.

What products do you carry as your basic necessities? I learned from makeup artist Way Bandy that less is more. You actually achieve more by putting on less. I carry moisturizer, a light foundation, preferably a cream powder. Definitely a bronzer; I don't go anywhere without a bronzer. A light lip gloss. And definitely a dark brown eye shadow.

What other things did you learn from Way Bandy? Can you talk a little about that experience? He was an inspiration to so many women as well as makeup artists all over the world. He's one of the people that made me want to be a makeup artist. Kevyn Aucoin said the same thing to me about Way. He was the first person to do my makeup. I arrived here from Africa, I'd never worn makeup in my life, and on my third day in New York City my face was painted by Way Bandy. He wouldn't let me look in the mirror and he'd packed the smallest makeup bag for me. The products he used on my face were like a talcum powder, a very light loose powder in a dark bronzy color. He used Vaseline as a lip gloss by mixing it with a black pencil and a brown pencil. I was being photographed by Francesco Scavullo in black and white so he just wanted the definition. It wasn't about the color. Then he brought out this instrument of torture that I'd never seen before in my life called the eyelash curler. I was petrified. [Laughs.] When he was finished with my face, he turned me around to face the mirror and, my God. I thought, Who is

this beautiful creature? It was still me, but a more beautiful me. All I kept thinking was how can I keep this face forever? That was the first time I realized the power of transformation that makeup possesses. When I looked in that mirror, I saw a creature I had never seen before.

Do you have a special regimen for your skin? I'm a staunch advocate of skin care. If there's one investment a woman should make, it should be for her skin care. I prefer a very simple routine—I don't like too many products on my face—but I do cleanse, tone, and moisturize my skin. I don't short-change myself. I'm religious about my skin-care regimen. When people tell me, "You don't look your age," that's the dividend from the investment I put into my skin care.

Can you talk a little bit about your experience with the designer, Halston? Oh, Halston. I'll never forget it. I'd just arrived in America, as I said, and three days later I was being photographed by Scavullo with Way doing my makeup, and literally, like five days later, I was doing a Halston show. I'd never worn heels in my life and I didn't know anything about runways. I walked into this towering showroom with mirrors everywhere. Halston was standing at one corner with his hands in his pockets and his ever-present cigarette in hand. He said, "Darling, can you walk?" I said, "How the hell do you think I got here?" [Laughs.] It was totally alien to me, what he meant by "walk." I wondered what the hell he wanted. He smiled softly and said, "Not that kind of a walk, dear." Halston was just genius. He was fun, condescending, ironic, and humorous. And he taught me a new meaning of "walk."

And what about Peter Beard? Most people don't realize that I really didn't know Peter that well when I was discovered by him. Even after all these years I still don't know him that well, but he's just an omnipresent person in my life because he's the one who discovered me and brought me to the United States to become a model. He's always appreciated my raw, natural, beauty.

Who are the women you most admire, and why? Marian Wright Edelman, the head of the Children's Defense Fund. I watched her one morning on the *Today* show. She was trying to galvanize the nation to support children and their specific needs, especially children from underprivileged families. By the time she had finished speaking, which was less than five minutes, I'd picked up the phone, called her, and asked, "What can I do for you?" People who have a voice and a passion that can inspire others to participate and help I find very exciting. And then I adore women like Cameron Diaz. Her natural ebullience and pure delight in living is contagious. She makes you feel happy. There's a need for power and a need for girlieness. They're both important.

You worked very hard to gain recognition in America, and now you are the CEO of IMAN Cosmetics, a line of cosmetics and skin care for women with skin of color. You ushered a new way of approaching women with skin of color. Was it difficult to make this dream a reality? Actually not. It was much more difficult for people to take me seriously. Leaving modeling to become an executive, I purposefully divorced myself from the industry and didn't go to certain parties or events so that there was a separation between my previous life and my future life as an executive. And I understood the market because I was a consumer, one who was having a hard time finding products for my skin tone. So I already had a connection with women in the marketplace who couldn't find products, especially foundations and powders. I became an expert and an authority in this field. Also, I redefined what it means to be "women with skin of color." This term embraces women everywhere—black, Latina, Asian and multi-cultural/multi-ethnic women around the world—and that is the IMAN Cosmetics woman.

At what age will you allow your daughter Lexi to wear makeup, and what advice will you give her? I'll teach her about skin care before I teach her about makeup. I'll probably wait until she's eighteen. Makeup makes you look older, or if not older, more sophisticated, and I don't want her rushing into looking older when she's not ready. Girls all want to look older, and then they hit twenty-five and they all want to look younger.

What is your personal fountain of youth? Sleep. [Laughs.] It is! If you have a good night's sleep, you look pretty the next morning. And that's a "beauty" item everyone can afford.

In these photos, shot for Italian Vogue, *the goal was for Iman to embody the essence of a strong, confident woman, so many of the elements are exaggerated: eyelashes that are twice too big, an oversized ring, and lots of color. In these photos, Iman is truly larger than life.*

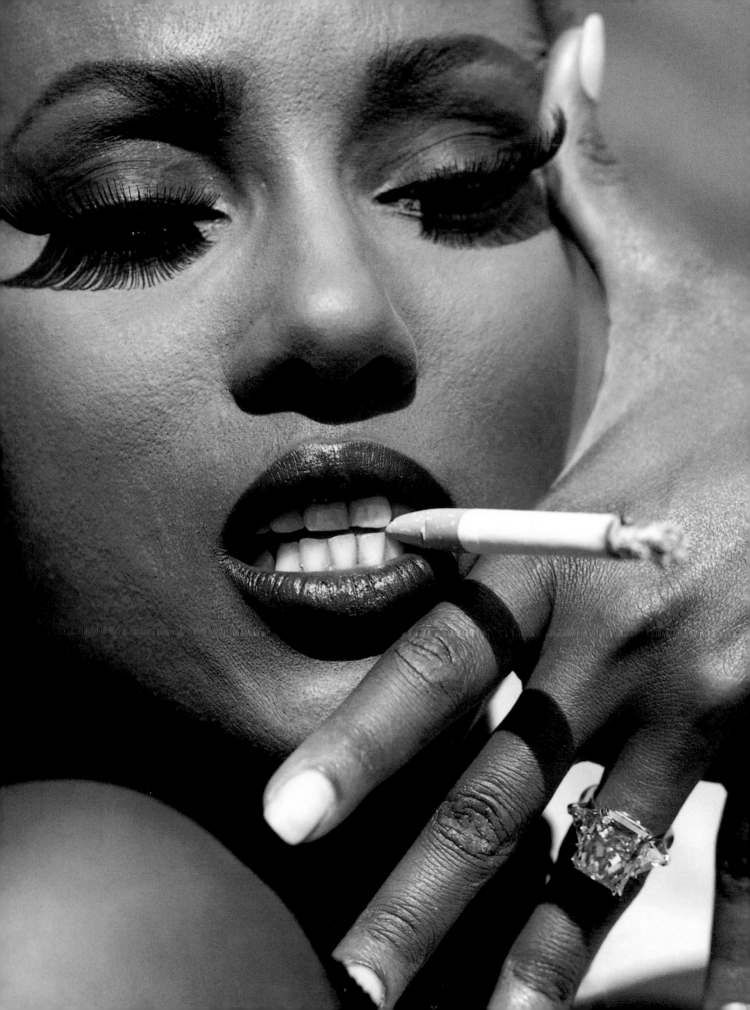

Brooke Shields

Brooke is America's daughter. From Ivory Soap to Calvin Klein, *Pretty Baby* to *The Blue Lagoon,* and *Endless Love* to *Suddenly Susan,* Brooke came of age in public with a gracefulness as natural to her as her porcelain skin and emerald-green eyes. She has embraced marriage and motherhood, conquered the Broadway stage, and authored a book—all with modesty and poise. When people say that beauty radiates from within, they are speaking of the Brooke I've come to know.

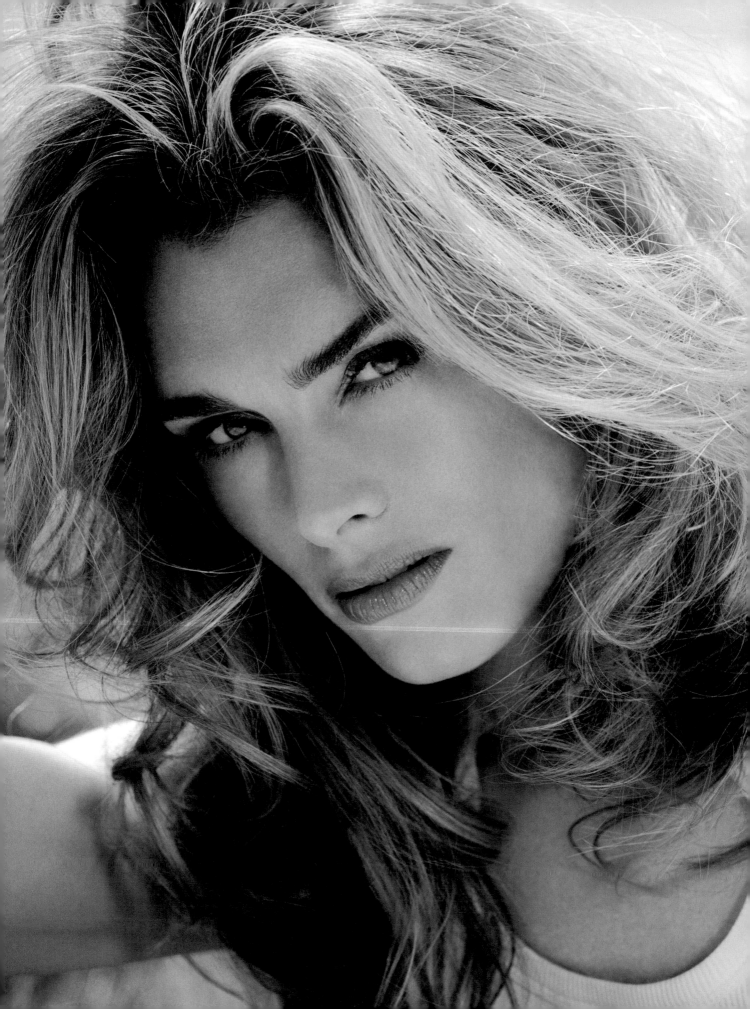

You are one of the select group of women in my book who were also in Francesco Scavullo's groundbreaking beauty books of the 1970s, which were a huge influence on me and one of the inspirations for this book. The Scavullo books were a first of their kind. Having been in the book, I don't think I was aware of how extraordinary it was. I was so young and for me it was just another day at the office, insofar as I had worked with Mr. Scavullo ever since I was a very little baby. I just assumed that every *Cosmopolitan* cover we did, Way Bandy would be doing makeup and Didier Malige or somebody great would do the hair. I was like their adopted child, everybody's little sister. They all sort of protected me.

That's really sweet. But after all these years in the spotlight, what's your approach to makeup now? I always prefer a little unless it's for a photo shoot, where it's all about drama

Sleep is a real tonic, and that's one thing you don't get a lot of when you're a parent.

What about exercise? I exercise a great deal, but the way I do it has changed. Nowadays, instead of taking a kickboxing class every day, I'm much more inclined to do yoga or to go hiking. I used to be obsessive about the idea that the harder the exercise, the more I sweat, the more pain I'm in, the more beneficial the exercise. As I've grown older I've realized that dancing, yoga, and hiking end up giving me the best results. And I'm happier now, so I'm sure that has its own effect.

Growing up, you were a beauty and fashion icon. Was there a lot of pressure on you? I had been doing it for so long that I was less impressed with being an icon than I was when I was twelve and I got my first *Seventeen* cover. When

"The beauty process was never something

I really learned how to do on my own."

and the extreme, and that's always fun, because it's more like a mask. In my personal life, I think less is more. I can't do my makeup as well as a makeup artist does, even though I've watched and listened and tried to learn for years.

What cosmetic necessities do you carry with you? Right now I have opted not to have a makeup bag, but in my side pocket I have the Stila Color Pushup Stick in Bronze Flash. I can put it on my lips, my cheeks, my eyes, and look like I've got something on.

How do you take care of your skin? My regimen varies, because in the transition from being pregnant to breast-feeding and then stopping breast-feeding, the quality of my skin continually changed. The one consistent thing that I have noticed is that when I'm hydrated it shows so much more in my skin. So the basic skin regimen that I will always follow is to keep it clean and moisturized. I do some kind of a mask or a deep cleansing once a week because, again, hydration and cleanliness are the things that affect my skin the most. I've also noticed that if I don't get enough sleep, the elasticity of my skin is really affected.

you're a kid, you aspire to be on *Seventeen,* not to be an icon. When I was twelve, to be on the cover of *Seventeen* was just it. The first cover I tried for, I didn't get. I looked too mature or something. I later got more famous and then they put me on the cover. I remember being really excited about it because it was such a big aspiration for me. I was already doing other covers—so many. It was *Vogue* one week, *Bazaar* the next, *Glamour* after that. It was a part of my everyday routine after school. Patrick [Demarchelier] shot for *Bazaar;* if you were doing *Cosmopolitan,* you were with Scavullo; and Richard Avedon did most of the *Vogue* shoots. The experience of shooting with those photographers was always more important to me than the covers themselves, and my mom saved all of them. It wasn't until I was older—on the cover of *Vogue,* shot by Annie Leibovitz, when the magazine put a pregnant me on its cover—that I appreciated that achievement. I went into the archives and looked at all my old covers and thought to myself, Wow, that's an amazing number of times to be on the cover of *Vogue.* To be honest, I'm more impressed now than I was then. So it's a shame in a way, but I think I was probably spared not being so impressed with my success.

What was it like for you, transitioning from model to actor? I'd done some television commercials, so the transition wasn't as hard. The workload was a lot longer and a lot more involved in film. Modeling, you went in at 3 o'clock, after school, and you were done by 8 or 9 p.m.—if it was a short shoot. But what I'd never really experienced until Hollywood was the transient nature of these intense relationships you form on film sets. For three months you practically live with a crew, then when it's over, you say goodbye and probably never see each other again. It made me really wary, at a young age, of getting attached to people. Also, you know, I never went through the stage of relative anonymity before being thrust into fame. I'd been modeling forever, and then at age eleven, I did *Pretty Baby,* which catapulted me into this frenzied world where, at the Cannes Film Festival, they tried cutting off my hair on the red carpet. It was surreal, but by the age of fifteen, it was not new to me anymore.

So describe yourself today as though you were a disinterested observer. I imagine that people look at me and think they have me all figured out, but I think I'm more of an enigma than anybody realizes. I'm so used to seeing other people's perceptions of me that it's hard for me sometimes to be objective. Do you know what I mean? Regardless of which picture they choose to put in *People* magazine every week—me with my daughter, me with my husband, or me at a certain event—I think no one's ever been really right. If I was a disinterested observer, I think I'd see many different people at one time, each one representing a facet of my personality.

You've grown up in the public eye, but I can't remember ever seeing you have an awkward phase. When I was younger I was kind of gawky. Then, when I was in high school, I acquired this sort of fatal hair situation—combination feathered and permed at the same time. Add fifteen pounds of baby fat and it was not a pretty sight. Even though I was getting flawlessly made up by the likes of whoever from the neck up, it took a lot of hell to get there, and the truth is that I was really messed up.

Was *Pretty Baby* (1978) your first film? I was in one movie prior to that called *Holy Terror* [rereleased under the titles *Alice, Sweet Alice,* and *Communion*], which was a little horror movie.

Of all of your films, which one is your favorite project? Aesthetically, and still to this day, it's *Pretty Baby.* I was spoiled at a very young age, working with Louis Malle and being surrounded by that caliber of talent. I have yet to experience that level of talent again. That was the first one, and I got sort of ruined. I'm also very proud of the work I did in James Toback's *Black and White* (1999), which was a very experimental, very unnerving experience. It was raw and noncommercial, and as natural as it could have been. I've taken some chances with my work, and I feel proud about it.

Is there anything in life you aspired to but never attained? Well, actually, the one thing I always wanted as a child and never attained is now within my grasp, and that is a peaceful, healthy, happy, integrated family life. As a child I used to wish that I had a home life like I saw in the movies, but it wasn't until I had my baby girl, Frances, that I realized that I would have to be the one to start the tradition. Now my husband and I share a life together with our child and I realize that what I was waiting for is actually starting, it's happening, and we're creating it.

List ten things in life that you love. I could say my daughter ten times with no hesitation, but I can't forget my husband, Chris. Then, after that, in no particular order, I'd list laughter, kindness, dancing, photographs, self-confidence, my talent, chocolate, my degree in French literature, and the last is waking up in the morning and being able to go back to sleep.

Who are some women who inspired you, and why? I think women who are strong and smart are beautiful. I think of someone like Anjelica Huston. Her beauty is so intoxicating and unique, and her talent is so versatile. I was surrounded by women like that as a child. I had a love affair with Rene Russo when I was little. I forget who the makeup artist was, but he had a low table in his apartment—it was in the '70s and I'd go over after school and sit at his table pretending to do my homework but really watching Rene Russo sitting on the floor eating walnuts. She was so natural and elegant. As for the ideal of beauty, I never really thought about it

What is left to say about Brooke Shields? I grew up with her face, on magazine covers and in the movies, and have seen her grow from a child model into a bona fide beauty icon. The look we created in these photographs is modern, independent, and strong, like Brooke herself.

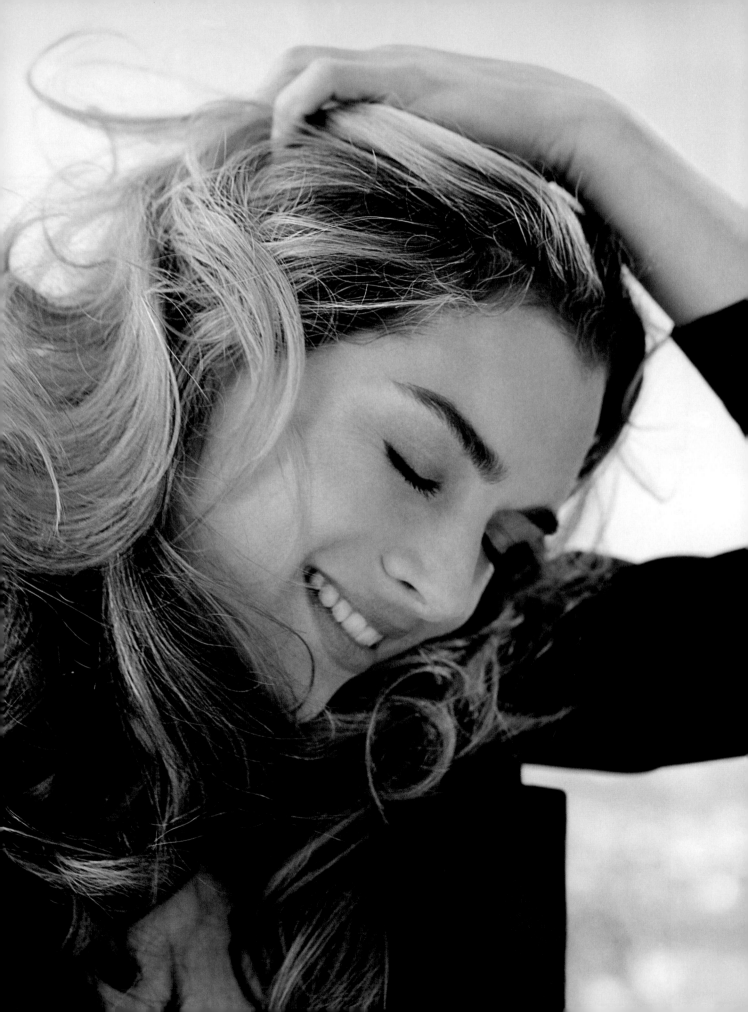

when I was young. I would sit in the makeup chair, get done up, and then go back to my child's life when it was all over. The beauty process was never something I really learned how to do on my own. I didn't buy the magazines, I never even assumed that I was in them. Even when I *was* on the covers.

How do you feel about aging, and how has it affected you personally? It's really a love-hate relationship. I love the experience. I feel much younger than my years, and I appreciate who I've become as an older person, but I also very often think I'm still a teenager. There's been an arrested development in the way I view things. It's less physical than it is emotional, I think. I never spent a whole lot of time examining myself because so many other people were already doing it for me. As a result, anything I see now is sort of a revelation to me, because I pay attention more.

At what age will you allow your daughter to wear makeup and what advice will you give her? Near our front door there is a mirror with a low ledge beneath it, and on that ledge is a bowl that I throw keys in and where I always keep a little pot of lip gloss. So basically, every day

"When I was twelve, to be on the cover of *Seventeen* was just it."

when I'm leaving, I get my keys and I put some lip gloss on. The other day my daughter walked by the mirror, stopped, took the pot of gloss out, and rubbed it on her lips. She didn't open it up, she couldn't figure that part out, so she just rubbed the whole thing on her lips. My husband and I looked at each other like, Did she just do what I think she did? She was twelve months when she started doing this. Part of me was shocked—she's already into makeup! Then I realized that after I give her a bath, we always do this little regimen in front of the mirror. We brush our hair and I put her cream on her face. Sometimes if I'm putting my lip gloss on she'll stare up at me and I'll pretend to put a little bit on her bottom lip as well. I thought, Oh my God, I'm putting makeup on my thirteen-month-old. So I would be sort of a hypocrite to say I won't allow her to wear makeup until a certain age. I'll probably try to negotiate with her as far as what's good makeup, like eight-hour cream on your lips versus, you know, ruby red lipstick.

What is your personal fountain of youth? When I'm happy, I look better and feel sexier, and when I find that confidence in my own skin, that's when I look my best. I think love is a tonic too—I look at pictures of myself when I first met my husband and there's a glow that I had then and still feel. *That* is like a fountain of youth. And for me, having a child is like being in love for the first time. Having a child makes me appreciate things that I normally took for granted—it's been a renewal of spirit, and where the spirit leads, the skin is sure to follow.

How would you like to be remembered? By my family as a loving, devoted mother and wife; and by the public as a smart, talented actress.

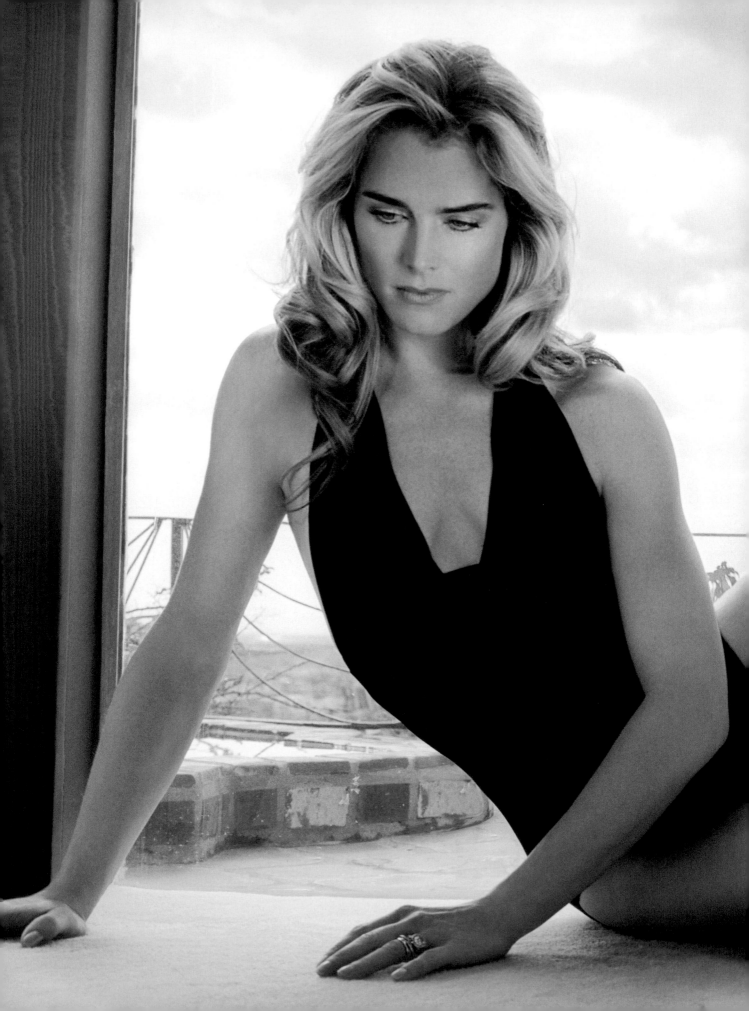

Rosanna Arquette

Big sister of an acting dynasty, Rosanna is drawn to strong directors like Martin Scorsese and Quentin Tarantino, and has gone out on a limb, artistically, in films such as David Cronenberg's *Crash* and Vincent Gallo's *Buffalo 66*. Turning her hand to directing, Rosanna tackled the subject of a woman's power in Hollywood with her debut film *Searching for Debra Winger.* We spoke at our favorite retreat throughout the years—Rosanna's cabin in Big Sur, California.

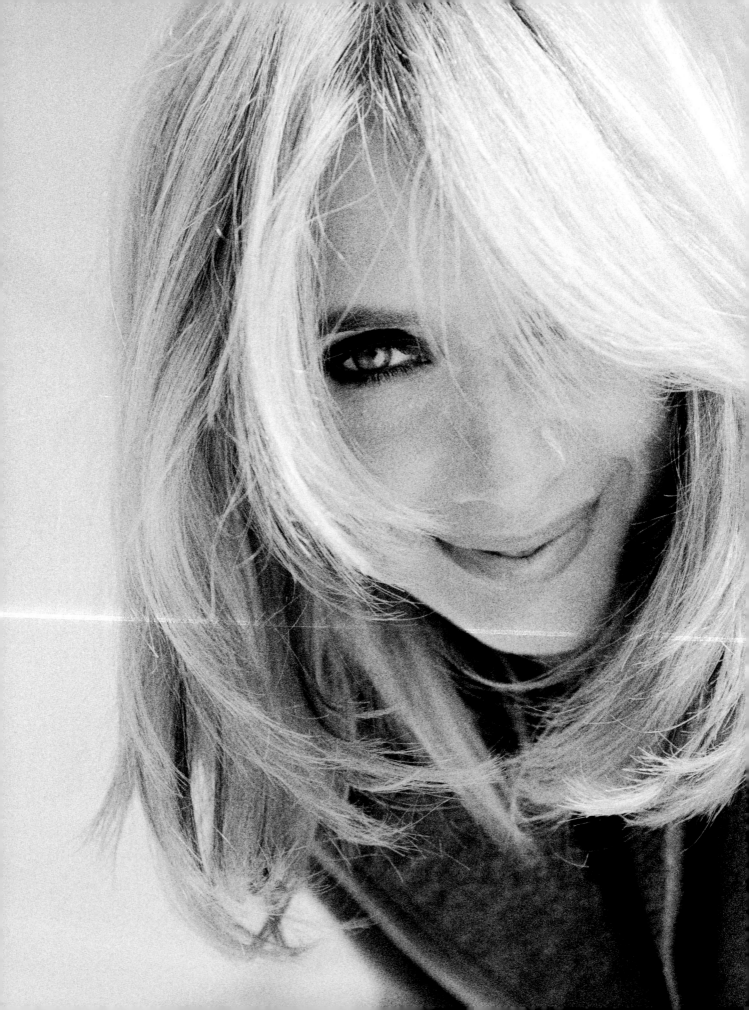

As the big sister of the Arquette dynasty and the first to go into acting, were you a role model to your siblings? I don't know that I was ever really a role model—everyone in my family is a thoroughly unique individual. I was the first one out of the gate, so they saw that it could be done, but they all found their own paths without much help from me. I never offered guidance, only encouragement.

Your directorial debut, *Searching for Debra Winger,* was an ensemble piece with various actresses talking about their experiences working in the Hollywood system. What drew you to musicians as the subject for your second film? I made *Searching For Debra Winger* because I was fascinated by that exact subject: How do women in Hollywood find bal-

said to me. Add to that the fact that as a child my mother showed me Michael Powell's film, *The Red Shoes,* which is about a woman having to choose between her art and her love. In the film, she throws herself in front of a train because she can't make that choice. And I saw that film when I was an impressionable four-year-old.

Do you think discipline is important to an artist? How structured was your upbringing? I had absolutely no discipline growing up. I had no boundaries and was allowed to do everything and anything I wanted to do. I left home at fourteen years old. Now, I am a mother and I have an incredibly artistic child, with boundaries. She's talented, an incredible ballerina with a good ear for music. She's a real artist. I allow

"I'm a woman in her forties in a town where women are not supposed to age."

ance in their lives, their art, and their careers? This time I'm doing it with musicians, because I am a music aficionado and have many friends who are musicians. Just to be able to sit down with Stevie Nicks or Yoko Ono is such a privilege and a treat. How does any artist balance his or her life and art to achieve the best results in each? It's the lifelong struggle, one we all share.

Didn't Bette Davis give you some advice as a young actress? It's too bad she didn't live long enough to be in your first film—she would undoubtedly have had some fascinating insights into show business. I was eighteen years old, but I was playing a fourteen-year-old when I met Bette Davis. Leo Penn, Sean Penn's father, was directing this miniseries, *The Dark Secret of Harvest Home,* that we were both in. Bette Davis sat me on her lap and said, "Just remember, Rosanna, you can never have both." She told me that I could not have a relationship and a career—that no actress could. I think, unconsciously, that made a big impression on me, because my inner conflict has always been, Can you have both? Many people seem able to. Susan Sarandon has a great working relationship with Tim Robbins, and a beautiful family as well. There are people who have both and make it work. I think I was always haunted by what Bette Davis

her full creative expression at home, but there are boundaries when she leaves the house, because we don't live in the world I grew up in anymore.

You've really gone out on a limb with films like *Crash* and *Buffalo 66.* What attracts you to a project and how do you find balance in your career? What attracts me to a project is a great script. I'm intrigued by things outside the norm. I love the anti-hero, and people that are in struggle. I love black comedy. I love great writing, but it's become increasingly hard to find these days. And when you do find it, it's usually in a low-budget film where you're working for scale. But acting is not in the forefront of my life anymore. It hasn't been for a while. I'm directing, and that's kind of where I'm at now. I really like being behind the camera. I think this is where I'll stay, because I'm a woman in her forties in a town where women are not supposed to age. I've seen what women will do to feed that beast, and it's not pretty. In many ways, celebrity is a disease. It is a disease of our culture.

And how do you define beauty? I think beauty comes from the inside, truly. I've known people who were outwardly very beautiful, but really quite ugly as individuals, reinforcing my idea that beauty somehow radiates from within. Physical

beauty is obviously real for the genetically blessed, but as the saying goes, it's only skin-deep. I think American ideals of beauty in general have become really distorted, and that has distorted how we define beauty. Flowers are beautiful—hydrangeas, for instance. I know that's kind of corny, but it definitely comes from the inside, so I think an inner calmness and serenity is a beautiful thing.

Who are the women you most admire, and why? There are several—some are living, and some are deceased. First is my mom, who died a few years ago. She was my touchstone. Then I'd say Jane Fonda. I have a huge picture of her in my living room. She looks so incredible right now. I mean, that's what we all want to look like, okay—Jane Fonda in her sixties. I admire women like Joni Mitchell, women who have beauty and brains, and have paid the price for knowing their own minds. I admire strong, independent women who've navigated broken hearts and weathered emotional storms and still emerged victorious. I admire women like that.

How do you feel about makeup? Do I believe in makeup! I'm not wearing any right now, as you can see, not a stitch. But I'm a true believer, and I depend on a great undereye cover. I've also grown really fond of tinted moisturizer. I've been using it instead of foundation.

How does makeup change the way you feel about yourself? It makes you feel prettier. If you see the most glamorous movie stars without their makeup, they're just normal-looking girls. I think everyone, the public especially, assumes that these "goddesses" wake up in the morning looking flawless. It's only in the movies that a woman can go to bed with a full face of makeup and wake up the same way. Try that in real life. I like to see women who are more natural with their makeup, but there's a way to do it. You don't get that look by wearing no makeup at all. Sometimes I love to get really made up, and the way it makes me feel is like playing dress-up when you're a little girl. I spend so much money on makeup. I'm always buying it.

Are you careful with your diet? Or do you follow any special regimen? No, I believe in whatever works for the individual.

It's all in the unique way each body reacts. I love to eat. I love pastas, pizza, french fries, and I really love chocolate.

You must exercise a lot. Your body is amazing. I exercise at least four days a week with a trainer. I have to. That is the only way I will do it. I will not do it on my own. I'm dreadfully undisciplined. I need someone to push me.

What do you do for the skin you're in? What is your regimen for skin care? I go to a woman named Donna Dupree for acupuncture—needles in the face—combined with a kind of massage machine. It definitely helps my skin. I haven't used collagen or Botox, but if someone invented an effective, nonsurgical face-lift with no risks or side effects, I'd probably try it. Who wouldn't? But right now I'm just trying to do everything I can to postpone the inevitable.

What do you consider your most unique quality, and your fatal flaw? I've never thought of myself as unique, but I think I have a creative mind that can take an idea, see it through to its logical conclusion, and make it concrete. I've been watching *Sylvia,* with Gwyneth Paltrow. It's always been my theory that, if she's not careful, a woman can give so much of herself to her man and her art that she loses herself in the process. Women do tend to do that, and a lot of them lose themselves in relationships. I've done that most of my life, but I don't do that anymore—and that is exciting. If I have a fatal flaw, it is impatience. I'm incredibly impatient, and sometimes too trusting. I'm a trusting person, so it's very easy to reel me in, and I tend to trust untrustworthy people. I'm an easy mark, but I'm working on that.

List ten things you love in life. My child, my man, music, Paris, Big Sur, my family . . . in that order. Animals, friends, creativity, and the concept of peace.

And do you think youth is wasted on the young? Oh, yeah. I wish I could have the skin and body I had at eighteen combined with the brain and soul of the woman I am today. You don't appreciate what you have when you're young. That's what I'm working on right now—to appreciate and be grateful for where I am and what I have today.

Rosanna epitomizes beach-girl chic. She looks great with clean, moisturized skin and a little mascara, or can just as easily go with the neo-'60s look of a strong smoky eye and a pale lip. Her rebellious nature and unflinching honesty reflect her hippie ethos, but moviemaking, motherhood, and a be-here-now attitude keep Rosanna firmly grounded in the present.

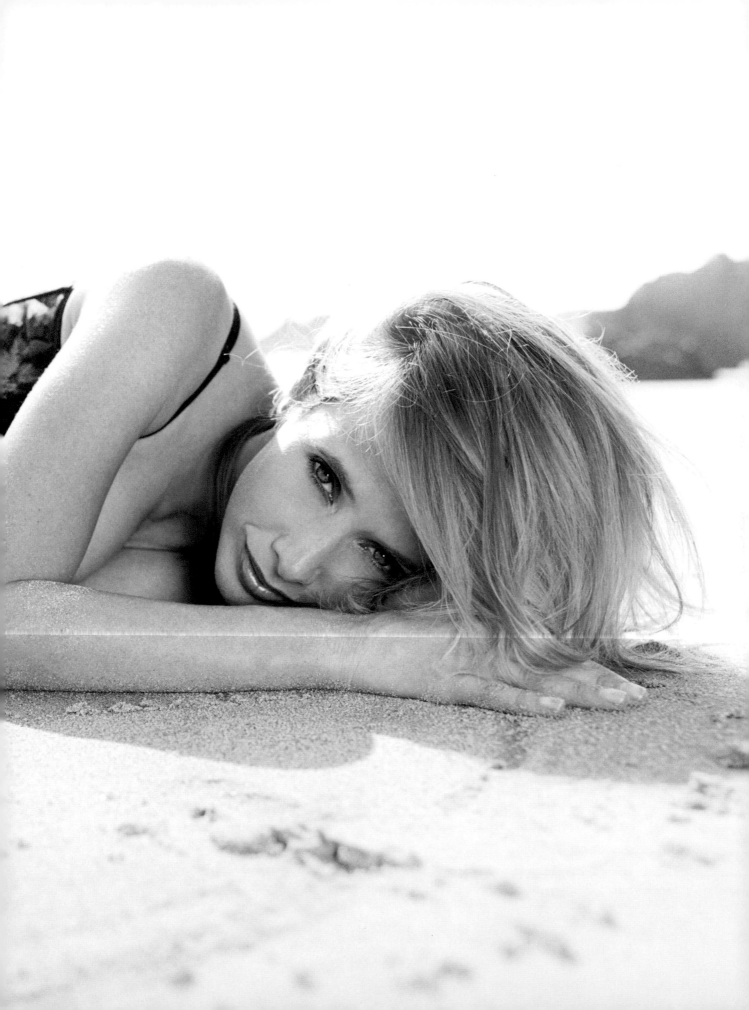

Sherilyn Fenn

Sherilyn's looks are a throwback to the old Hollywood studio system. If she'd been born fifty years earlier, she would have been put under contract by MGM, dressed by Adrian, and been on the cover of *Photoplay* on a regular basis. Instead, she was discovered by David Lynch, cast as cherry-twisting temptress Audrey Horne in *Twin Peaks,* became the celebrity face of Dolce & Gabbana, and ultimately photographed by George Hurrell in one of the final studio sessions of his celebrated career. For this interview we met in my living room, a familiar gathering place for us.

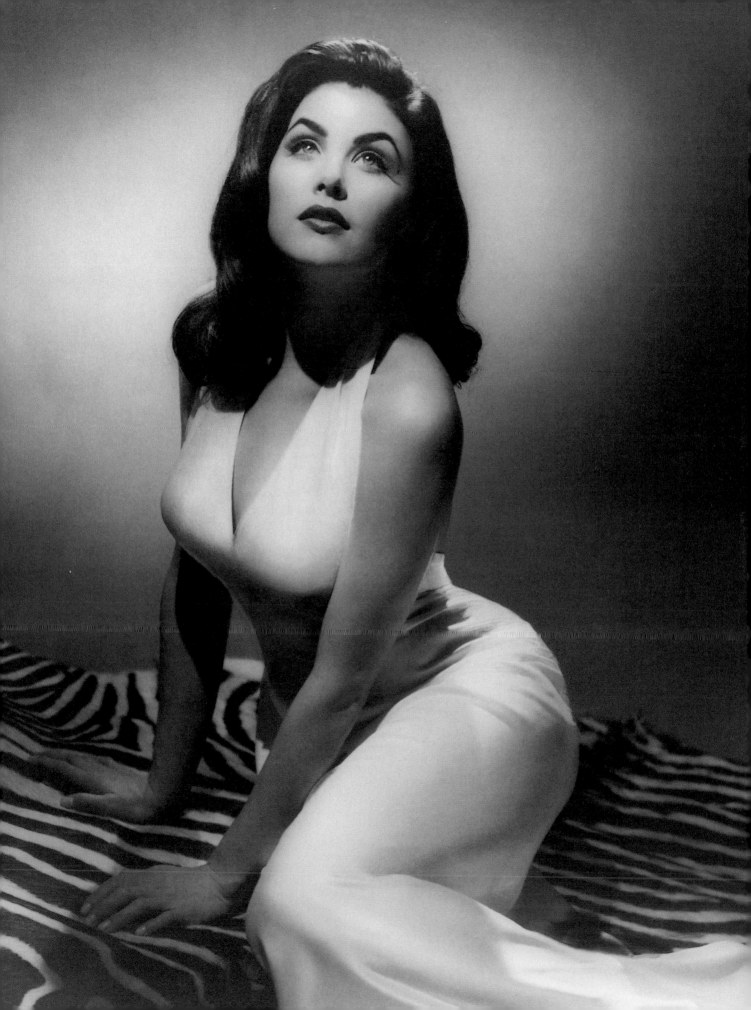

You became the first celebrity supermodel at a time when fashion supermodels like Linda Evangelista and Christy Turlington were doing most of the editorial and advertising work in magazines. Today, actors line up to do fashion and cosmetic campaigns, but at that time you were almost alone in the field. Was there a lot of pressure on you? I never looked at it that way. I was just young and having fun. I was excited at what was happening in my career, all the attention I was getting, and the doors that were opening as a result of it. Magazine covers led to an interest from Dolce & Gabbana, which led to a campaign with Steven Meisel. And the whole time I'm thinking, Wait, I'm 5'3", I'm not a model—I knew that I got the job as a result of my work as an actress—and I never kidded myself that I was competing with professional models on any level.

How does makeup change the way you feel about yourself? The funny thing is that I think I wear less makeup now at forty than I did when I was twenty. I used to get in trouble for going to auditions wearing a little too much makeup. I'd cake it on. It took me a few years to learn that less is more.

What are the basic cosmetic products you would be sure to pack for a three-hour cruise? A lip conditioner and lip pencil that looks kind of natural. Orgasm blush by Nars is a current favorite. And mascara. You taught me all the secrets.

And how would you take care of your skin? The basics. I really like Sisley products. I avoid the sun at all costs, and drink lots of water. I think the outside reflects what's going on inside. The times when you look your best are usually when you feel good and are taking care of yourself.

You have rock royalty on your family tree—your aunt Suzi Quatro, one of the first tough female rockers. How did she influence you growing up? Was she around you a lot? I grew up in Michigan. I'm a Michigan girl. She would come home to visit at my grandparents' house. She lived in London and had the most beautiful clothes, the most expensive shoes, the most expensive jewelry . . . and I wanted that stuff. I remember being a little girl, looking at her stuff and thinking, My God, this is so beautiful. And I remember how much attention she got from my family. I didn't grow up wanting

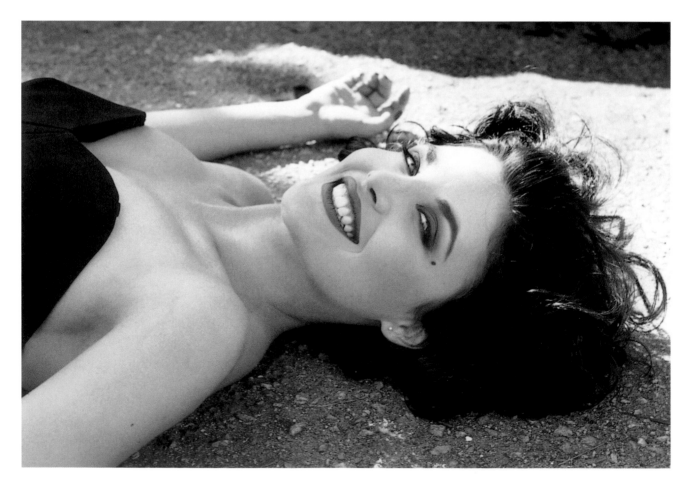

to be an actress or to have people look at me. I wanted to be loved. On some unconscious level I twisted that around somewhat, and I think that's why I went after the career I went after because I thought that I would get love, acceptance, and importance from my family and friends, or maybe just the world in general. I thought that would make me feel complete and good. Of course, it isn't all quite that simple.

Can you list ten things you love in life. God. My son, Miles. I love music, and being out in nature. I love walking. I love seeing great artwork, like the few times I've been to Europe and actually stood in front of a Rembrandt or Picasso. I love cooking, especially yummy soups. I love discovering new things for the first time, like my son's first words and his first revelations—when they're young, there are all kinds of

"Having a child gave me a sense of completion

as a woman that I never found anywhere else."

You have a beautiful son who is almost ten years old. How did your pregnancy affect you, and how did it affect your career? I felt complete. I'm thrilled that I made that choice. It wasn't by accident; it was completely premeditated. Having a child gave me a sense of completion as a woman that I never found anywhere else. It really sunk in the first month or two after he was born, holding him and caring for him, and having my whole existence revolve around someone else whom I loved so much. I remember thinking, My God, I looked to men, and to my career, and to all kinds of things trying to find this feeling of completion, and here it is. It felt like I'd come full circle. My son is still the best thing in my life.

What would you consider your most unique quality? When I'm really listening to people close to me, if I can really be present and intuitive, sometimes I can help them. That's important to me, to be a good listener.

And your fatal flaw? I think hanging on to false beliefs about myself left over from my youth. There are things in our lives that unconsciously inform decisions we make. Observing my son, I notice how the tiniest thing can affect him for months, or years. It's hard to shake loose deeply ingrained habits, but that's my goal, to be free of negative things.

firsts. I'll never forget the first little laugh out of my baby boy. I love finding the connections between life and spirituality. I don't know if that's ten things, but it's good enough.

How do you feel about aging? Let's say this: I don't want to be fifteen, twenty, twenty-five, or thirty-five again. Our culture courts youth and diminishes the elders who have wisdom. You don't have to play by those rules, and I refuse to live that way. My mother always said that water finds its own level, so let the insecure comfort each other.

Who are the women you most admire, and why? There are a few women I admire for different reasons. Cate Blanchett, Debra Winger. She was in the business, then made this other choice in her life. The general reaction was, "Oh my God, you left the business!" And her reply was, "No, I entered life." A friend of mine is in her mid-fifties and has lived a really crazy, wild life. Later in life she became a shrink, and now she facilitates all of these great workshops. I am inspired by people who are unafraid to make a totally different choice in their life.

Is there a motto or personal philosophy that guides you through your life? Think less, feel more.

Sherilyn was my first muse. Her features are perfectly symmetrical, with aquamarine eyes, high cheekbones, and heart-shaped lips framed by raven-colored hair. Sherilyn evokes the sultry allure of old Hollywood, which is the look we gave her in these pictures—classically elegant, with a hint of mystery.

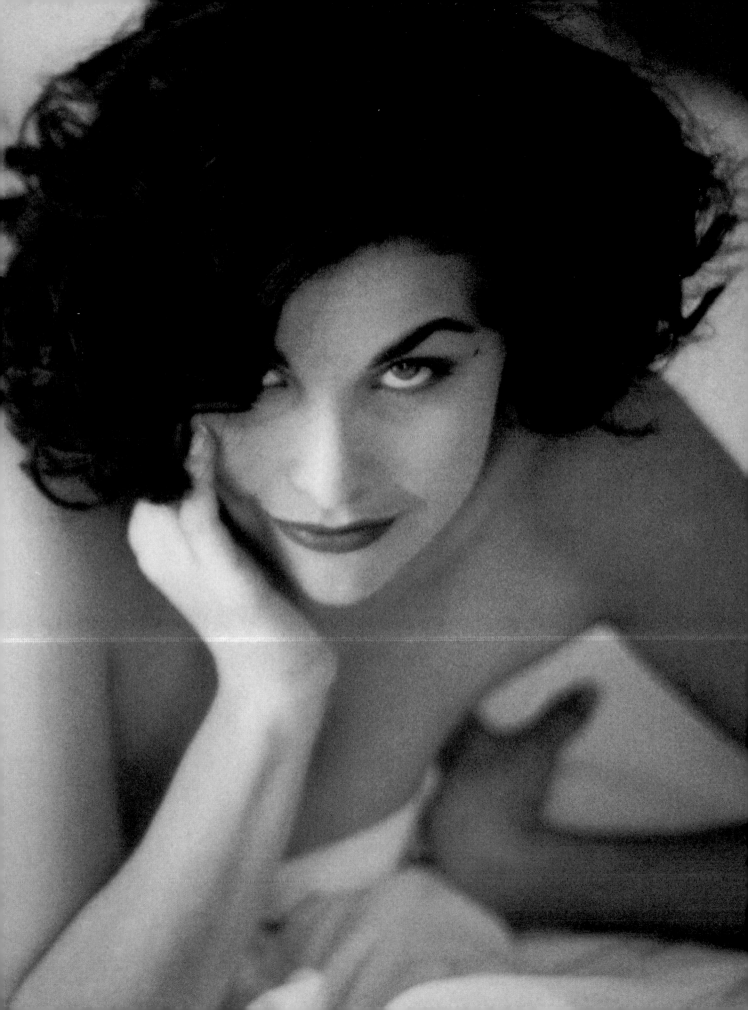

Renée Zellweger

It's been fascinating to watch Renée's evolution. With as many facets as a diamond, she has mastered the art of the public appearance, evolving from girl-next-door to screen siren without losing the vulnerability that is her essence. She chooses her roles like a prizefighter, and just when you think she's reached her peak, she'll top herself again. I admire her for never sitting still or resting on her laurels. For Renée, the journey truly is the destination.

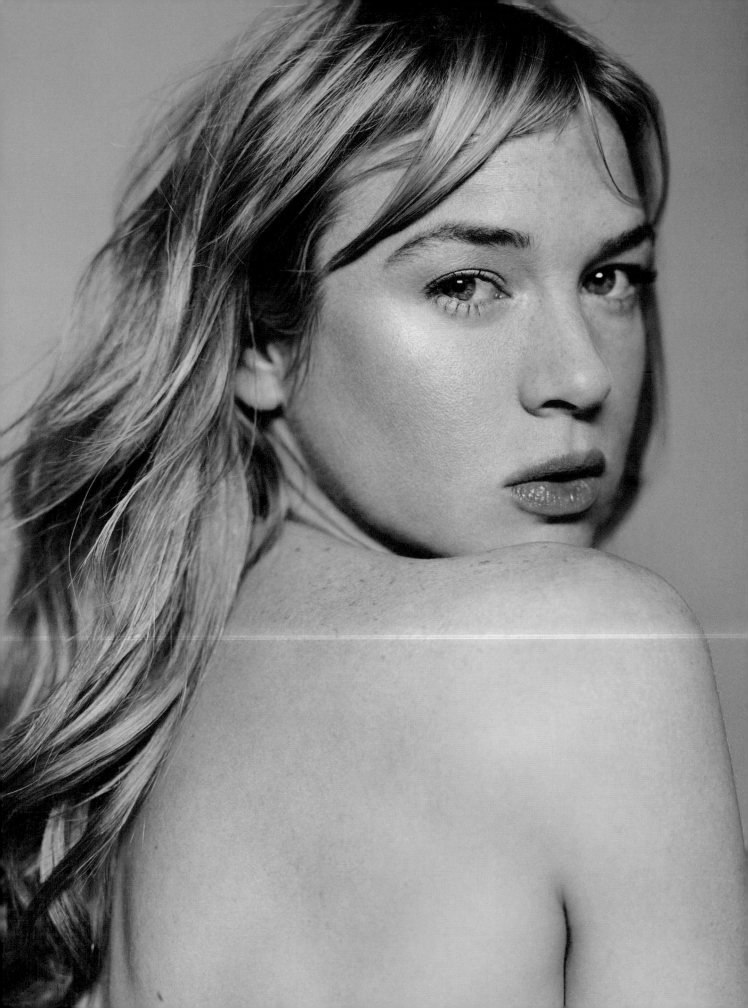

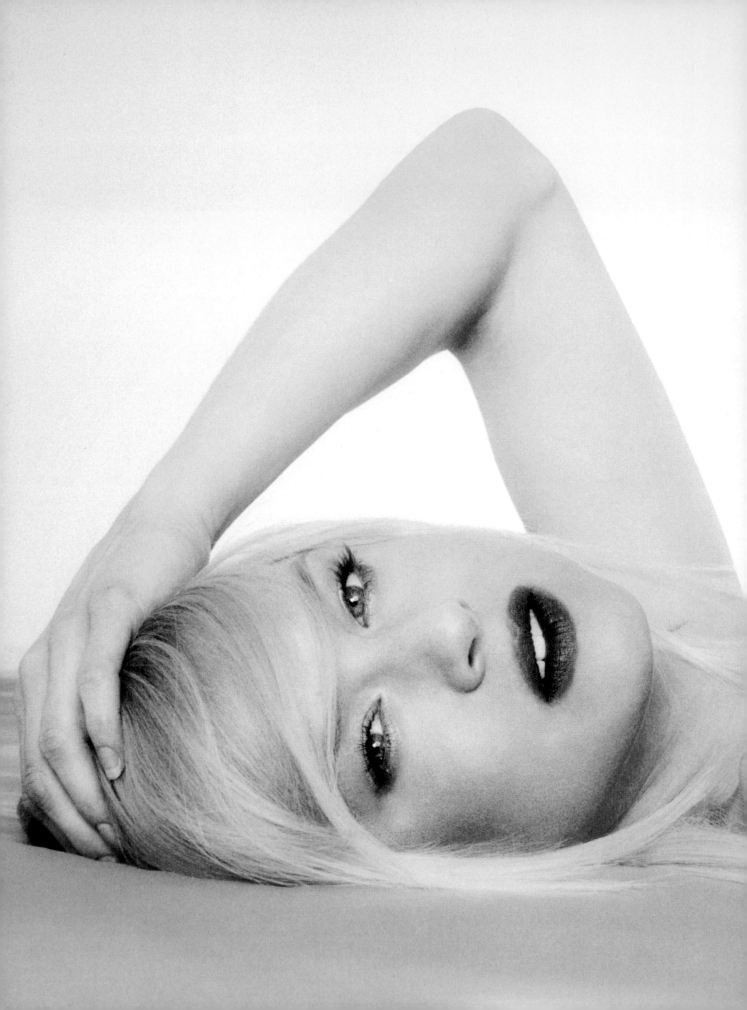

What is the meaning of beauty for you? I think that there is no denying the belief that true beauty resides within. The most memorable, beautiful women I have encountered embrace themselves and seek out and celebrate what is beautiful in others.

"Makeup helps to define and authenticate a characterization."

What qualities do you most admire in others, or seek to cultivate in yourself? Generosity, grace, and gratitude.

Every swan was once an ugly duckling. When did your transformation occur? I think transformation is growth and a life-long process. You can't possibly stop trying to manipulate your appearance in order to satisfy what you think others expect of you too soon. It's like taking off size-and-a-half-too-small shoes: It's incredible how much easier it is to dance.

As an actress, how do you use makeup to develop and refine the characters you play? Makeup helps to define and authenticate a characterization and clarify its historical placement through recreating the beauty trends of the period during which the story is set. Makeup choices reveal subtleties about the character's personality: her taste, how she perceives herself, and how she wishes to present herself and be perceived. Character makeup also suggests things about a character's background, like her social and economic status, and can reveal values, moral standards, and educational and religious influences as well. It is an invaluable tool even when its use goes seemingly undetected.

These photographs perfectly encapsulate the dual aspects of Renée's allure. She is an actress and a movie star, a natural beauty as well as a full-fledged Hollywood glamour girl, reminiscent of another era. I love highlighting her eyes by using individual lashes and then applying a stain to her perfectly pouty lips.

Salma Hayek

Vivacious and expressive, Salma is the foreign import of our generation, embodying the Latin essence as thoroughly as Brigitte Bardot and Sophia Loren, in their time, did for the French and the Italian. Through her acting, producing, and modeling for a number of cosmetics companies, Salma has remained true to her cultural roots but has transcended them to become a citizen of the world.

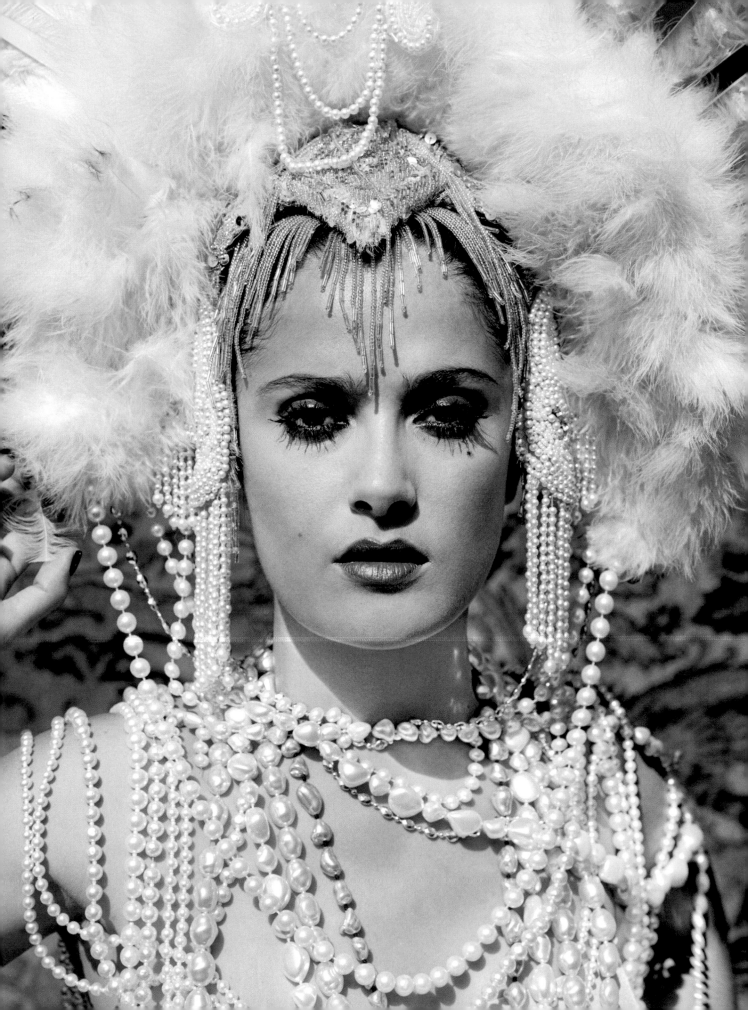

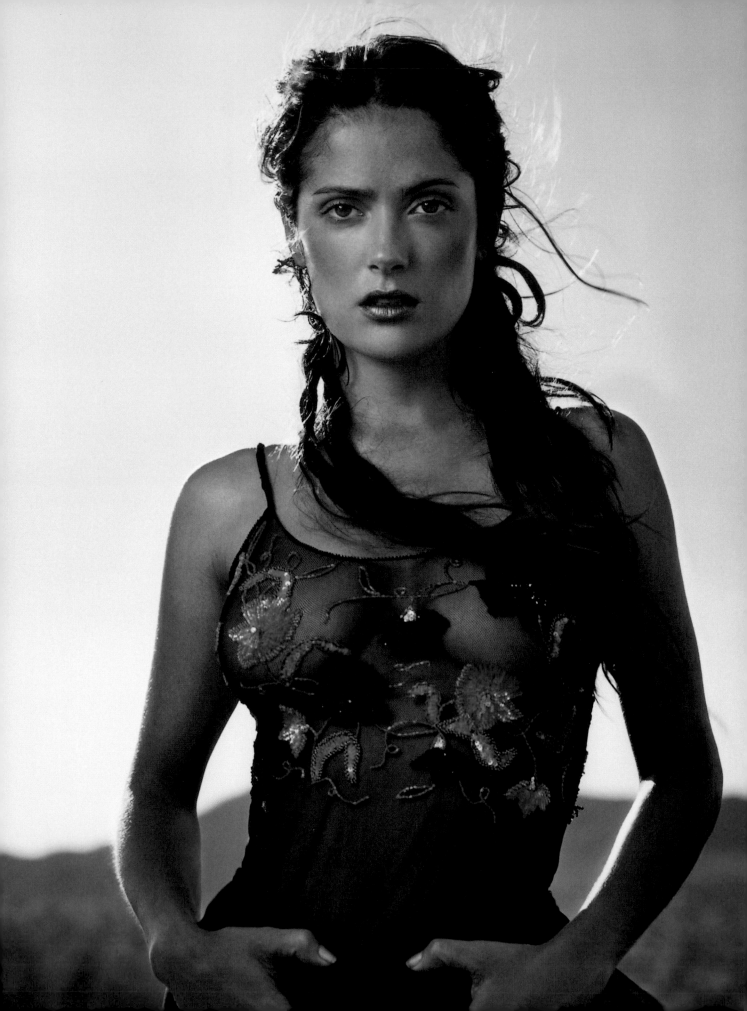

Where were you born? I'm from a small place in Mexico, in the state of Veracruz, called Coatzacoalcos.

What were the influences of American culture on you growing up? Mexico is very influenced by the United States because we are neighbors. And, of course, American cinema and music are seen and heard all over the world. So, I was familiar with the cinema and the music. Not extremely familiar, because we didn't have that many cinemas in my town—first only one, and then two when I was older—so I didn't have a lot of variety, but I was always eager to see the new movie.

Describe yourself as if you were a disinterested observer. I am a different woman depending on who's doing the looking. Being in the public eye, it's important to keep this in perspective because people's perceptions of you reflect who they are as much as who you are. I think I am a woman who is excited about life in all its many aspects. I am never bored because I have a good imagination and I am always curious. I am very passionate because life excites me and I want to improve myself and evolve as a human being. My life contains so many things that have nothing to do with my work or career. It's a well-rounded life. If one thing is not going particularly well that day, there are plenty of other things to keep me from becoming fixated on the negative.

What do you think about makeup, and how much do you wear in your private life? I wear it a little. Very little. When I am working, I wear only as much as is necessary. Makeup is great, but I don't like to use it every day, because then you're not surprised. I don't focus so much on the way I look in my everyday life, but I have a lot of respect for makeup artists because they can surprise me with the way they make me look, and I've been looking at this face for a long time now. The best makeup people are real artists, and they truly enjoy what they do. They relish the challenge of putting a fresh face on a client they may have been doing for years. I always enjoy working with you because I am excited to see what you will turn me into, what you will teach me about myself that I wasn't aware of, and what you will coax out of me that I didn't know was there.

When you were preparing for the role of Frida Kahlo, did you gain any insight into her own self-image? I did a lot of research into her self-image. Years' and years' worth. I even made my own look book. I collected every picture ever taken of her and researched the exact date of each one. If there were twenty taken in the same month, I figured out which day came earlier than the others. Putting the photos in chronological order, I discovered first how Frida created her identity, and then how she changed it and it transformed. I compared the photos to what was happening that year in her life. She was a living work of art. Her life imitated her art, and her art imitated her life. I understood a lot of things about her before we started shooting the movie, but I understood them in my head. I began to understand her with my heart when we were filming and every day I would go through the ritual of transforming my image into hers. For me it was almost like a meditation to go through hair, makeup, and wardrobe.

Salma's beauty is a natural resource—bounteous, and not merely skin-deep. When she enters a room, she possesses it. Her deep brown eyes are soulful and complex, and I love to accentuate them with mascara and dark eyeliner.

I did the wardrobe as a ritual just as she did. She would spend hours creating herself each day. Makeup and hair really helped me get inside of her character.

How does makeup change the way you feel about yourself? Makeup is a good tool because you can be playful with it. It can help you get into different moods. It improves your looks, and it sends a message of respect, and self-respect, to others. If you're dressed up with nice makeup, not only do you look good, but you're saying to the people you are with that you feel honored to be in their company, that you made an effort to live up to the occasion. It's important not to become dependent on makeup, though. Some people

As a Mexican, it's easier to make it in Hollywood than in Europe if you don't have a name. I have worked in Spain before, but that's about the only place. Also, it made sense to me that since America has such a large Latino population, it would be easier for me to find characters that I could play here. That said, when I first came here to work, there weren't any real parts for a Latin woman unless it was the maid or a prostitute.

When the film of *West Side Story* was made in the 1960s, Natalie Wood was cast as the Puerto Rican Maria. If they were casting a movie like *West Side Story* today, you'd likely be the main contender for that role. Do you realize how

"Beauty projects a sensation of well-being and calm,

but at the same time it is easiness and stimulation."

become terribly insecure if they don't have makeup on. It becomes like a drug. You have to wear the makeup, you cannot let the makeup wear you.

Were you a fan of the Mexican actress María Félix? Yes, certainly. María Félix was huge in Mexico, and still is. There were a number of Mexican divas, and each of these women were very glamorous—as glamorous as the American movie stars, or more. They had great class and sophistication. María Félix, for example, was not as well known in the United States, but she was an icon of beauty and elegance in Europe. Dolores del Rio was a beautiful, elegant woman who made films in both Hollywood and Mexico, but there are others, perhaps not as well known in the United States, who had the same level of class in the way they presented themselves. I was definitely influenced by American movie stars, but the Mexican divas were beautiful women who possessed glamour and cachet.

Could you have resisted Hollywood's call, as María Félix did? No, I wanted to do movies here. María Félix really liked Paris and Europe, as do I, but I want to make movies, and the movie capital of the world is Hollywood. I'm very interested in European filmmaking—some of my favorite films are European—and I hope one day to work there as well.

much you have helped to generate acceptance of Latina actresses? Yes, it's very exciting. It's a different world in Hollywood today. When I first came here, because I am Mexican, people actually laughed at the idea that I could get a leading part in a movie. I am honored to be part of a generation that has seen such a huge transformation in the perception of Latin American peoples, and I'm proud of our new position in the industry.

What is your definition of beauty? I connect beauty with joy. Beauty projects a sensation of well-being and calm, but at the same time it is easiness and stimulation. That's what joy is, and I think that is what beauty is as well, a sensation of calm and excitement at the same time. Beauty is a projection of joy.

And lastly, how do you feel about aging? It doesn't frighten me to get old. I don't see aging as a condition where you're going backward or are in decline. Quite the contrary. I think if you experience things with passion, admiration, humility, and with the purpose of learning from every experience, then eventually you attain wisdom. I see the passage of time as something that makes me better, because with the knowledge gained by experience, you have the tools to navigate your life in a better way. If you're happy, it keeps you young.

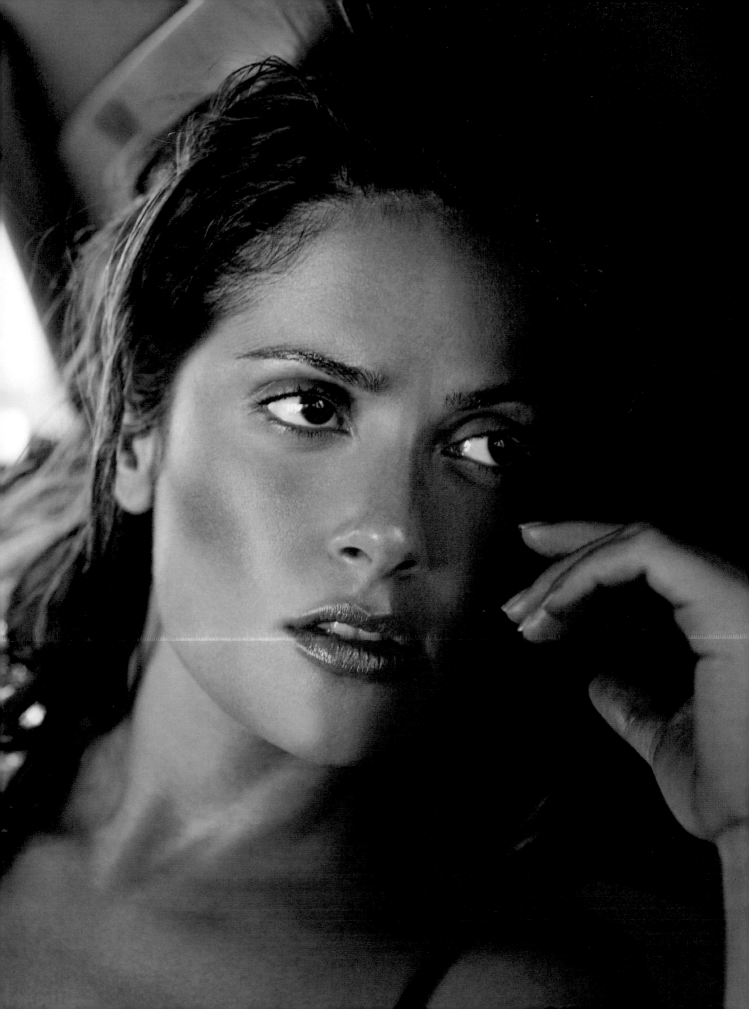

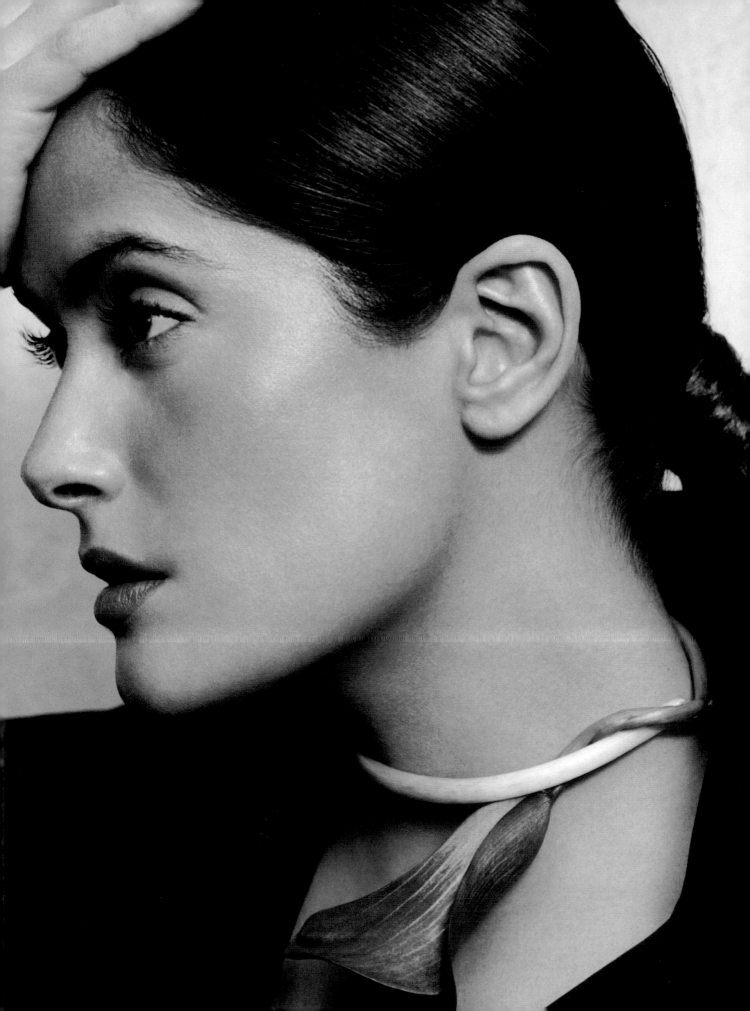

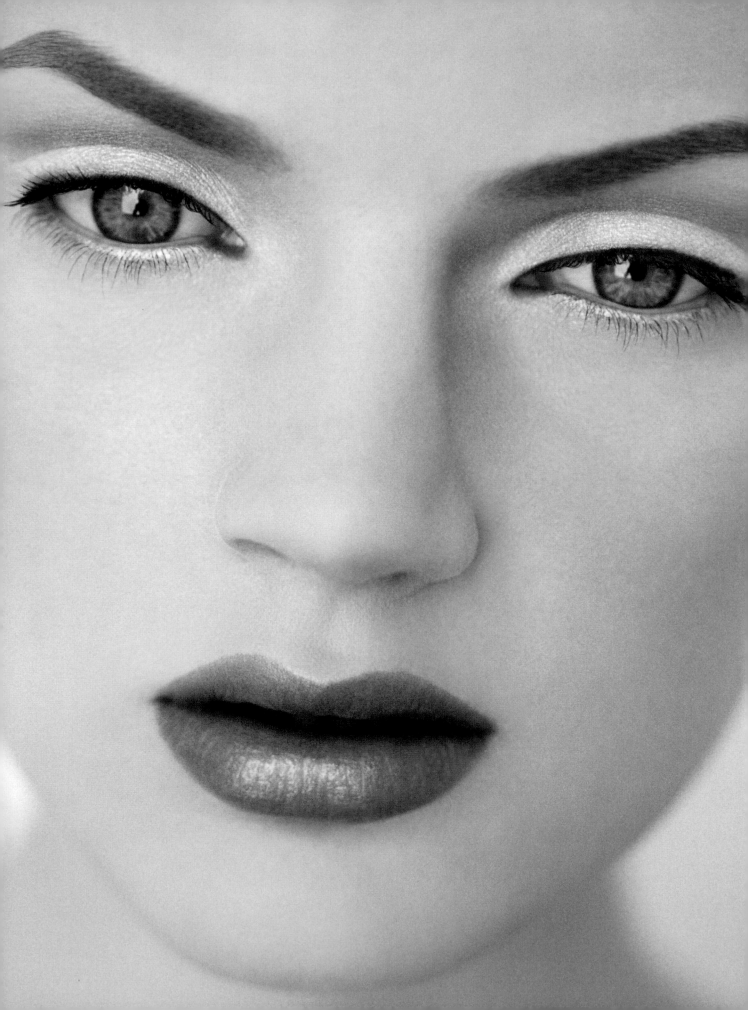

HOW TO APPLY MAKEUP

AND ACHIEVE A MASTERPIECE EVERY TIME

Beauty is every woman's birthright—it is not the exclusive province of models and movie stars. But it is left to each woman to discover her beauty, claim it, and define it for herself.

Start with a mirror and some honest self-assessment. Forget the overall shape of your face and focus instead on the feature that's most attractive or unusual. What seems to call for emphasis? Your cheeks? Your eyes? Your mouth? Choose one. Trying to play up everything at once is an all-too-common pitfall. Five of the looks that recur throughout this book (in any number of variations) can be replicated fairly easily at home. But don't mistake ease for effortlessness: The truth is that beauty takes work, and work takes time. Invest a little of both and you'll be rewarded with a newly deft hand—and, more importantly, with an expanded sense of possibility.

Admittedly, not every look is right for every woman, but unless you experiment, you are relying on preconceived notions that are limiting at best and anachronistic at worst. One of the biggest mistakes you can make is to cling to a look for too long (the Rothko-esque eye-shadow strata you perfected in high school, for example). The good news is that getting out of a rut rarely takes much; even a slight change can give you a whole new look.

Another key question: Are you wearing the right shade of foundation? If your face, neck, and décolleté don't blend seamlessly, the answer is no. Depending on your history of sun exposure and skin treatments, your face may actually be significantly lighter or darker than the rest of the skin in the area—and matching your foundation to your jawline (as conventional wisdom once dictated) only highlights that distinction. If you match your foundation to your neck and chest instead, you'll see a unifying effect.

The art of contemporary makeup lies in creating an integrated impression from distinct parts. Here's an important corollary: A lot of makeup well blended looks better than a little makeup slapped on. For that reason, I emphasize technique.

Before we get to the how-tos, one last point to bear in mind: Everything begins with liking yourself. Self-confidence and self-respect create a radiance that no bronzer or blush can duplicate. As brilliant as makeup can be . . . it's only makeup. Inner beauty—of every stripe—counts for infinitely more.

The model Guinevere, photograph by Robert Erdmann

THE FOLLOWING FIVE LOOKS form a progression: Each requires slightly more boldness than the one before. Though you certainly don't have to go in order, doing so will allow for a slow, comfortable immersion instead of a dramatic plunge. Also, for all their differences, the looks have a few things in common. First, the ideal starting point: skin that's been consistently nurtured—and freshly cleansed and moisturized. Taking care of your complexion obviates the need to over-camouflage and creates the freshest makeup canvas.

The second common thread is the recommended set of tools. The right brushes, in particular, can be a revelation, making application noticeably easier and more precise. A one-time splurge on a high-quality set (which is maintained through regular cleanings—at least once per month) is well worth the investment.

THE BASIC TOOLS:

1. Separate brushes for concealer, foundation, cream blush, facial powder or bronzer; lip-, eye-, and brow-color; and eyeliner.

2. A good eyelash curler is another must, as it really helps to open the eyes (a relatively small percentage of the population has lashes that curl upward naturally; most of us have lashes that grow downward). Whether you prefer the puffy, padded plastic variety or the sleek metallic one, your lash curler should approximate the width of your lid.

3. The last tools to consider: loose, product-free mascara wands (to remove any rogue clumps) and foundation sponges. You can buy both cheaply and in bulk at beauty supply stores.

The third common element to the looks is the technique or process by which foundation, concealer, blush, lip liner, and false lashes are applied . . . and by which lashes are curled. The steps you should always follow, in order (unless otherwise instructed by the text that accompanies a specific look):

1. Apply foundation first. If you need moderate to heavy coverage, use a brush to apply a cream or stick formulation. For lighter coverage, use a sponge to apply a liquid or cream.

2. Find a concealer that's as close to your foundation shade as possible. There's a widely held, antiquated idea that concealer should be pale—at least a shade lighter than your foundation. But the result is totally unnatural and raccoon-like. One easy solution: Stick to a brand that offers multiple formulations of its foundations (and countless cosmetics companies do). A liquid version can serve as your foundation, and a stick version of the same shade name can serve as your concealer.

3. **With the aid of your concealer and a brush,** dab away any major imperfections (discolorations, scars), but unless you're going for the Hollywood glam look, leave freckles alone.

4. **Your cheek color** should—unless otherwise noted in the individual looks—match your skin's own natural flush. Once you've found an appropriate shade, apply it to the apples of cheeks with either a brush for cream blush or your fingers. Blend outward from the center, until only the most diffuse hint of color remains at the perimeter. (Again, the idea is to mimic your natural flush.)

5. **Using a sponge with a bit of foundation on it** (and if you used a sponge to apply foundation at the beginning of this process, whatever remains of the product should suffice), press lightly over the just-blushed area for an even more natural-looking, almost airbrushed effect. You can do the same wherever colors aren't yet perfectly blended; this will soften and eliminate any remaining lines of demarcation.

6. **To create the perfect lip shape,** follow the technique of makeup legend Way Bandy: Starting at the center (of the bottom) of one nostril, draw an imaginary line straight down to where your lip starts, and place a dot of pencil there. Next, do the same thing below the other nostril. Finally, place a third dot midway between the two others, then connect the dots, line the lower lip, and use the pencil to fill your mouth in.

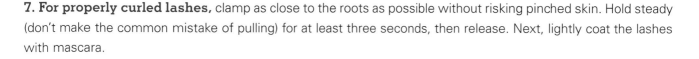

7. **For properly curled lashes,** clamp as close to the roots as possible without risking pinched skin. Hold steady (don't make the common mistake of pulling) for at least three seconds, then release. Next, lightly coat the lashes with mascara.

8. **If you'd like extra pop,** add some false lashes. For the most natural-looking results, use only individual lashes—and only the shortest versions thereof (still plenty long). Place a tiny dot (think: pinhead) of lash glue on the hand you won't be applying the lashes with, then dip the base of the lashes into the glue. This step prevents over-gooping. Next, starting at the center of your eye and working your way outward, lay the base as close to roots of your own lashes as you can. If the base touches your eyelid, you've gone too high. Once you get the placement right, re-mascara your lashes with a single, finishing coat. Make every lash count.

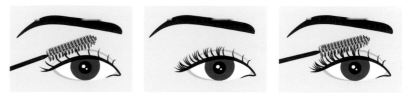

THE NATURAL LOOK

The idea here is to look, quite simply, like an extraordinary version of yourself (think: the gorgeous girl next door). Kate Hudson on page 165 is a great example of this look.

1. For the most natural-looking brow definition, use brow pencil and powder, both in the same shade (one that matches the color of your eyebrow). Using a soft toothbrush, brush the brows into shape, then fill in any gaps with the pencil. Pluck any hairs that fall obviously outside this line, and finish by going over the entire brow with a powder-dipped brow brush.

2. Next, using a medium- to dark-brown eyeliner, and keeping as close to the roots as you can, trace just above lash line. With an eyeliner brush, smudge the color into roots of your lashes; you'll be creating depth without obviousness.

3. With a pale, sheer cream shadow—and your fingertip or a brush—add the faintest sweep of color. The shadow should look fresh and dewy, like a light, golden wash across your lid. For depth, place a cream taupe shadow right where the brow bone starts.

4. Once your lashes are curled, apply mascara—black or dark brown for the top; brown or soft brown for bottom. Remove any stubborn clumps with one of the aforementioned extra wands. Then if you'd like, apply false lashes, but just to the outer corners. With even one or two individual add-ons, you'll be surprised at the difference.

5. Line and fill in your lips with a natural lip-colored pencil, then add a coat of sheer gloss or lipstick.

6. Rather than powdering, which tends to make the skin look artificially matte (skin has—or at least should have—a certain sheen and freshness), blot with oil-absorbing papers during the course of the day. If you can't forgo the powder, stick to the T-zone.

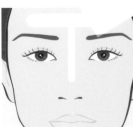

THE BRONZED GODDESS

This sultry beach look has two variations: the St. Tropez (à la Bardot) and the California (sort of a surfer girl motif). It looks amazing on Lindsay Lohan on page 103.

FOR EITHER VARIATION:

1. **Make sure your body matches your face;** you can't have a bronzed face and a white body.

2. **To create the perfect canvas,** combine one dot of foundation with two to three dots of bronzer; a liquid bronzer generally blends most easily with foundation. Then apply the mixture evenly to your face and neck.

3. **Intensify the bronze at the highest peaks of your face** (essentially, the T-zone, but also, the high planes of your cheeks), as these are the areas that would get the most color naturally.

F + B B

4. **Next, take a cream blusher** to add a last bit of flush to the apples of your cheeks and the bridge of your nose.

5. **Don't worry too much about your brows;** if you have to fill them in, do so with pencil but not powder (overly done brows hardly look at home on the beach).

FOR THE ST. TROPEZ BRONZE:

1. **Line the inner rims of your eyes** with brown pencil, then press your eyes closed to let the color smudge a bit.

2. **Use a cotton swab** to blend in any excess.

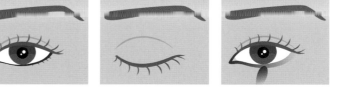

3. **Finish by coating your lashes** with lots of mascara (in the same color choices as with the natural look), but some clumping is fine here; no need to brush off excess with a wand. Keep lips in the coral family, but remember: Corals don't have to be ugly and old-fashioned; peach or apricot is the more modern version.

FOR THE CALIFORNIA BRONZE:

1. **Forgo the eyeliner and the mascara clumps;** use gold or bronze shadow on the lid and a bronze or cocoa stain on the lips.

THE '50s VIXEN
Even if a dark, opaque mouth seems a bit much for you, you can still pull off a version of this look with a sheer, deep lip. Annette Bening epitomizes this look on page 75.

1. Find your perfect red lipstick (there's one for every woman, but finding it may require lengthy, friend-aided research at the beauty counter), and apply meticulously with a lip brush. With red, there's little room for error. For daytime, you may want a stain, whereas for night, choose a formulation with more depth.

2. You'll want a well-defined brow here (use the pencil and powder technique), false lashes, and a couple of coats of mascara, but the eyelid should really be completely nude.

THE BARDOT
Though this look is a throwback to the 1960s, you'll look thoroughly modern with the right touches. The photograph of Rosanna Arquette on page 191 is the perfect example.

1. Start by lining your eyes (including your inner bottom rims) in whatever dark color works for you: black, navy, or dark brown.

2. Blend with a cotton swab. If there's bleed-off from the bottom, blend the color into your skin before you proceed.

3. Find an eyeshadow that closely resembles your liner color, then, using the shadow, retrace the pencil-lined areas to create a soft smoke around the eyes.

4. Blend the shadow upward into the lid, but not above the crease.

5. Follow the standard lash-prep steps, but in this case, add a couple of extra coats of thick, black mascara—unless you've used a brown shadow, in which case you should coat your top lashes in black mascara and your bottom in brown. Note: For this look, the clumpier the mascara, the better. Create a truly nude-looking lip; you may even want to apply a light coat of foundation to your mouth to take the color down.

CONTEMPORARY HOLLYWOOD GLAMOUR

This is a look every starlet, including Jennifer Garner on page 26, has worked since the dawn of Hollywood, but with fresh, real-looking skin.

1. Apply the standard foundation and concealer.

2. Use a foundation brush to stroke on a sheer, illuminating cream stick (for light to medium skin, either a white or beige shimmer is best; for dark skin, bronze or gold shimmer). The placement should go as follows: (a) a wash of shimmer that goes all the way from the lid to the brow bone; (b) a subtle crescent moon shape that starts at the outer edge of brow and ends at the top of the cheek bone; (c) a stripe down the center of nose, and right above top lip. The point is to highlight these areas and give a star-like (and seemingly starlit) freshness to the face.

3. Apply blush per usual, then use the "airbrushing" trick (done with a foundation sponge and described above) on the cheek color and on the highlighted areas as well.

4. **A highly defined, arched brow** is a distinguishing feature of this look; if you're uncomfortable shaping on your own, either use an arched brow stencil from a beauty supply store, or splurge on a professional shaping. You also want to make the brow darker and stronger than usual here, so go with a slightly deeper shade of pencil and powder than you normally would.

5. **In addition to the standard lash embellishments,** if you're making this a nighttime look, add a dark liner—black, brown, or navy—to the top lid, and pull the edge out a bit. But remember: You want only a tiny upward lift, not a full-on cat eye.

6. **As for your lips,** instead of lining them with a nude pencil, use the standard technique to line them with red.

7. **Pick the perfect vampy lip product:** for the adventurous, a rich crimson to a creamy plum lipstick; for the more cautious, a sheer stain in the same color range.

8. Finish by applying pressed powder to the corners of nose and mouth, as well as to the forehead (to contain the shine).

PHOTOGRAPHY CREDITS

ACKNOWLEDGMENTS

Steven Arnold Doris Butler Larry Schubert Paul Jasmin Gore Vidal Gavin Lambert Linda Wells

Lisa Walker John Carabino Ray Allington Mark McKenna Katie Ford Nicholas Callaway Adam Kaller

Cindy Szerlip George O'Dowd Melissa McCarthy Daniel Annesse Ellen Greenwald Romy Trahan

Charles Melcher Lia Ronnen Lauren Nathan Sam Shahid Donna Dupre Ron LeGates Stacey Souther

Sara Jane Hoare Arlu Gomez Kim Creighton Shelter Serra Michael Fisher Magnet Sue Hostetler

Special thanks to all the women and their publicists who made this book possible.

A very special thanks to my girls—Heidi, Maria, Ro, Joan, and Amanda.